W9-CTW-181

DATE DUE

Letters and Labyrinths

Letters and Labyrinths

Women Writing/Cultural Codes

Diane Cousineau

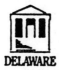

DELAWARE

Newark: University of Delaware Press
London: Associated University Presses

© 1997 by Associated University Presses, Inc.

to photocopy items for internal or personal
se of specific clients, is granted by the copy-
fee of $10.00, plus eight cents per page, per
ght Clearance Center, 222 Rosewood Drive,
. [0-87413-627-X/97 $10.00 + 8¢ pp, pc.]

l University Presses
44u Forsgate Drive
Cranbury, NJ 08512

Associated University Presses
16 Barter Street
London WC1A 2AH, England

Associated University Presses
P.O. Box 338, Port Credit
Mississauga, Ontario
Canada L5G 4L8

The paper used in this publication meets the requirements
of the American National Standard for Permanence of Paper
for Printed Library Materials Z39.48–1984.

Library of Congress Cataloging-in-Publication Data

Cousineau, Diane, 1946–
 Letters and labyrinths : women writing/cultural codes / Diane
Cousineau.
 p. cm.
 Includes bibliographical references (p.) and index.
 ISBN 0-87413-627-X (alk. paper)
 1. English literature—Women authors—History and criticism.
2. American literature—Women authors—History and criticism.
3. Women and Literature—United States—History—20th century.
4. Women and literature—England—History. 5. Authorship—Sex
differences. 6. Duras, Marguerite. Amant. 7. Letters in
literature. 8. Memory in literature. 9. Autobiography. I. Title.
PR119.C74 1997
820.9'9287—dc21 96-53198
 CIP

PRINTED IN THE UNITED STATES OF AMERICA

To my sons, David and Matthew

Contents

Acknowledgments

Parts of chapter 3 originally appeared as "Virginia Woolf's 'A Sketch of the Past': Life-writing, the Body, and the Mirror Gaze." *a/b: Autobiography Studies,* 8 (Spring 1993), 51–71 and as "Women and Autobiography: Is There Life Beyond the Looking-Glass?" *Caliban* (January 1994), 97–105. Used by permission.

Parts of chapter 5 originally appeared as "Leslie Silko's *Ceremony*: the Text as Spiderweb." *Revue Française d'Etudes Américaines* (February 1990), 19–31. Used by permission.

Letters and Labyrinths

Introduction

Lᴇᴛᴛᴇʀs and labyrinths, towers, mirrors, and photographs—these objects surround us in our daily lives and speak to the creativity and innovative possibilities of human culture, the degree to which we invent, form, shape, and give meaning to our world and lives. However, one might also suggest that they are emblematic of a code that has already been put in place and that we are the mere perpetuators of a master plot. The following pages explore the way these objects, vacillating between concrete presences and metaphorical configurations, inform literary texts and provide a suggestive background on which to interrogate gender-related issues as well as questions of subjectivity.

I

The "private life" is nothing but that zone of space, of time where I am not an image, an object. It is my political right to be a subject that I must protect.[1]

Roland Barthes introduces the question of subjectivity in terms that insist on the interpenetration of the personal and public spheres and warns us of the ease through which the word subject slides into its derivative, subjection. The photograph, as Barthes and others before him have pointed out, is the cultural object par excellence that captures the subject in the very process of becoming an object. A number of other cultural artifacts, however, are equally resonant in registering the intricate ways that cultural codes and private desires intertwine to create our sense of ourselves as subjects. For this reason I suggest that excavating these artifacts might give us a privileged means of entry into literary texts, directing us simultaneously to the most urgent personal concerns of the writer and to the cultural codes in which she is embedded. Labyrinths and towers, mirrors, letters, and photographs are thus the means through which I at-

tempt to explore the question of human subjectivity as it emerges in a series of literary works written by women. These writers—Jane Austen, Virginia Woolf, Jamaica Kincaid, Vivian Gornick, Marguerite Duras, and Leslie Marmon Silko—represent a rich diversity of social, ethnic, and racial origins, as well as offering us a variety of geographical and historical settings. It is my hope that drawing them together under one cover will create an unexpected wealth of textual interplay, bringing into being a community of women whose concerns call to each other across the space of their differences.

Obviously, the fact that I have chosen women writers adds a particular slant to this exploration of cultural objects, reminding us that structures of meaning are always products of choices that define a particular culture and that women have most often been marginal to these definitions. This is especially important to remember since these artifacts inevitably take on significances that in a particular culture become signs of values and assumptions that we perpetuate perhaps unawares. First objects, they then become metaphors, spinning off a proliferation of meanings; the ambiguity of words, however, cedes to the specifications of culture and thus certain meanings will be privileged—the fluidity of words turned to stone—inscribed in and dictated by cultural demands. Nevertheless, like all human creations, once created these cultural embodiments have a life of their own that refuses to be contained within the strictures that we have invented or try to enforce. A potency for new structures of meaning to emerge thus remains.

In fact what is most striking about these artifacts is the way they both testify to cultural values and preconceptions and undermine these certainties, the way they are indubitably inscribed in doubleness and contradiction. Because they are metaphorical embodiments as well as objects and because all metaphor negates certain possibilities of meaning through the process of selection and substitution, some meanings are necessarily driven out as others stand in for significant cultural values.[2] The question, then, is to what degree are these repressed meanings contained within our lives, signs of their refusal to stay put, quiet, and unspoken? What do these artifacts tell us about our deliberate effort to segment, order, and shape into dualistic and hierarchical categories, experiences and meanings that always threaten to break out of such binary structures? These questions remind us again that such fixings are inevitably gender related, that is, reflect biases and assumptions of a patri-

archal culture and that women's perspectives on such matters might lead us to perform new balancing acts.

What I am interested in is thus twofold: first, the multifarious, ambiguous, and self-contradictory meanings that these objects embody and give rise to and the way they emerge at particular moments in time and history; second, how women writers situate themselves in response to the dominant values that come to be associated with these artifacts and that at times prescribe certain roles for female and male alike and then make these relative values and positions appear as if they correspond to essential realities. To what degree are women conscious of the way they are being played out and represented in cultural norms and able to take their own playful and ironic distance from such impositions? And if the question of gender per se is not the main one at stake, to what extent do these women's use of such figures in their writings suggest innovative ways of looking at these artifacts, metaphoric potential yet unrealized? Finally, how do questions of genre and form reflect the unleashing of this previously bounded energy?

I certainly do not pretend that only women are capable of such challenges to traditional modes of representation, and I am indebted as much to male writers and theorists as to female in exploring these questions. However, I believe these specific writers provide us with unprecedented insights into the ways our lives interpenetrate with these objects and offer us jarring insights into what is lost if we continue to act out the dominant roles and values incorporated in these artifacts. One might also suggest that the heightened perspectives of these writers on their culture issue from the fact that each is situated, either historically or ethnically, between two worlds. Austen is at the critical juncture between the eighteenth and nineteenth centuries and Woolf, the nineteenth and twentieth. The others are themselves embodiments of cultural intersection: Duras, Indochinese and French; Kincaid, Caribbean and American; Gornick, Jewish-American, and Silko, a mixture of Mexican, Laguna, and white blood. For each the metaphorical implications of the artifact serve to reveal both the parameters of the world in which she finds herself and the means of breaking out of cultural and aesthetic constraints.

Each chapter, then, begins with a brief overview of the cultural meanings inscribed in the artifact at stake and then concentrates on a literary work, or works, that extends our notion of its structural possibilities. Undoubtedly the same line of inquiry

might be extended to other writers as well as other cultural objects. These particular artifacts, however, are particularly intriguing because they lead to the most crucial of contemporary critical concerns: the labyrinth and the tower to questions of gender that are inscribed within the linear and logocentric principles at the foundation of our culture; the mirror and the photograph to the crisis of representation that defines the present era; and the letter to the essential matter of all human discourse, the possibility of interhuman exchange. What is continuously in question is the way we constitute ourselves as human subjects across the cultural divide.

II

I begin with Jane Austen's *Emma* and the artifact of the letter for several reasons. First, because it situates us in a moment of dramatic cultural change in which the very notion of subjectivity is to emerge with unprecedented force. Poised on the edge dividing the neoclassical and the romantic era, Austen's novels invite us into a world where substantial developments in the social and economic world are met by equally significant shifts in the experience of individual consciousness. The rise of industrial capitalism and the increased social mobility and pursuit of private gain and self-interest that it brings severely dislodge the prevailing social order. At the same time, the neoclassical verities of reason, nature, and tradition are giving way to a conception of a world that is as much created as perceived by the human subject. A sense of communal good and public responsibility has still not ceded to the obsessive pursuit of private introspection and desire, but inklings that the promise of harmony between public and private spheres is no more than a felicitous fiction make themselves increasingly felt. The letter, synecdoche of the system of postal exchange, serves as an emblem of this tension: at once a vehicle of the most personal and private reflections, it is also a reminder that all human discourse is regulated by public codes and channels and thus subject to institutional control.

At first glance a rather peripheral object in the novel, the letter gradually emerges as the nexus of a structural network that reveals the doubleness and divisions lurking beneath Austen's smooth and elegant surface. The implications of its trajectories for the human subject are all the more alluring since we recog-

nize that the letter might be seen as embodying the quintessential nature of all human discourse and interpersonal exchange.

The novel's praise of the efficiency of the post office offers us in miniature an affirmation of the principles on which all human exchange is founded—the solidity of personal identity and the certainty that human messages will arrive smoothly at their destination. However, the plot of *Emma* would suggest otherwise; initiated by a refusal of desire that calls into question the very notion of a unified identity and characterized by doubleness and denial, Austen's narrative design assures us that human desire and communication travel by circuitous routes and detours rather than clear principles of purpose and destination.

Although the historical and cultural context is very different, a recent story by Jamaica Kincaid offers us a dramatic example of the symbolic force of the letter in relation to these matters, underlining as well the degree to which the conventions of letter writing encode cultural demands and displays of power. The speaker, a Caribbean girl educated at a British school, tells us:

> On a day that began in no special way that I can remember, I was taught the principles involved in writing an ordinary letter. A letter has six parts: the address of the sender, the date, the address of the recipient, the salutation or greeting, the body of the letter, the closing of the letter. It was well known that a person in the position of a woman, and a poor one—would have no need whatsoever to write a letter, but the sense of satisfaction it gave everyone connected with teaching me this, writing a letter, must have been immense. I was beaten and harsh words were said to me when I made a mistake.[3]

The perception that the most private of matters is yet subject to cultural principles of discipline and punishment is also fundamental to *Emma,* tenuously poised as it is on the intersection of the private and public spheres and foreshadowing Foucault's insights into the relation of knowledge and power. As Lionel Trilling once put it in words that might directly apply to the novel: "Some paradox of our natures leads us, when once we have made our fellow men the objects of our enlightened interest, to go on to make them the objects of our pity, then our wisdom, ultimately of our coercion."[4] The degree to which civilized behavior masks such a paternalistic attitude is an important question raised by the social structure that prevails in Highbury.

As I suggested earlier, the letter leads us to questions fundamental to all discourse. Indeed, because of its material nature

(a concrete piece of paper that we put into an envelope and then affix a stamp), it reifies such principles as stable and unified identity (signature), certainty of destination and destiny (address), and the possibility of human exchange. The letter thus might be seen as guaranteeing the reciprocity of intersubjective communication. The question of who is speaking to whom is, however, far more complicated than the conventions of letter writing would have us believe. To return once more to Kincaid's story:

> The exercise of copying the letters of someone whose complaints or perceptions or joys were of no interest to me did not make me angry then; it only made me want to write my own letters, letters in which I would express my own feelings about my own life, as it appeared to me at seven years old. I started to write to my father. . . . "My Dear Papa, you are the only person I have left in the world, no one loves me, only you can, I am beaten with words, I am beaten with sticks, I am beaten with stones. I love you more than anything, only you can save me."

This heartfelt, plaintive appeal couched in the most authentic and sincere cries is followed, however, by a jarring disclaimer: "These words were not meant for my father at all, but the person for whom they were meant—I could see only her heel. Night after night I saw her heel, only her heel coming down to meet me." Meant for her mother, who had died in giving birth to this daughter, these words are only allowed expression in displaced form. This travesty of the principle of address and delivery continues as the letters are never sent but hidden, then found by a boy and duplicitously delivered to the girl's teacher, who insists on reading the letters as addressed to herself:

> In my letters to my father I had said, "Everyone hates me, only you love me," but I had not truly meant these letters to be sent to my father, and they were not really addressed to my father; if I had been asked then if I really felt that everyone hated me, that only my father loved me, I would not have known how to answer. But my teacher's reaction to my letters, those small scribblings, was fascinating to me—a tonic. She believed the "everybody" I referred to was herself and only herself.[5]

The circuitous and erring route of human address and response delineated here would seem an echo of Lacan's much quoted phrase: "The sender receives his own message in reverse form"[6]

and suggests the complex and unconscious mechanisms and codes that infiltrate our words, derailing conscious intention, speaking at the same time they are silenced. The mysterious trajectories of the letter lead us to the intense divisions that mark human subjectivity; following such paths is particularly revelatory in the case of *Emma* where we see, on the level of both plot and character, that clear and perfectly executed messages belie the very principles on which they are founded.

III

The crisis of subjectivity haunting Austen's work, its tensions maintained in exquisite balance, will explode at the turn of the next century and emerge most resonantly in Woolf's statement: "In or about December, 1910, human character changed."[7] The mixture of irony and self-consciousness, nonchalance and high seriousness that mark her tone issue in the modernist preoccupation with the inner life and multiple points of view that will lead to such daring experimentation in form and fictional technique. Woolf's continual exploration of the question of human subjectivity and her obsessive attempts to situate her own being in this critical moment of historical and cultural development make her an irresistible figure to approach in this regard. Heiress, through her father, to a literary tradition that will be her life's blood, she cannot accept either the materialist tradition of her immediate forebears or the patriarchal structures that her father incarnates. However, neither can she simply reject the position of the father as the necessary presence that allows her entry into the Symbolic Order. *To the Lighthouse* offers us an astoundingly complex performance of Woolf's attempt to come to terms with her maternal and paternal legacies, as well as a site that registers the crosscurrents of feminism and modernism.

The artifact that beckons us here is the tower, the cultural object, along with the labyrinth, from which we reconstruct the quest of the hero, the central motif of Western culture. The structure of the quest is essential to the cultural representations from which we assume the contours of human identity and extrapolate the positions that men and women assume in the world. If the phallic image of the tower stands upright and beckoning as the symbol of human aspiration, of knowledge and conquest, the labyrinth is often conceived as the feminine, a womblike space, seductive but deadly, which must be pene-

trated, traversed, mastered, and left behind. But neither object is simply one thing even if both attest to the necessity of a male hero with the qualities of courage, perseverance, fortitude, and determination and a woman as the vessel of such heroic gestures. Lacanian theory encourages us to view the tower as a stand-in for the phallus, the ground on which human subjectivity and sexual difference are built; however, it also suggests the artificial nature and the limitations of such monuments. Certainly other writers before Lacan have underlined that the tower is not immune to connotations of narcissism and sterility and self-defeating positions of grandeur. From the warning of the biblical account of the Tower of Babel to Primo Levi's description of the towers of Auschwitz, we are confronted with the less than heroic dimensions and deadly consequences of such grandiose visions:

> The Carbide Tower, which rises in the middle of Buna and whose top is rarely visible in the fog, was built by us. Its bricks ... were cemented by hate; hate and discord, like the Tower of Babel, and it is this that we call it:—*Babekturn, Bobelturm;* and in it we hate the insane dream of grandeur of our masters, their contempt for God and men, for us men.
>
> And today just as in the old fable, we all feel, and the Germans themselves feel, that a curse—not transcendent and divine, but inherent and historical—hangs over the insolent building based on the confusion of languages and erected in defiance of heaven like a stone oath.[8]

Despite the somewhat comforting reminder that such monuments must be viewed in historical rather than archetypal terms, Primo Levi's words leave us with a lingering chill and disturbing questions. Does the tower as an extension of the phallus testify to a self-destructive principle that our culture is founded on? If, as Lacan tells us, the phallus is the critical signifier of the Symbolic Order from which we assume our cultural identities and from which the law of gender is instituted, how do we reach an understanding of the implications of these towering artifacts that takes into account both their oppressive nature and their necessary presence? Is it possible or even desirable to simply wish away the Symbolic Order? I suggest that Virginia Woolf's *To the Lighthouse* offers us a means of understanding the complexity of such questions as it enacts the passage from the Imaginary to the Symbolic from a woman's point of view. Because Woolf is simultaneously so drawn by the promise and

so sensitive to the dangers of the Imaginary, she makes us aware of the liberating force of the Symbolic—even for a woman—at the same time that she underlines the perversions of a patriarchal order gone astray. Drawing on conventional meanings of the lighthouse that identify its solid and isolate presence with masculine identity, she expands its metaphorical power to encompass the process of symbolization itself and with it the constitution of human subjectivity.

IV

While my emphasis in the chapter on *To the Lighthouse* is the passage from the dual relation to the rigors of the triangular relation, which both Woolf and Lacan recognize as the sole means by which human subjectivity can be achieved, the following chapter attempts to deal with the particularity of the girl's development. The self-reflective surface of the mirror, with its promise of capturing the real through the seductive lure of the visual image, invites us to the specificity of the mother-daughter relationship and provides the ground for the consideration of women's autobiographical works.

The mirror confronts us with the human dream of reaching an image of perfect *mimesis,* offering us the means of achieving absolute knowledge and self-reflection through visual forms. The experience of Narcissus notwithstanding, our fascination with the looking glass continues to witness our unabashed propensity for self-scrutiny and our desire to find in the polished surface of the mirror an image of wholeness and harmony worthy of self-love. However, from Narcissus's fatal captivation in his reflected image to Lacan's influential study of the mirror phase, the promise of revelatory vision and truth that the mirror image offers is countered by the suspicion that the image is mere artifice—deceptive and dangerously captivating.

The multiple and often contradictory meanings to which the mirror gives rise serve as a suggestive ground on which to interrogate the surface of self-reflection that is my focus in this chapter, that of life writing, for here the subject's self-conscious immersion in creating images of the self becomes the actual substance of the text. The very questions inscribed in the mirror's properties are echoed in the tensions of autobiography where the promise of revelation and truth must confront the always less-than-perfect embodiment possible as soon as any

truth is reduced to static and coherent images that present themselves as polished surfaces of the real. If the writer of autobiography is inevitably grounded in the domain of the Imaginary—a particularly seductive and dangerous realm for the daughter—is there any way that she can escape the parameters of the mirror gaze and the self-conscious pose that autobiography imposes? Woolf's "Sketch of the Past" offers us a complex engagement with such concerns, registering the tension between the elusive experience of the body and the containing reflection of the looking glass. Two other autobiographical works by contemporary writers, Jamaica Kincaid and Vivian Gornick, provide the means for further speculation on the effects of sexual difference on the autobiographical strategies of men and women. Products of different cultural and social milieu, these three writers offer examples of formal innovations in life writing that register their authors' struggles to negotiate the dangers and attractions of the mirror gaze. In the process they raise provocative questions about the meaning of autobiographical truth and the relation of truth to fiction.

V

While the previous chapters deal with questions relating to the constitution of subjectivity, the chapter on Marguerite Duras's *The Lover* brings us to the shattering effects of history on our understanding of notions of human identity and representation. It is not incidental that at the same time this text is perhaps the most radical challenge to conventional notions of generic distinctions between fiction and autobiography. If the previous chapter makes us wary of accepting the image as the means of acquiring access to our identity, the next chapter—assuming the legacy of the holocaust—completely dispels the idea of the image, and all such modes of visual representation, ever providing sufficient access to the real. The photograph, I suggest, offers us a particularly suggestive means of entry into *The Lover* and allows us to approach the radical shift of consciousness brought about by the Second World War.

Centered on a photograph that was never in fact taken, Duras's text raises far-reaching questions about the consequences of our photographically informed culture. To what extent does the proliferation of photographic images mitigate against our under-

standing of the world while encouraging us to believe that we can easily seize its truth? To what degree does it lead us to believe that we can grasp human reality by collecting fragmented pieces of it and so encourage cultural attitudes that are acquiescent as well as acquisitive?[9]

The photograph's promise of a privileged access to the real is for Duras an extension of the false promises of all mimetic approaches to the truth of human existence. Fully aware of the photograph's tantalizing appeal, she offers a text that captivates us with the promise that truth resides in such images at the same time that she reveals the failure of visual representation as the embodiment of the real. If Duras is not the first to register the ambivalent effects of the photographic consciousness to which we are heir, she brings us to an intensified awareness of its aesthetic and ethical implications and gives added significance to the crisis of representation that defines our era. By making us continually experience the disjunction between word and image in her writing, she suggests that the static form of any visual image is always inferior to the word, which insists that the real is a function of the tension between presence and absence, the very temporal gap that visual forms seek to deny. By punctuating her account of a childhood in Indochina with unexpected and jarring allusions to the Second World War, she makes us situate such aesthetic considerations in the historical context that most severely challenges our efforts to describe reality through traditional modes. The impact of this novel, I argue, gathers enormous force if one superimposes on its colonial setting the history of the concentration camp revelations that Duras herself alludes to as the defining moment in her conscious life. The crucial question then becomes: How does a writer bear witness to having lived through an historical event that has acutely transformed her sense of human reality in a way that will make her readers experience the radical difference that this experience has made? For Duras, no matter what the content of her writing, it is imperative to register this dramatic shift in consciousness that traditional forms of representation are incapable of conveying.[10] The photograph, then, is for Duras, as it is for Sontag and Barthes, a most trenchant means for interrogating the culture in which we find ourselves; for us it is also a means of approaching what is most distinctive about her own writing.

VI

Duras's insistence on subjectivity as the site of dark and violent forces is echoed on a different register in Leslie Marmon Silko's contemporary novel *Ceremony.* For both of these writers raised on the edge of two cultures, the early knowledge of transgressive cultural exploitation and violence leads to an unflinching examination of the human position without the solace of any self-righteous moral stance that presumes its own innocence and purity.

For Silko, however, a consideration of the legacy of mixed blood provides a means of transcending the linear and logocentric principles at the base of Western culture, which have too often encouraged the exploitation and victimization of the other. Writing in the wake of the newly awakened political consciousness of Native Americans in the 1960s and 1970s, she seeks to revitalize the spiritual and communal values of her people at a time when these questions are crucial to both Indians and other Americans. To approach a vision beyond the dualisms of Western culture, she offers us the spider web as the defining structure of her novel, which leads us in turn to a consideration of the labyrinth, a figure that is similar to, yet crucially different from, the web.

The labyrinth, like the tower, summons up images of heroic ventures and posits the mastery of the sense of direction as the supreme heroic virtue while acknowledging the inevitability of the loss of direction, the obligatory wandering through circuitous and dead-end paths, sites of disorientation and unavowable desires. Threatening a total loss of perspective at the same time that it offers a pattern of exquisite order, the doubleness of the maze affirms the need for mastery and control at all costs. It also posits the line as the prevailing structure of Western culture and validates the principles it perpetuates: logocentrism and hierarchy, causality and chronology. The figure of the labyrinth, then, offers us a compelling, if somewhat limited, vision of the world. Insisting on the drive for total vision and total recall—and implicitly a totalizing chain of command—it demands that we seek to control a world that is conceived of as a fixed background (the static structure of the labyrinth), its points fixed and determinate, its beginning and ending preordained.

The spiderweb, in contrast, is a series of interlacing lines that come together at points of intersection, emphasizing not lines

of opposition (dualistic categories) but instants that partake of both directions. The web thus focuses our attention on what is transitional—the moment of becoming—and valorizes the marginal, the impure, and what cannot be reduced to the dimensions of a line or a single thread. The images of weaving that the web inevitably evokes remind us that the French word for a person of mixed blood is *métis*; related to the word *métissage,* which means braiding, it carries none of the negative connotations that the English translations (mulatto, half-breed) always do. The weaving together of disparate strands, whether in individuals or woven cloth, might therefore be taken as pointing to a higher level of development and complexity rather than as necessarily suggesting an inferior state. That there is no exact equivalent of *métis* in English is significant to an understanding of the cultural blindness that characterizes our perspective.[11]

The structure of the spider web that informs Silko's novel, on the level of form as well as content, thus introduces us to new forms of subjectivity and an alternative to the vision of the quest traditionally tied to the figure of the labyrinth. Incorporating poetry and prose, myth and contemporary stories, but refusing hierarchical distinctions between the two, *Ceremony* offers us a notion of subjectivity grounded in the image of weaving: disparate strands coming together to create hybrid forms. Finally, this world created in the image of Spiderwoman rather than God the Father leads us to ways of representing women that far exceed the traditional role allocated to Ariadne.

From *letters* to *labyrinths,* we witness women writers' continuing attempts to constitute their own subjectivity across cultural divides. These chapters direct us to the breathtaking products of these efforts (belles lettres) while reminding us that all letters (as alphabetic signs) are subject to displacement and rearrangement, creating intricate structures of meaning (labyrinthine designs) that continuously beckon and that can never be finalized.

All of these texts have preoccupied me for many years, my ideas becoming increasingly complicated, and so I have tried not to reduce them to fit into any one particular methodology; at the same time, I am particularly grateful for the insights gleaned from the theories of deconstruction, psychoanalysis, and feminism, as well as the scholars who have so perceptively explored the territory surrounding these cultural objects before. Most of all, this study is a witness to the powerful effects these works have exercised on me, the pleasures and provocations of the word.

1

Letters and the Post Office: Epistolary Exchange in Jane Austen's *Emma*

THE letter as a form of human communication embodies the assumptions, values, and ideology implicit in all human discourse, whether oral or written. Its particularity is the concreteness of its material form—paper, envelope, stamp—and the degree to which its conventions (signature and salutation) reify such notions as a coherent human identity and a clear sense of destination and destiny. At once connected to the most common and practical matters of everyday life, lending concrete substance to and continual evidence of the idea of human exchange, the letter also reveals the difficulty, perhaps impossibility, of the reciprocity of such communication. That such contradictory notions should be embedded in the very structure of the letter has been forecasted by Derrida in his concept of *différance*. In the *Postcard* he tells us, "In a word . . . as soon as there is, there is *différance* . . . and there is postal maneuvering, relays, delay, anticipation, destination, telecommunicating network, the possibility, and therefore the fatal necessity of going astray, etc."[1] The following reflections are an attempt to trace out the implications of these words in regard to epistolary exchange itself and then in relation to the informing structures of Jane Austen's *Emma*. At a time when the traditional form of the letter is in danger of being rendered obsolete by E-mail, it is perhaps all the more important to reflect on the way the postal system has informed our notions of subjectivity in both the private and public realms. The letter's pivotal position at the intersection of these two sectors makes it all the more beguiling as an artifact of Western culture. That this position is neither innocent nor innocuous is clear from the resonating words of a character in a recent novel by Jamaica Kincaid: "I once had a pen pal on a neighboring island, a French island, and even though I could see her island from mine, when we sent correspondence to each

other it had to go to the ruler country, thousands of miles away, before reaching its destination."[2]

That a letter can be written, signed, and sealed into an envelope, and that a stamp can be affixed to it one day and the next it can be delivered to the addressee still seems a mysterious and startling accomplishment, even in an age whose technological feats have far outdistanced the marvelous acts of the post office. Letter writing and the postal system, so essential to our sense of ordinary reality and the way we imagine ourselves in the world, embody numerous codes that we unreflectively accept and through which we assure ourselves of the stability of our identities and the viability of our social presences. They sustain our belief in the possibility of effective communication and seduce us with the promise of intimacy and prompt and proper delivery. The very phrase *special delivery* suggests the extraordinary capacities of the post office and captivates our imagination with the prospect of secret and privileged relations.

Other vocabulary associated with epistolary exchange similarly draws our confidence, guaranteeing the authenticity of the letter and affirming the authority of this circuit of communication. The *signature,* guarantor of self-presence and self-knowledge, attests to the existence of a responsible and unified self that assures the truth of the letter's body. Serving as a "contractual oath of truth," this proper name, as Gilmore underlines in another context, "collects experience, change and continuity, family relations, and social agency in a signifier of commanding proportions, for it signifies not only the person in the present whose birth certificate bears that name but the very possibility of the subject's temporal and spatial coherence."[3] Its inscription at the end of the letter thus sustains the belief that the identity of signifier and signified are one and that words and their referents are to be safely identified. In fact, the evocative power of the signature to conjure presence at the very moment of absence is the foremost feature, indeed the very magic and seduction of the epistolary situation. In her book on epistolarity, Altman underlines this feature by situating the letter along both the metaphoric and metonymic poles. The letter belongs to the figure of metaphor because "it conjures up interiorized images and comparisons," but it also serves as an example of metonymy because "the letter, by virtue of physical contact, stands for the lover."[4] The presence of the one who signs the correspondence

is thus certified at the same time that his or her absence is acknowledged.

As the *signature* affirms the authenticity of personal identity, the *postmark* attests to the authority of the social system, the sign that the message has been processed through the proper channels and will be delivered intact. It is no wonder that the originators of the novel turned to the epistolary form to authenticate the "realism" of their genre as they attempted simultaneously to portray and inscribe the "reality" of personal and social identity. And it is no wonder that in Pynchon's *The Crying of Lot 49,* when representation no longer figures as the raison d'être of the novel, the violation of the centralized authority of the postal system announces a paranoia that leaves no form of identity intact.

The letter sustains our belief in the immediacy of truth and the communicability of lived experience, the subtle movement and intensity of emotion. This is the very reason that early novelists seized on the epistolary form and tried to claim for it the status of truth rather than fiction. However, as quickly as the letter invites belief in sincerity and revelation, it summons up images of betrayal and deceit. The epistle's promise of intimacy and secrecy inexorably invites thoughts of transgression. The temptation to read the private revelations of another, to violate the privileged relation of two people, perhaps to gain access to the lovers' discourse, increases as the desire and demand for secrecy is felt. The epistolary exchange is thus subject to betrayal from many sides, not least of all from the unpredictable whims of the postal system itself. Therefore, to the image of the sealed letter must be added those images of the intercepted letter, the forged letter, the unopened letter, the letter that arrives too late, and letters that cross in the mail.

The eighteenth-century epistolary novel, to be sure, was fully grounded on the combination of intimacy and betrayal, sincerity and deceit that the letter embodies. Most striking in this regard is *Les Liaisons Dangereuses,* which with great delight offers us the corruption to which letter writing gives way and insists that the dual relation of epistolary exchange is almost always transgressed by the presence of a third. Not only are all of Valmont and Mme Mertheuil's intimate relations with others subject to the correspondence of these master plotters, but the very letters that each sends to and receives from others matter of factly become part of their private and unholy epistolary exchange. Thus, the letter as a source of the sincere and spontaneous out-

pouring of emotion immediately gives way to the letter as the site of calculated deliberation and deceitful intent.[5]

Epistolary exchange is indelibly marked by dissimulation whether the correspondents are calculating and willfully deceitful, like Mme de Mertheuil and Valmont, or are absolutely sincere, pure in their integrity, like Mme de Tourvel and Danceny. The latter are equally immersed in deception, as Rousset underlines, although it is themselves, rather than the other whom they unwittingly betray: "the compulsion of their feelings often leads them to say more than they realize."[6] The sanctity of the epistolary situation is thus threatened on all sides: by the gaze of an outsider, whether a personal acquaintance or an invisible censor, and by the conscious betrayal of those involved. However, as the example above indicates, the threat is a more fundamental one: the words of the letter cannot be circumscribed by the conscious intent of the writer, and the authenticity of any correspondence is undermined by the fact that neither addresser nor addressee can be bound within the inscription of the salutation or signature. Again, what I say about the sender or receiver of letters is equally true of those engaged in any form of human communication; the letter, however, is a striking example because it emphasizes, indeed reifies, the idea of a unified and stable human identity.

The very time lapse that is built into epistolary exchange underlines the fact that she or he who writes is not necessarily the same as she or he whose words are read. Altman reminds us of the diversity of temporal moments that the letter holds: "the actual time that the act described is performed; the moment when it is written down, the respective times that the letter is dispatched, received, read, or reread."[7] It is not simply that each partner is subject to changes in feeling, moods, or thought but, more radically, that he or she is never the singular self that the letter's signature promises, that words are never masters of themselves, and that language always carries us into that place that is both dependent on, and subversive of, its laws. The temporal ambiguity that characterizes letter writing emphasizes the degree to which human discourse, as Felman tells us in her elucidation of Lacan, "is never entirely in agreement with itself, entirely identical to its knowledge of itself."[8] Thus, even when there is no outsider (representative of the larger social world), the necessary third in the structure of epistolary exchange always points to the unconscious discourse of the parties themselves.

The comforting sense of presence that the letter offers gives way to discomfort and unease. The distinction between addresser and addressee fades, too, for whom, in fact, does one write to and for? Although there is no doubt that the addressee informs every aspect of the epistolary project, bringing it closer to dialogue than monologue,[9] an irresolvable ambiguity remains. To what degree is the addressee in part a means of addressing, discovering, creating the self? Are all letters in part disguised self-address? Is the letter always in part a staged utterance?

In writing on the genre she calls "amorous epistolary discourse," Linda Kauffman argues that the letters of the female heroines she discusses "are related less to the mimetic than to the diegetic qualities of narrative, for the narrating heroine is intensely, constantly present as analyst, catalyst, and creator of her own desire. Since every letter to the beloved is also a self-address, ... the heroine's project ... also involves self-creation, self-invention."[10] Inevitably as one writes to another, one addresses the self as the practice of rereading one's own letters confirms. Thus, the dual relation between addresser and addressee must be founded on the doubling and division that inform the letter writer's sense of self. What Versini says of Richardson's Clarissa might be said of all those involved in epistolary exchange: "She is her own first reader; the epistolary exercise makes of her a spectator of herself."[11]

Engaged in writing and thus the law of the Symbolic Order, the letter writer is simultaneously caught in the world of the Imaginary, caught in the image of its own reflection and the experience of its own divisibility: "*Je est un autre.*"[12] Who does one become when one writes a letter? Surely a dramatic persona, to say the least, even if the writer consciously engages herself or himself to the utmost sincerity; but perhaps even less, a phantom or specter, as Kafka would have it:

> The great feasibility of letter writing must have produced—from a purely theoretical point of view—a terrible dislocation of souls in the world. It is truly a spectre of the addressee but also with one's own phantom, which evolves underneath one's own hand in the very letter one is writing.[13]

Perhaps more than any other genre, the letter blatantly speaks of the irremediable division of the self, on the level of both the Imaginary and the Symbolic; its incapacity to be true to, or

consistent with, itself. Offering us at times language as therapy and cure, it nevertheless insists on the fictional nature of both salutation and signature. The addressee is no less an invention and projection of the writer than is the addresser, and so phantom speaks to phantom. Although the letter's presence promises to transcend space and eradicate absence, the temporal discontinuity inherent in its form reveals that the desire for immediacy and presence is denied at the very moment it is uttered.

Perhaps, then, the subject of inquiry in regard to the letter should not be its truth value or contents but its effect. This is the question that Jacques Lacan introduces in his essay on Poe.[14] It is suggestive, especially when we remember the degree to which letters are primarily involved with effects. Letters themselves are most often written in response to events that the reader never witnesses or participates in, but whose effects are paramount. Moreover, the writer composes (and composes himself or herself in the process) with his or her gaze on the other in order, primarily, to produce an effect. Finally, the effect of any letter is subject to interpretation, which underlines that all identities, events, and destinations are matter for and subject to exchange.

Lacan reveals how complex these matters are as he traces the trajectory of the letter in Poe's text, concentrating on the effects of this signifier rather than its content and seeing in the letter's movement, in the symbolic displacement of the signifier, an analogy to the workings of the unconscious. What I want to stress, here, however, is the way Lacan's comments further complicate all notions of message and destination, letter writer and addressee, and insist on the equivocal nature of all effects. "The sender receives from the receiver his own message in reverse form,"[15] Lacan tells us, calling into question the linear model that is at the foundation of the system of postal delivery. The letter is no object but a performance enacted by two performers whose conscious intent is cut through by unconscious desire. "The message, I am reading," as Barbara Johnson writes in commenting on Lacan's sentence, "may be either my own (narcissistic) message backward or the way in which that message is always traversed by its own otherness to itself or by the narcissistic message of the other." Thus, the fact that Lacan ends his essay with the promise of the efficacy of the post office, "a letter always arrives at its destination," is not without a certain irony, as Johnson underlines in response to Derrida's criticism of Lacan's essay, for the reversibility of the letter's trajectory ensures

that the destination is far from a simple and unequivocal matter. On the contrary, the destination is only created at the moment of reading and is not necessarily the "literal addressee, nor even whoever possesses it, but whoever is possessed by it."[16]

Epistolary exchange, then, subverts the very system of communication that it creates. It simultaneously calls into question such notions as self and other, identity and destination, finality and truth at the same moment that it posits its foundation on them. Contemporary writers more blatantly undermine the truths seemingly affirmed by the services of the post office, as the essays in a recent volume on epistolary literature indicate, consciously "using the letter genre to express the impossibility of describing a unitary, integrated self."[17]

The novel that I would like to turn to now, however, is neither a contemporary nor even an epistolary novel, but an early nineteenth-century novel that is so thoroughly informed by the presence of the post office that it enters directly into the questions raised in the preceding pages and reveals how far reaching the cultural prescriptions embodied in letter writing are. Jane Austen's *Emma* is also more interesting than a contemporary novel for my purposes because it is poised on the very contradictions that simultaneously uphold and deconstruct the foundation that epistolary exchange rests on. This position reflects the novel's pivotal place in literary history, its registering of both the waning stages of neoclassical principles and the forthcoming romantic fascination with individual psychology. In turn this position can itself be related to changes in the contemporaneous system of postal exchange. As Charles Porter reminds us:

> The increase both in postal services and in sentimentally inspired correspondence in the eighteenth century is contemporary with the publication of Mme de Sevigné's letters, the rise of the epistolary novel, and Rousseauist autobiography. Finally, in the age of the development of rapid postal exchanges, in a matter of hours or days, there is the flood of personal literature that accompanies the outburst of emotional expression characteristic of Romanticism.[18]

Written after the epistolary novel had reached its peak by an author who had tried and given up writing in this genre, *Emma* is nonetheless structured around the intrigue of epistolary exchange. That the content of this correspondence remains hidden during most of the novel, even though its effects seriously inform and transform the main action of the plot, offers us another example of the functioning of the letter as signifier and

its exposure of the otherness of all discourse. This otherness—
at once a manifestation of the most private and unavowed desire
and the cultural forces that unconsciously shape our assump-
tions and behavior—once again underlines how complex the
interpenetration of these two realms are.

That these concerns are essential to Austen's novel is further
reflected in the tension between dual and triangular relations
that permeates *Emma* (and, as we have seen, structures all letter
writing as well as all other discourse). Pointing to the conflict
between the desire for intimacy and its refusal, the division be-
tween conscious intent and unconscious desire, this tension
also underlines the role of the social and linguistic structure as
the invisible code that assumes a third position in every dual
exchange. That this position powerfully informs the individual's
subjectivity in the two senses of the word (i.e., subjection as well
as agency) becomes apparent in the novel's ending, which so
uncannily portrays the return of the repressed and seems
smoothly to bring the novel to its proper destination. Moreover,
the scene in which Emma, under Knightly's guidance, is brought
to recognize her guilt, leaves us poised on the edge of an
alarming question: To what degree does the moment of recogni-
tion always involve doing violation to the difference that consti-
tutes each human subject?

This question directs us to the relation between personal reve-
lation, the emphasis on introspection and confession that the
epistolary novel brings into literature, and the power of control
exercised by the social structure or its representatives (e.g., the
post office). The status of the post office as the site of social and
economic power is not to be ignored, as Austen herself reminds
us in a somewhat playful manner at the end of her early episto-
lary novel, *Lady Susan:*

> This correspondence, by a meeting between some of the parties, and
> a separation between the others, could not, to the great detriment
> of the Post-Office revenue, be continued any longer. Very little assist-
> ance to the State could be derived from the epistolary intercourse
> of Mrs. Vernon and her niece; for the former soon perceived, by the
> style of Frederica's letters, that they were written under her
> mother's inspection! and therefore, deferring all particular inquiry
> till she could make it personally to London, ceased writing minutely
> or often.[19]

As the locus where public and private identities merge, the post
office leads us to the discomforting realization that once inquiry

into intimate concerns becomes matter for public display, the emotions offer themselves up to judgment and correction by the powers that be. As McGowan, drawing on Foucault, writes: "The romantic identification of the emotions, the inner vital sparks, as the crucial facts of human life created a new field in which power could, and felt it must, intervene."[20]

With these questions in mind, I turn to *Emma,* hoping to trace out some of the implications of Derrida's cryptic and enticing statement that the letter is not "un genre mais tous les genres, la littérature même."[21] My focus of inquiry, then, is not simply the presence of the post office and letters in the novel, but the way the novel is informed by the same ideological assumptions as epistolary exchange at the same time that it, like the letter, undermines this dominant cultural discourse.

A little more than midway through *Emma,* a curious and un-expected passage occurs, all the more so because it is spoken by Jane Fairfax who is not given to such impassioned utterances:

> "The post-office is a wonderful establishment!" said she.
> —"The regularity and dispatch of it! If one thinks of all that it has to do, and all that it does so well, it is really astonishing!"
> "It is certainly very well regulated."
> "So seldom that any negligence or blunder appears! So seldom that a letter, among the thousands that are constantly passing about the kingdom, is even carried wrong—and not one in a million, I sup-pose, actually lost! And when one considers the variety of hands, and of bad hands too, that are to be deciphered, it increases the wonder."[22] (260)

The post office becomes the focal point of conversation during Emma's dinner party for the Eltons. The immediate context of its appearance in conversation is Mrs. Elton's dismay over the fact that Jane walks to the post office daily in spite of inclement weather. Jane's preoccupation with her mail, ostensiby her ex-pectation of letters from her dear friends in Ireland, in reality her secret correspondence with Frank, points to the importance of the postal system on the level of plot and underlines the degree to which we shall be immersed in matters of "hypocrisy and deceit, espionage and treachery" (390).

The plot is also marked by the frequent arrival of letters that reinforces the dominant rhythm of the novel: the alternation between expectation and delay, the anticipation and postpone-ment of events, emphasizing the gap that stands between desire

and its fulfillment. Frank Churchill, for example, is introduced to Highbury through the "great good sense" of his letter to Mrs. Weston on her marriage to his father, and the subsequent forecasts and postponements of his arrival are announced by mail. Announcements, invitations, apologies, explanations, proposals, and refusals are all matters for the post; and the splendid capacities of the post office assure connection between Highbury and the larger world: Maple Grove, Enscombe, London, and Ireland.

The significance of the postal system is far reaching, and, as Derrida suggests in *The Postcard,* the letter can be seen as the perfect representative of the logocentric era in its assertion of identity and destination. It affirms the possibility of communication, continuity, tradition, and truth, the neoclassical values that many readers find so effectively embodied in Austen's novels. However, as Austen intimates, the very notion of the efficiency and order of the postal system calls forth its opposite, the possibility of "negligence and blunder." This possibility, that a letter might go astray, is taken up by Derrida (there is, after all, a dead letter office) to call into question the absolutes that the postal system as representative of logocentric culture contains. In his analysis, identity, destiny, and decidability yield to detour, chance, discontinuity, and misunderstanding, all ruptures that Austen's novel displays.[23]

In *Emma* the post office stands as the affirmation of the order and stability of English civilization, the perfect representation of a society that questions neither its identity nor its destiny. However, in Austen's novel, the absolutes that exist at the foundation of the text frequently call forth their opposites just as the possibility of blunder lurks directly within the structure of the postal system.[24] Crucial to the turning of Austen's plot, after all, is the possibility of a letter going astray. Frank's letter of explanation is never mailed to Jane but is locked away in his desk contrary to all his intentions. In his letter to Mrs. Weston, Frank later remarks: "Imagine how till I had actually detected my own blunder, I raved at the blunders of the post" (390). The resonance of these words is reinforced as letters are twice associated with blunders in the novel. In the word game that is the focal point of an evening in Highbury, Frank offers Emma the letters of the word "blunder," which she tries to decipher under the watchful eye of Mr. Knightly. The status of "letters" as signifiers is thus doubly affirmed as the novel plays out the effects of signifiers to which characters and readers alike are subject.

The letter's reification of the concepts of identity and destina-

tion has its parallel in the prominence that these ideas assume in the novel. Perhaps here we should recall that the clear demarcation of identity is predicated on the assumption that the meaning of each word can be rigidly contained and relegated to a fixed position. *Emma* voices utter confidence in such notions of "truth"; however, the novel also suggests that both personal identity and destiny are firmly rooted in social convention. Characters live in a social space that defines their boundaries; to transgress these limits is to lose one's identity. This is why Emma's rudeness to Miss Bates is so disgraceful: her behavior is irreconcilable with her superior social position. As Weinsheimer says, "To forget one's self is to overstep a social boundary as it is to transgress the division between self and other. It is to forget one's place or status, as if there were a definite social space surrounding an individual coextensive with his self; and when the self-space is exceeded, 'you are not yourself.'"[25]

In similar fashion words achieve precise definition. Elegance, for example, appears repeatedly in the novel, each time taking on a meaning that is more refined and increasingly indisputable. The authority implicit in words allows Mr. Knightly to distinguish with utter confidence between the French word *aimable* and the English aimiable (131). Words take on absolute presences, and both words and people have the possibility of being brought to their final destiny, that is, the "perfect arrangement." Men and women aspire to the perfect match, equal or superior connection, and riddles may be gathered into an "arrangement of the first order" (59).

However, while the text offers us characters whose identifies seem stable and words whose meanings seem exact and indisputable, the opening pages of the novel encourage us to avoid the assumption that words or characters are capable of remaining within such clearly defined boundaries. Equally apparent is Austen's delight in the doubleness and ambiguity in which identity is offered and then withdrawn, communication is based on misunderstanding, and the clarity of words is undermined by their connections. In the much quoted first sentence, Emma's qualities and situation are precisely stated: "Emma Woodhouse, handsome, clever, and rich, with a comfortable home and happy disposition, seemed to unite some of the best blessings of existence." However, the certainty of identity is immediately withdrawn through the ambiguous significance of "seemed." Already we might suspect the difficulty of locating "any fixed moment when the self *is* itself."[26] The playful tone that Austen adopts,

suggesting her enjoyment in meaning that is held back or deferred, is echoed a few lines later when the narrator remarks on the disadvantages of Emma's situation: "The danger, however, was at present so unperceived, that they did not by any means rank as misfortunes with her."

The matter of Miss Taylor's identity is equally unclear, evolving from governess to mother to friend to sister within one paragraph. Authority dissolves into its shadow in the person of Miss Taylor and not even a shadow in the presence of the patriarch, Mr. Woodhouse: "Having been a valetudinarian all his life, without activity of mind or body, he was a much older man in ways than in years; and though everywhere beloved for the friendliness of his heart and his amiable temper, his talents could not have recommended him at any time" (3). The importance of social identity, we know, is not to be doubted, and Austen's grace allows her to present the most damning evidence of incompetency without ever denying the respect and obedience that is due. Nevertheless, if the position of the father, the foundation of the social structure, is held sacred, the holes in the structure, the gaps which threaten, are insistently present.

As the question of identity becomes problematic in the first few pages,[27] so does the matter of destination. Marriage (and, with it, the perpetuation of the social structure), the equivalent of destiny in the novel, is called into question through the curious choice of words that unites marriage and death. The marriage of Miss Taylor brings on a state of mourning in the Woodhouse household; grief and the sense of loss dominate as Emma sits in "mournful thought of any continuance." To cope with the hole that has been created in her existence, Emma will take up her work of mourning: matchmaking. Much later in the novel, marriage and death will again be linked in an unexpected juxtaposition: "Human nature is so well disposed toward those who are in interesting situations that a young person who either marries or dies, is sure of being kindly spoken of" (157). Marriage, the value that seems to be continually affirmed in Austen's novels as the means through which society is revitalized and the balance of opposite forces maintained, suddenly takes on a rather grotesque form.

The image of the perfect connection in marriage continues to beckon, however, in much the same way as the natural world brought within the limits of the perfect arrangement provides an irresistible vision. The exquisitely arranged landscape around Donwell Abbey offers a delight and comfort to the hu-

man mind that can only be described as English: "It was a sweet view—sweet to the eye and the mind. English verdure, English culture, English comfort, seen under a sun, bright without being oppressive" (317). The description of the countryside around the Abbey draws readers into an enchanting space, but suddenly they find that they have arrived at a dead end:

> It was hot; and after walking some time over the gardens in a scattered, dispersed way, scarcely any three together, insensibly followed one another to the delicious shade of a broad short avenue of lines, which stretching beyond the garden at an equal distance from the river, seemed the finish of the pleasure grounds.—It led to nothing; nothing but a view at the end over a low stone wall with high pillars, which seemed intended, in their erection, to give the appearance of an approach to the house, which never had been there. Disputable, however, as might be the taste of such a termination, it was in itself a charming walk, and the view which closed it extremely pretty. (317)

The charming walk and the splendid view lead to no appropriate end. The approach is without destination. The perfectly arranged property of Donwell Abbey, which fills Emma with "honest pride and complacency," is unexpectedly put into a perspective that questions the purpose of all the arrangement and charm that has produced the heights of English civilization.[28]

Marriage, whose aim is to reproduce and perpetuate this delightful society, offers a destiny that is no idyll as a glimpse of Highbury reveals. True, it is a tightly knit community with strong values and traditions in which an individual may be guided to the assumption of his/her proper moral and social responsibilities. True, its strength lies in the fact that although it is an imperfect society, it is a community where human weakness can be transformed or simply tolerated because of the sense of common destiny that prevails. But it is also a society that exacts a great toll from the individual. If Emma can be read as an idyll, it can also be read as a parallel text to Freud's *Civilization and Its Discontents,* for it strongly insists on the cost to the human subject that the maintenance of this social cohesiveness demands. The clear sense of destination that the novel seems to uphold, embodied in the ideas of the proper marriage and the continuity of the social order, is thus undermined even as it is assured.

The smallness of Highbury, the confines of its social as well as physical space, accentuates the restraints placed on individual desire. The possibilities for self-expression and development are

severely limited, as Emma dramatically realizes when she faces the disquieting and immovable situation that has resulted from her matchmaking efforts: "Their being fixed, so absolutely fixed, in the same place, was bad for each, for all three. Not one of them had the power of removal, or of effecting any material change of society. They must encounter each other, and make the best of it" (125). This sense of limitation—physical, social, and mental—pervades the novel. Hillard has underlined the degree to which human vitality is threatened with confinement and extinction in the closed world of Highbury and has shown how this theme is reinforced by the dominance of spatial metaphors and the lack of action verbs in the novel.[29] That this confinement is particularly wearing on Emma just because she is a woman becomes blatantly clear through a comparison of her position with Frank's. Because of their resemblances in character and situation, the difference that gender makes becomes particularly glaring: "His position of lucky triumph after a career of giddy and reckless charm parallels hers, but with the exaggeration permitted to a man. He is permitted impropriety and the freedom to wander away from a valetudinarian parent on a scale Emma could never think of for herself: he acts as her male alter ego, as willful as she and less constrained."[30]

This sense of confinement reaches its breaking point at Box Hill where repressed tension and hostility erupt, revealing how tenuously balanced the strands of community are. The small group sets out for Box Hill confident that all plans have been made to ensure a perfect day. The day is fine and "nothing was wanting but to be happy when they got there" (323), and yet the primary tone is one of "deficiency." Again the perfection of arrangement is marked by a lack at its center. Where there should be harmony and union, a "principle of separation" reigns. Disappointment and boredom lead Emma and Frank to engage in tasteless flirtation. Still unhappy and irritable, however, Emma is led on to her grievous insolence, her insulting words to Miss Bates, and the day ends in mortification and guilt. The episode underlines, in Freud's words, the degree to which "civilized society is perpetually threatened with disintegration," and while successive chapters will repair the breach in the community, this unity is achieved by "an ever-increasing reinforcement of the sense of guilt." Emma's self-recrimination will reach its peak, and agitated and depressed, she will vow at all cost to make amends. The advance in civilization, as Freud insists, must be

paid for by the individual in a "loss of happiness through the heightening of the sense of guilt."[31]

These reflections bring us to the role Knightly plays as the agent of Emma's moral reformation and to the relationship between knowledge and power assumed in the novel. To what degree does the play for power always masquerade behind the appeal to reason, or to return to the crucial question raised earlier in terms of epistolary exchange: To what extent is the private sphere always subject to the authority of the dominant social forces and their representatives (here, Knightly)? Emma's sense of guilt is immediately activated as a result of Mr. Knightly's words of reprimand and his penetrating gaze—a surveillance that she feels herself subjected to throughout the novel and that she receives with ambivalent emotion. Speaking from the position of authority, he will lead her to confession in the private anguish of her own thoughts. Foucault's analysis of confession is instructive here. As he reminds us in *The History of Sexuality,* confession "is also a ritual that unfolds within a power relationship, for one does not confess without the presence (or virtual presence) of a partner who is not simply the interlocutor but the authority who requires the confession, prescribes and appreciates it."[32] Furthermore, no matter how benign the authority figure, a certain rhetorical violence is inscribed within the confessional scene. "Insofar as the confessional subject is poised between absolution and punishment, truth telling is enmeshed in a rhetoric of violence. One knows the effects of truth and absolution, in no small part, through their difference from error, sin, and punishment."[33]

Emma finds herself taking up Knightly's "vision of the scene— the truth of his representation there was no denying" (331)— and yields to his authority. In doing so, however, she does violence to her own subjectivity, for, as Neil points out, "she is forced to identify with a selfhood that identifies itself in opposition to her."[34] That this self will be defined in terms of masculine principles is underlined by Spacks: "the male realm provides the standard by which females can judge themselves and know themselves wanting."[35] Mr. Knightly consciously plays the voice of reason to Emma's imaginative excesses at the same time he readily admits his fascination with that very excess: "there is an anxiety, a curiosity in what one feels for Emma" (33). Thus Knightly's rational stance is not completely objective, and one might surmise that if he had not been jealous of Emma's interest in Frank, his reprimand would have been less severe. True,

Emma's words are inexcusable, but her blunder is perhaps not as egregious as Mr. Knightly insists. In the moral framework that the novel provides, her act is certainly not as reprehensible as the failures of her male counterparts, that is, Elton's deliberate cruelty to Harriet during the ball or Frank's continuous hypocrisy and deceit. Her rude behavior is momentary and can be quickly corrected; here we are reminded of Mrs. Weston's earlier judgment of Emma: "she will make no lasting blunder" (32). Mrs. Bates's hurt will easily subside just as Harriet's lovesickness lasts only long enough for her to fall in love again. If such blunders could not be absorbed into communal life, the delicate balance of this society would surely be destroyed. This is the other half of the picture sometimes passed over by commentators who exclusively emphasize the responsibility of the upper class to the less fortunate members of society and the need for respect and delicacy of feeling that Emma's words violate and upon which the functioning of the social structure stands.[36] In any case what is not always remarked here is that implicit in such views is the patronizing attitude inherent in Knightly's words and upon which justification of the English class system rests: "Were she prosperous, I could allow much for the occasional prevalence of the ridiculous over the good. Were she a woman of fortune . . ." (330).

Further implications of this attitude that affirms and extends the power of the upper classes from the economic and social spheres to the psychological emerge in another, and very different, episode. When, wearied and distressed, Jane Fairfax meets Emma as she is hurrying away from Donwell, there is a curious exchange between the two. Refusing Emma's carriage, Jane insists that she will be all right on foot and then suddenly breaks out : "Oh! Miss Woodhouse, the comfort of being alone!" Emma is quick to respond with sympathy: "Such a home, indeed! Such an aunt! . . . I do pity you. And the more sensibility you betray of their just horrors, the more I shall like you" (319). Of course, Emma misinterprets again, but her words subtly reveal the way the expression of private emotion inevitably invites the exercise of power. For Jane to confess her pain and desire to Emma would be to subject herself to Emma's pity, power, and patronage much in the way that Harriet has. Even if Emma has indeed conquered her desire to manipulate others, she would still be in the position of control, and Jane would be bound to her psychologically as well as socially.[37]

The novel, then, seems poised on the recognition that the

exposure of feeling always leaves itself open to the sway of power as well as reason. From this perspective Emma herself, the most fully developed expression of sensibility in the novel, seems a character whose very existence brings forth the desire to exert control. In this regard, her relation to her sister is enlightening. Although Isabella functions mainly as a foil to highlight Emma's vitality and wit, her extreme sensibility—most apparent in her susceptibility to thoughts of illness in herself and others—provides a gloss on Emma's tendencies: both as to the symptoms and to the direction of the cure. Isabella has unhesitantly given herself over for examination and control to the authority of the medical establishment much as Emma will later bind herself to Knightly's authority, a parallel that does not instill complete confidence.

I would like to return to the scene between Emma and Knightly once more, again not to excuse Emma's rudeness but to alter slightly the perspective of this scene so that another discourse emerges at the moment that Emma and Knightly's words are spoken. Surely the intensity of emotion at stake here gathers from an unspoken discourse. Knightly's words are foremost an attempt to reinstate his intimate relation with Emma at the very instant when he fears such intimacy is to be dissolved: "Emma, I must once more speak to you as I have been used to do" (330). The voice of authority conceals the lover's pain. In turn, Emma's agonized recognition of the truth of Knightly's recognition is as much a reflection of the breach she feels in their relation as it is a result of the pain she has inflicted on Miss Bates. That this scene of recognition is simultaneously a scene of misrecognition on the part of both characters is beautifully conveyed in the description of their parting.[38] At first too mortified to speak, Emma keeps her face turned away from Knightly, and then just after he hands her in to the carriage, she turns to him "with voice and hand eager to show a difference" (331), but he has already turned away. The scene reads like a lovers' misunderstanding, or, I cannot avoid thinking, like two letters crossing in the mail. The nature of words that ensures they will always say both more and less than what they mean suggests the inevitable missed communication that defines human exchange.

The episode at Box Hill underlines the central conflict of the novel: the tension between instinctual gratification and the life of the community. For a fuller awareness of the implications of this tension, we must explore the significance of the insistent

pattern of triangular relations that structures the text. In the epistolary situation, as we have seen, the intimacy of the dual relation is inevitably threatened by a third (whether as representative of the social structure or the private unconscious); here in a curious reversal, it is the privileged relation of the couple that is experienced as a threat. What are the implications of this reversal, and what is the relationship of this triangular structure to the one discussed earlier in which the third position points to the locus of the Other, the unconscious? Let me suggest that the answer lies in Lacan's insistence that the unconscious be explored not only in individual terms but as a cultural process that shapes human beings through its linguistic and social codes, simultaneously repressing and embodying individual meaning and desire.[39]

The opening pages of the novel present the disruption of a triangular relation—Emma, Woodhouse, and Miss Taylor—thereby creating the tension that initiates the movement of the narrative, and the equilibrium will not be restored until the end of the novel in the transformation that establishes Emma, Knightly, and Woodhouse as the new triangular structure. This similarity within difference offers resolution to the novel and confirms Todorov's description of narrative transformation: "the second equilibrium is similar to the first, but the two are never identical."[40] In each case the potential danger of the dual relationship—Emma and her father or Emma and Knightly—is obviated by the presence of a third. What exactly constitutes the danger of the dual relation? Why is there such a proliferation of triangles in the novel: Mr. and Mrs. Churchill and Frank; Mrs. and Miss Bates and Jane; Mr. and Mrs. Weston and Frank; Emma, Elton, and Harriet; Mr. Dixon, Miss Campbell, and Jane; Emma, Frank, and Jane; and finally Mr. and Mrs. Weston and their new child? Why is Miss Taylor's departure experienced as such an irrevocable loss as Emma and her father sit down to dinner "with no prospect of a third to cheer a long evening" (2)?

The dual relation by its very existence, as Austen seems to have intimated, constitutes a threat to civilization. In *Civilization and Its Discontents,* Freud writes: "Sexual love is a relationship between two individuals in which a third can only be superfluous or disturbing, whereas civilization depends on relationships between a considerable number of individuals. . . . A pair of lovers are sufficient to themselves, and do not even need the child they have in common to make them happy." By its very exclusivity, the dual relation threatens to undermine the

principles of civilization. On one level it aspires to the primal unity of mother and child, a relation that is regressive and self-reflecting and that never attains entry into the Symbolic, the world of language and culture. Moreover, it represents the possibility of incestuous relation (whether parent-child or brother-sister), which the relation of lovers always in some way seeks to imitate. For society to come into being, the forbidden relation must be sacrificed, and Freud tells us in no uncertain terms: "this is perhaps the most drastic mutilation which man's erotic life has in all time experienced."[41] But the desire itself is not exorcized; it is merely repressed; its power resides. Thus, the foundation of the social structure is repression, and the public as well as the private realm is constituted by unconscious mechanisms.

The space opened up by Miss Taylor's departure is threatening in part because it invites Emma to take the place of the governess (who has assumed the place of Emma's mother). This position is feared, but it is also desired as is emphasized by Emma's reluctance to give up this place in her father's household for marriage: "'I believe few married women are half as much mistress of their husband's house as I am of Hartfield; and never, never could I expect to be so truly beloved and important; so always first and always right in any man's eyes as I am in my father's" (74). When Emma finally agrees to marry, she does not in fact give up her place as mistress of Hartfield. Her father is provided for, and the triangular structure that affirms Austen's attachment to the principles of responsibility and community is maintained. However, the joint presence of father and husband in the father's house, as well as Knightly's paternal role toward Emma, testifies to the incestuous longing and repressed desire that the social structure is founded on. These intimations hover on the edge of the plot while its manifest content insists that the presence of the third is needed to ensure that selfishness and self-indulgence are not allowed to flourish and that instinctual life will not threaten the good of the community. Furthermore, the third, in the person of the child, the member of the new generation, provides the means for revitalizing, as well as perpetuating, a society that is continually in danger of stasis and sterility. Jane in the Bates household, Frank's appearance in the lives of the Churchills, and the new baby at Randalls all provide for renewed vitality in relationships that are otherwise doomed to an unbearable stasis.

In the world of Highbury, romantic love does not supersede

the larger values of the community. Austen's ending realizes the author's attachment to the principles of civilized living; however, it is not completely satisfying. That Knightly should give up Donwell Abbey and live under the dominion of Woodhouse is discomforting, especially in the light of Knightly's earlier words: "a man would always wish to give a woman a better home than the one he takes her from" (378). Moreover, much as one feels the force of love between Emma and Knightly—and surely their conversation in the garden, in its hesitancy and continual misunderstanding, is one of the most affecting of such passages in literature—he or she might also feel, as I have already suggested, the degree to which their marriage attests to the power of incestuous longing. This implication is reinforced earlier by its negation in a short exchange between Emma and Knightly. Accepting Knightly's invitation to dance, Emma replies:

> "Indeed I will. You have shown that you can dance, and you know we are not really so much brother and sister as to make it at all improper."
> "Brother and sister! no, indeed!" (290)

The ending, in its upholding of the triangle, affirms the absolute importance of community, but it equally attests to the tremendous force of the instinctual life of the individual that must at all expense be kept in bounds.

Much as the text attempts to keep this force at bay, it speaks forcibly within the novel as the voice of the Other, what has been repressed and continually threatens to erupt. Most importantly, its force provides the energy for a central structure of the novel: the play of the novel's double intrigue. What is most striking about the construction of Austen's narrative is not simply her use of the subplot but the way in which the subplot refuses to remain submerged and gains ascendancy over what seems to be the main plot. The subplot, which develops out of Frank and Jane's secret engagement and continually threatens Emma's plotting and manipulation, finally asserts its dominance. Readers, assimilated to Emma's view of the world though aware of its limitations, are thrown off-center when they realize that the direction of events has come from elsewhere; another text has, in fact, been in control. Spacks's evocative description of the reader's position on discovering Frank's role as master plotter accentuates "the degree to which we as readers, have participated in the making of the fiction" and brings us back to the

language of epistolary exchange: "Instead of the pleasures of reading other people's letters, we have been offered the gratifications of complicity—only to have our satisfaction in it repeatedly undermined."[42]

The reversal is disconcerting, for while readers have assumed that they were at the center of the text, they find the determining text was actually another. The driving force of events has come, not from Emma, but from Frank. As Tumbleson puts it, in terms again appropriate for our epistolary concerns: "An alternative, epistolary *Emma*, a *Frank*, could be constructed from his viewpoint via his correspondence that would contain all the same principal events, the same friendships and matches, as the book as it stands, although with completely altered emphases."[43] The decentering of the reader is perfectly appropriate to Austen's purpose, for it enables us to imitate Emma's sense of dislocation, her realization that she is not, after all, where she thought she was. In fact she is not who she thought she was. Not only has she been blind to the world around her, but, more importantly, she has been blind to her own desires, "totally ignorant of her own heart" (364). Like the letter writer who believes that conscious intent and sincerity are sufficient means to the truth, Emma is unaware of the otherness of human desire. Here we see the way the two triangular structures intersect or collide. The third as a means of defense against the danger of the dual relation must confront the power of that other third, the position of the unconscious, which, as we have seen in the case of epistolary exchange, is never absent from human discourse and always in danger of erupting.

The use of the subplot, in fact, gives voice to what has been submerged in the official plot, suggesting that what is most real is in another place, has been driven under, that is, repressed. In the opening pages, Emma, confronted with change, the space of freedom and desire—retreats, resists the very idea of change, dangerously aligning herself with her father in his abhorrence of all change, especially marriage, which is "the origin of change" (3). Recognizing the absurdity of her father's attitude toward marriage, she nevertheless adopts it as her own and believes that she is acting in accordance with her own desire. This moment marks the dominance of the Imaginary in Emma's life, her captivity in alienating images.[44]

Denying change, Emma repudiates all desire within herself, barring it from consciousness. Direct expression of desire is thus driven into the subplot where it is given form in the secret

passion of Frank and Jane, who have refused to defer their feelings out of respect for their families but act selfishly in the immediacy of desire. In the end the force of their desire will gain ascendancy on the level of plot just as Emma's repressed desire for Knightly (figure of the father) will emerge. Emma's recognition of her love for Knightly—"it darted through her with the speed of an arrow, that Mr. Knightly must marry no one but herself!" (360)—partakes of the uncanny.[45] Containing what is both old and new, the most obvious and yet the most unexpected, her vision is dazzling, marking as it does the return of the repressed.

The truth of Emma's recognition, however, is not more revealing than the blindness and blundering that provides the action of the novel, for amidst this blundering, the submerged desire is acted out. As Peter Brooks insists, the ending does not hold the "exclusive truth of the text"; it does not "abolish the movement, the slidings, the errors and partial recognitions of the middle."[46] Emma's matchmaking and meddling, her creations and imaginings, and her oscillation between blindness and truth are equally determinant of the text's meaning.

Emma's plot gathers its momentum from the refusal of desire that initiates the movement of the narrative. The textual energy that is created in the arousal of expectancy and possibility—the space opened up by Miss Taylor's departure, the tremendous difference that we are made to feel this action makes, and the sense of curiosity that Emma's very presence embodies—is immediately stifled in Emma's resistance to the plot of her own awakening. The sense of energy being deferred is echoed in the narrative, which teases us with the hint of great promise but a promise that is not quite itself, a promise that is in danger of not being realized. The detour begins as this energy, which is denied immediate outlet, is bound within the text in a series of repetitions which themselves become a "kind of tantalizing play with the primitive and instinctual."[47]

Emma's plot is characterized by a series of approaches and withdrawals that bring her into play with her instinctual desire in transmuted form. Although her desire is submerged, it will appear in disguised fashion as she engages in games of love and fantasies of secret passion. Confident that she has no intention of marrying, certain that it is not her nature to be in love (74), Emma turns her attention to matchmaking. With "no prospect of a third," she herself chooses to become a third and creates a triangle between Harriet, Elton, and herself. Lost in the images

of her own creation, she continually confounds her own repre-
sentation of reality with the thing itself. Her portrait of Harriet,
which proudly offers an image superior to the original, is a per-
fect example of her captivity in her self-created images, but
there is also her interpretation of Elton's riddle, her unraveling
of the mystery of the piano, and her analysis of the game of
letters. In each case the image is "a blind alley in which subjec-
tive intention drowns in its own creation, collapsing into its
object and failing to keep its distance from its own internal
vision."[48]

Humiliated by the results of her matchmaking efforts, Emma
is nevertheless driven to repeat herself later when her imagina-
tion is powerfully stirred by the image of Harriet and Frank
among the Gypsies. For the moment, however, she vows to give
up meddling, and her imagination turns from Harriet to Jane
as she more boldly enters the intrigue of romance. She will
participate vicariously in the emotions of forbidden love in iden-
tifying with Jane in the triangular relation she constructs be-
tween Jane and the Dixons. Finally, she will approach the
possibility of a dual relation in her flirtation with Frank, but
what is most striking about her attitude in this affair is her great
concern with their public image, the way the two of them appear
to others. She takes great pleasure in seeing the image of Frank
and herself reflected in the eye of the other, the third: "the hon-
our, in short, of his being marked out for her by all their joint
acquaintance" (180).

In her relation with Frank, she very guardedly approaches the
possibility of love, wondering at first if she might really be in
love, then entertaining "no doubt of her being in love" (231),
although taking comfort in the fact that she is not too much in
love. Finally, she concludes with confidence that she will soon
have done with the whole question of love: "Every consideration
of the subject, in short, makes me thankful that my happiness
is not more deeply involved,—I shall do very well again after a
little while—and then, it will be a good thing over; for they say
everybody is in love once in their lives, and I shall have been
let off easily" (232). Always in control, never giving herself over
to the vulnerability of unguarded emotion, Emma is, in fact,
never in control but driven on by the tension of repressed de-
sire, the difference between conscious choice and unconscious
demand. This tension issues in the form of her schemes and
connivances and the feelings of hope and anticipation that are
so often subject to detour and delay and finally threaten to erupt

as winter turns to spring: "She felt as if the spring would not pass without bringing a crisis, an event, a something to alter her present composed and tranquil state" (276). Emma's attempt to master her own destiny and the world's finally leads to extreme vulnerability as the plot returns to its beginning, and she once again faces loss, this time a more crucial one, the loss of Knightly: "The prospect before her now, was threatening to a degree that could not be entirely dispelled—that might not be even partially brightened" (372).

The threat is again averted, however, and Emma is returned to Knightly, her first guide and teacher, in a movement that is both a return to origins and a return of the repressed. Again we come to that perfect ending that raises as many questions as it answers. The narrator assures us that "it was a union of the highest promise of felicity in itself, and without one real, rational difficulty to oppose or delay it" (412). But these words are not completely reassuring since we have no promise that all that is on the level of the Imaginary and irrational has been equally disposed of. We are to take comfort in the fact that Emma has been placed in the hands of Knightly, her moral and rational guide, but we have already seen that knowledge and power inevitably combine and that Emma's recognition of Knightly's authority has dangerous implications for herself as a subject. Fortunately, rather than unfortunately as some critics would argue, the narrator's sense of play up to the novel's end allows us to envision that Emma's reform, for example, her dutiful submission, is far from permanent. Otherwise we might indeed be disappointed. As Spacks writes: "The reader who has found herself or himself amused, entertained, and impressed by the vagaries of Emma's imagination, by her will to make interest where little obvious stuff or interest exists—such a reader must feel the loss involved in Emma's settling down under Mr. Knightly's exemplary tutelage."[49]

Knightly's vision knows nothing of the mysterious detours of truth that Emma has traveled. If his strength lies in his firm notions of truth and morality—"Mystery; finesse—how they pervert the understanding: My Emma, does not everything serve to prove more and more the beauty of truth and sincerity in all our dealings with each other" (392)—Emma's strength lies in the intuition, voiced by the narrator, that "seldom, very seldom, does complete truth belong to any human disclosure" (381). The masculine consciousness in the novel, even when it is informed by sensitivity and understanding, is severely limited.[50] That

Knightly's logical approach ignores great realms of human experience is hinted at in the first chapter when he presents two clear-cut images of Emma's matchmaking efforts to which Emma immediately interposes a third:

> "And have you never known the pleasure and triumph of a lucky guess?—I pity you.—I thought you cleverer—for depend upon it, a lucky guess is never merely luck. There is always some talent in it. And as to my poor word 'success,' which you quarrel with, I do not know that I am so entirely without any claim to it. You have drawn two pretty pictures—but I think there may be a third—a something between the do-nothing and the do-all. (8)

Emma refuses to disallow the power of luck or chance, the force of the mysterious and the unknown, but the subtlety of her vision makes no impression on Knightly. In the novel the "truth" as that which hovers invisible on the edges of human experience is unknown to the masculine intelligence. It is Emma, not Knightly, who is cut through by the truth of human desire and approaches the radical otherness of human identity. If patriarchal civilization is upheld in the novel—and certainly the respect granted to the place of the father is never withdrawn—its notion of truth is severely dislodged, just as the nature of identity and destiny as stable and knowable entities is continuously undermined in the course of the narrative. Finally, the only truth in *Emma* is the truth of the text, which refuses logic and linearity and makes no promise of delivery; instead it makes its way though detour and reversibility, returning us at the end to its beginning.

If the status of the post office is affirmed, it must be remembered that postage is never guaranteed. We are also forewarned that the postal service holds the power of the final word: address unknown/return to sender.

The psychological and social tensions balanced so beautifully in Austen's work will explode with great force in the post-Freudian world of the twentieth century; nevertheless, a woman novelist such as Virginia Woolf will still harbor ambivalent feelings toward the world of the father. In exploring the significance of the artifact of the tower in *To the Lighthouse* in the next chapter, we will approach the complexity of Woolf's perspective as well as her distinctive understanding of human subjectivity. Before moving on, however, it is well to record Woolf's apprecia-

tion of the deft and graceful way Austen dealt with being a woman in a predominantly male profession. Writing of Austen's relation to the "man's sentence" that had shaped literary taste, Woolf admiringly notes: "Jane Austen looked at it and laughed at it and devised a perfectly natural, shapely sentence proper for her own use and never departed from it."[51]

2

Towers in the Distance: Virginia Woolf's
To the Lighthouse

THE tower figures throughout myth and legend as a controlling image of the quest motif. Far off in the distance, it beckons to the hero as actual structure or as hallucinatory image, its light signaling the successful completion of the journey. Some, like Childe Roland in Browning's poem, are granted the vision of the tower "after a life spent training for the sight," only to realize the imminence of their own end. Nonetheless, even they have the victory of a heroic death:

> And yet
> Dauntless the slug-horn to my lips I set,
> And blew. "Childe Roland to the Dark Tower came."

The image of the tower Browning offers,

> The round squat turret, blind as the fool's heart,
> Built of brown stone, without a counterpart
> In the whole world,[1]

might seem incommensurate with its power—unyielding surely, but also blind with a force that equals this intransigence—yet we are assured of the potency of its presence which will transform as well as transfix the identity of the hero.

Conversely, the absence or destruction of the tower suggests exile and abandonment, utter loss and desperation as in Nerval's haunting line: "Le Prince d'Aquitaine à la tour abolie." Thus, in the wake of twentieth-century disillusionment, Eliot, with great resonant effect, can simply borrow the fragmented line in the last part of *The Wasteland* and make us feel how far its quest is from fulfillment and how distant and uncertain the promise of renewal remains.[2]

Not always named, the tower's presence is sometimes implicitly acknowledged: either as an integral part of the castle which the knight seeks or the potential form of the city the hero is to found. Aeneas, for example, is only able to turn away from the burning towers of Troy and endure the temptations and trials of his long journey because of the vision of the New Troy that lies before him. In the central quest of Christianity, the goal is again the city, the kingdom of the New Jerusalem. Keeping with this tradition, Spenser, in *The Faerie Queen*, will underline the allegorical implications of St. George's quest through the image of the hero looking toward the heavenly city from the top of the mountain of contemplation.

Whether secular or religious, the traditional mode of the journey of the hero almost always includes the presence of the young woman. The reward of the quest is often succession to the secular kingdom as well as marriage with the beautiful daughter of the king, who not infrequently has been imprisoned in a forbidden tower. Embodying a female presence, the tower has also been understood as a symbol of the feminine, its roundness warm, containing, womblike. In fact the tower is a kind of labyrinth, as its narrow passage and winding stair would suggest. An essential part of the heroic quest is therefore the traveling through of the space of the feminine and the partaking of the creative powers contained therein, all of which leads to the transformation and rebirth of the hero. This interpretation has been pursued by Jung and his followers at great length, and Jung's preoccupation with the symbol of the tower is particularly intriguing because, in spite of the self-consciousness of his reflections, one feels that certain ironies of his own situation escape him. When in *Memories, Dreams and Reflections* he writes about the tower that he himself had constructed and lived in, he emphasizes its feminine aspect: "From the beginning I felt the tower as in some way a place of maturation—a material womb or a maternal figure in which I could become what I was, what I am and will be." He goes on to underline its transformative powers: "it gave me a feeling as if I were being reborn in stone";[3] the image of rebirth, however, seems to lead to a curiously inanimate state. For Jung, then, at the same time that the tower represents the "maternal hearth," it symbolizes aspirations that go beyond the merely feminine and reflects the overreaching desire for immortality:

> words and papers, however, did not seem real enough to me; more
> was needed. I had to achieve a kind of representation in stone of

my innermost thoughts and of the knowledge I had acquired. Or, to put it another way, I had to make a confession of faith in stone. That was the beginning of the "tower," the house which I built for myself at Bollingen.[4]

More and more the existing structure, "begun with the idea of a primitive hut," is experienced as inadequate. Although "it had become a suitable dwelling tower," Jung increasingly recognizes "that it did not yet express everything that needed saying, that something was still lacking." Thus he adds to it once more and then again until he has his private tower room "where I would exist for myself alone."[5] Thus we see the feminine side of the tower yielding to phallic proportions. No longer is the emphasis on immersion in the containing element of life's creative powers but on greater heights—isolation, spiritual concentration, and transcendence: "In the course of the years I have done paintings on the walls, and so have expressed all those things which have carried me out of time into seclusion, out of the present into timelessness."[6]

Rooted in earth, the tower rises to celestial heights, inviting men to visions that are bound by neither temporal nor spatial limits. As Bachelard says, "the tower sounds a note of immense dreams."[7] Narrowing toward its apex, as often is the case, the tower assumes a conelike and elongated shape, a prolonged verticality that aligns it with those things "long and upstanding" which Freud categorizes as phallic symbols,[8] although both he and Jung tend to classify such architectural symbols, including the citadel, castle, and fortress, as feminine. From a base of broad receptivity, the tower grows narrower as it ascends, suggesting that the containing female vessel is finally to be transcended at a point that is exclusively male and isolate. Whether in the traditional religious quest in which woman, like Beatrice, serves as the means of the ascent to God or in the secular variant in which she serves as creative muse, woman is left behind as the hero reaches God or himself becomes self-sufficient creator.

One would not want to deny that the tower invites a heroic stance; it offers an image of solitude and dignity, of concentrated strength and resistance, and speaks of a heroism of cosmic proportion, but the ancient image of the tower of Babel should warn us of the danger implicit in such a proud and arrogant stance. This ironic vision gains prominence in modern times, as Yeats's pointed question underlines: "Is every modern nation like the tower, / Half dead at the top?"[9] This reflection coming from Yeats

is especially chilling because who more than he dreamed of towers, domes, and golden cities that would fulfill his vision of an "artifice of eternity?" Yeats knows only too well the inextricable connection between the timelessness of art and the impure world of time, but still, as Frye points out, when man, and not God, creates, the consequences for nature are not insubstantial: "The builder of Byzantium is not a God conceived as independent of man, and when man is thought of as the only visible creator, nature is no longer a creation but a ruin, and man builds his palaces out of and in defiance of nature."[10]

The sound of death haunts the towering structure. It is thus not surprising that Frye's description of the last phase of the romantic quest, marking "the end of a movement from active to contemplative adventure,"[11] is the vision of the old man alone in his tower that one finds in both Jung and Yeats, an image that has more than a hint of sterility about it even as it suggests a heroic state of self-sufficiency. Again Frye provides an appropriate gloss on the ironic perspective afforded by this image of the tower: "the vision of wisdom pursued by age is an attempt to grasp the static order of something that must be dead before it can be understood."[12] Totalizing, unyielding, blind, intransigent, isolate—the tower, in its magnificence, summons the male to construct its image in proportions of stone and then to transform the teeming life of creation to its image.

The final irony, however, is perhaps provided by the perspective of the young woman imprisoned within the tower. Pynchon's Oedipa Maas, despite her increasing sense of entrapment, refuses the confines of the masculine vision of the tower and presents the possibility that the very notion of the tower as a self-contained structure is an illusion. If escape is thereby rendered impossible, so is the structure of the quest:

> Such a captive maiden, having plenty of time to think, soon realizes that her tower, its height and architecture, are like her ego only incidental: and what really keeps her where she is is magic, anonymous and malignant, visited on her from out-side and for no reason at all.[13]

In this paranoiacally contemporary vision, the quest is invalidated because there is no place that escapes the confines of the tower, and rescue by the knight assures only the momentary illusion of victory. The young woman is thus left wondering: "If the tower is everywhere and the knight of deliverance no proof

against its magic, what else?"[14] As the contours of the tower disappear, the hero is left to confront the insubstantial proportions of his own image.

Where is there to go, then, that would bring us beyond the boundaries of the masculinized conception of the tower? Perhaps with Virginia Woolf to the most daring of all stances—to the tower's very tip: "Was there no safety? No learning by heart of the ways of the world? No guide, no shelter, but all was miracle and leaping from the pinnacle of a tower into the air?" (268).[15]

For Woolf, this precarious stance reflected the radical cultural changes that defined her era as well as her sense of the fragility of the human psyche. Born in 1882, she would witness the lingering effects of the patriarchal institutions of Victorian England, the horrific consequences of the Great War, and the most intense phase of the feminist movement.[16] Although in the years preceding her birth women did not have a legal claim to property, any income they earned or the children they bore, she would see women gaining the right to vote and entering professions that had been completely closed to them before. These changes coupled with the devastating mental and physical effects of World War I—the thorough undermining of the traditional values of transcendence and reason, patriotism and progress—infused the period with a sense of crisis that would carry over to the dominant aesthetic movement of the time: modernism. For Woolf, the concerns of modernism and feminism were never at odds, for both were committed to subverting conventional structures of authority whether they be patriarchal institutions or the illusionist-realist forms of traditional fiction.[17] Deploring the inadequate representation of the human world that both patriarchy and conventional narratives offer as eternal verities, Woolf focused on a mode of subjectivity that refused the subject-object dualism that both belied the lived reality of human experience and generated hierarchical distinctions on all levels. In place of the unified and coherent subject and linear time, she insisted on fragmented moments of subjectivity lived simultaneously in the present, past, and future. Instead of affirming the objectivity of the male gaze, she insisted that the privileging of the dominant masculine point of view was intrinsically suspect, leading to intellectual rigidity, tyranny (domestic and political), barbarism, and war. It is important to note, however, that although she was highly conscious of the abuses of the patriarchal structures of her culture, she neither rejected that culture out of hand nor minimized the position of

the father. If she unflinchingly recognized the excesses and abuses of her own father, she nonetheless accepted the intellectual rigor, love of literature, and devotion to writing that were his gifts. Ultimately, though, she rejected him as both guide and shelter, choosing instead the precarious position at the tip of the tower where "all was miracle and leaping" into the open air.

Woolf's ambivalent feelings are registered in *To the Lighthouse*, which brings us to a radical point of reflection on the relation of the female to the artifact of the tower. The title indicates the degree to which Woolf draws on the quest motif for the structure of her novel, and the first page posits the tower as the goal that gives orientation to that journey. Furthermore, the novel draws on the traditional feminine and masculine attributes of the tower: its starkness and solitude giving rise to images of masculine heroism and its beam suggesting expansive and fecundating feminine energy. The tower, however, as it appears in the novel, incorporates but goes beyond these somewhat conventional readings, for its metaphorical potential, I would argue, is to figure forth the symbol-making powers of the self and thus to represent the Symbolic Order through which men and women acquire selfhood. For Woolf, however, the vulnerability of the subject who constructs her/himself in this way is never effaced, and this radical instability informs her very image of the tower: the precarious balance at its tip and the temptation of the pinnacle opening out into unfettered air.

My discussion of the Symbolic draws on the theories of Jacques Lacan but also insists on the aspects of his theory that challenge the phallocentrism in which it is embedded. In spite of the fact that some readers reject his conceptions as hopelessly mired in patriarchal ideology, I still feel that these ideas allow us to articulate, what is for me, the crucial matters of this novel. Moreover, I would suggest that Lacan, as much as anybody, realizes the tenuous ground on which the phallic presence (the tower) lies even as he affirms its undeniable position in the formation of human consciousness.[18]

My reading of the novel thus centers on the way Woolf transforms our perception of the possibilities of the "archetypal" tower and invites us into that nebulous realm: the formation of the female subject. Given her sensitivity to questions of gender and her intense perception of the precarious nature of the self and the artificial ways in which we define the self, Woolf would seem a particularly illuminating writer to turn to in this re-

gard.[19] *To the Lighthouse* is revelatory because it concerns the very process through which the self is constructed. That the novel holds an especially significant place in Woolf's own history is underlined by her comments in "A Sketch of the Past," where she underlines the curious catharsis that followed its completion. "When it was written," she tells us, "I ceased to be obsessed by my mother. I no longer hear her voice; I do not see her." She goes on to consider that in writing the novel, she did for herself "what psycho-analysts do for their patients: I expressed some very long felt and deeply felt emotion. And in expressing it I explained it and then laid it to rest." But she is not completely satisfied with her explanation: "Why because I described her and my feeling for her in that book, should my vision of her and my feeling for her become so much dimmer and weaker?"[20]

I would like to speculate that the catharsis that Woolf experiences after completing *To the Lighthouse* results not simply from her success in expressing her emotion but from the fact that the novel itself articulates the passage from the maternal realm to the world of the father,[21] or in Lacan's language from the Imaginary to the Symbolic, the crucial moment in the life of any subject, male or female.[22] In writing the novel, Woolf thus confronts the moment and meaning of death (that is, death as the experience of irreparable separation and loss) through an act of repetition that Felman tells us is "what a practical psycho-analysis is all about":

> What, then, is psychoanalysis if not precisely a *life usage of the death instinct*—a practical, productive use of the compulsion to repeat, through a replaying of the symbolic meaning of the death that the subject has repeatedly experienced, and through a recognition and assumption of the meaning of this death (separation, loss) as a symbolic means of the subject's coming to terms not with death, but, paradoxically, with life?[23]

The literal death of the mother in Woolf's novel figures forth the separation and loss that is the mark of human subjectivity and the individual's entry into the Symbolic Order, the only means of assuming his/her position in the intersubjective world.

Lacan's notion of the Symbolic and its application to feminine consciousness is thus raised acutely in Woolf's novel. If, as some feminist critics insist, the Symbolic is a patriarchal structure imposed on, but inappropriate to, female consciousness, what do we make of a novel written by a women whose structure affirms this concept as central to the development of human

consciousness? Do we say that as a woman existing in a patriarchal culture she cannot help but inherit this perspective at the same time she inherits the symbolic phallus—the lighthouse—and is doomed to make it the central image of her novel? Or do we read the novel as an affirmation of Lacan's insight into the formation of human subjectivity that some readers refuse without a complete understanding of the implications of their refusal? Female critics such as Toril Moi, Juliet Mitchell, and Jacqueline Rose argue that to refuse the Symbolic is simultaneously to deny the formation of the unconscious and also to ground the feminine in an essentialism as reductive as any image generated by patriarchy.[24] Furthermore, to reject the Symbolic is not simply to escape to a pre-Oedipal haven of unity and bliss but to court the dangers of a psychotic state. Woolf, more than anyone, understands the complexity of these questions, and as Moi underlines, she "discloses the dangers of the invasion of unconscious pulsions as well as the price paid by the subject who successfully preserves her sanity, thus maintaining a precarious balance between an overestimation of so-called 'feminine' madness and a too-precipitate rejection of the values of the symbolic order."[25] Moi here is writing of *Mrs. Dalloway,* but I would argue that this crucial awareness informs every page of *To the Lighthouse.*

Mitchell and Rose underline the degree to which rejection of Lacan leads to biologism and essentialism in relation to sexual identity and raise critical questions in regard to the possibility of a feminine form of writing. They point out that both for Freud and Lacan, the formation of sexual identity only comes into being with the subject's entry into language and the Symbolic Order; thus to speak of femininity as predating this stage and to posit a pre-Symbolic stage of consciousness, which should serve as the ground for women's writing, is to ignore this crucial insight of psychoanalysis. The female body cannot serve as a source of a feminine language, because "there is no pre-cursive reality . . . no place prior to the law which is available and can be retrieved. And there is no feminine outside language."[26] The notion that woman has a privileged access to the maternal body, which grants her "access to a different strata of language, where words and things are not differentiated" and which is untouched by prohibition and the law, is untenable because language, sexual difference, and thus the notion of femininity only come into being with interdiction and law.[27] As rich and alluring, as different as the female body might be, how can it serve as the privi-

leged site of language when all language is symbolic, and all experience is mediated through language and culture?

Woolf's novel is enlightening in this regard because it gives such intense expression to the desire for an unmediated relation to the world, a realm in which the mother presides, as in the first part of the novel.[28] But it also recounts the inevitability of the loss of this world and the terrible price that must be paid as individuals sacrifice their immediate relation to the other to realize their own subjectivity. The self only becomes a subject through the acquisition of language. The word, the symbol, is born out of loss, the disappearance of the thing, and the substitution of the sign for the experience. Thereafter, men and women meet themselves and the world through language, a necessary intermediary, but one that introduces the unconscious and repression, leaving them strangers to themselves and their desires. An insight into the radical instability or decentering at the foundation of human identity is the crucial point at which Woolf and Lacan meet. A host of feminist readings of Woolf that look to her for affirmation of a strong feminine identity refuse the most challenging, though discomforting, aspect of her feminism, which is the denial of the humanist and patriarchal image of a fixed and fundamental human identity, whether male or female.[29] To admit this instability, however, is not to deprive women of agency or the power of action.

To the Lighthouse records the passage from the dual, immediate, or mirror relation to a triangular, mediated relation, that is, from the realm of the Imaginary to the Symbolic. This is, of course, the Oedipal configuration, which Lacan insists is not simply a stage like any other in genetic psychology but the "fundamental structural moment in the life of a 'subject.'"[30] My reading of the novel is not, however, predominantly concerned with the most obvious oedipal content, James's relation to his father, but with the way the entire novel moves from a concern with the dual relation in which desire seeks immediate fulfillment in the world to an acceptance of the triangular relation in which desire is filtered through the mediation of the symbol. The quest that interests me cannot therefore be identified solely with Ramsay's rigid and abstractly intellectual search for R or the final journey to the lighthouse that Cam, James, and Ramsay undertake. The quest is equally Lily's struggle to finish her painting and all the characters' attempts to reach backward to the past through memory. All these actions involve the subject's immer-

sion in the Symbolic Order, which alone provides the space for the formulation of the unconscious and the possibility of desire.

In recent studies of the novel, the trend has been to distinguish painstakingly between Lily and Cam's quest and that of James and Mr. Ramsay in an effort to find an escape from the father's law and posit a realm accessible to mother and daughter alone. As suggestive as studies such as Margaret Homan's and Elizabeth Abel's are,[31] I still find them unsatisfying for reasons that I will take up at the end of the essay. Attempts to deal with the daughter's development as different and more difficult than the son's are necessary and admirable, but to refuse the position of the third—the dimension of the Symbolic and the unconscious—seems to me questionable both in relation to Woolf's insights and the problem of human subjectivity in general.

The novel's opening re-creates the unbounded, homologous space of the earliest mother-child relation. Although the first line is a projection into the future: "Yes, of course, if it's fine tomorrow," said Mrs. Ramsay," the emphasis is on the present and the promise of the future to transfigure that present. Her words reach out to James and embody mother and son in a continuous space, reflected in the way the narrative voice moves from James's consciousness directly into that of Mrs. Ramsay as she imagines him a great public figure. Spatial and temporal distances disappear as the prospect of the trip assumes a present reality: the lighthouse almost "within touch." Then abruptly this moment of unity is destroyed with the appearance of Mr. Ramsay and his words: "it won't be fine" (10). The space between present and future, James and the lighthouse, and wish and reality returns, and the fullness encompassing James and his mother is pierced by the keen blade of "facts uncompromising."

Thus, we are plunged into the drama of the Oedipus complex. The father is experienced as a purely negative force, destroying the perfect harmony of the relation between mother and child. The prohibition, the warning that the dual relation is not to be allowed its exclusivity, has been uttered, but the longing for that original unity persists throughout the first section of the novel. From the first page to the last where Mr. and Mrs. Ramsay each answer to the image of the other's desire, the dual relation predominates, offering the promise of fusion and the unmediated fulfillment of desire. In the first section, fittingly called, "The Window," the Imaginary or mirror relation predominates. This stage, according to Lacan, begins with the early relation between

mother and infant which is marked by an indeterminacy of fixed boundaries and the child's desire to identify with the object of the mother's desire. The child has no sense of an absolutely separate identity; there is no distance, no difference, and no absence—only the fullness of presence. The child's later identification with his or her image in the mirror continues these effects. Offered a reassuring, though alienating, image in the looking glass, the child begins a long history of wandering in the play of reflection and doubling, the confusion of self and other. Lemaire summarizes the Imaginary as "everything in the human mind and its reflexive life which is in a state of flux before the fixation is effected by the symbol, a fixation which, at the very least, tempers the incessant sliding of the mutations of being and of desire."[32]

This account perfectly describes the state of fluidity and flux that characterizes the first section of the novel. Characters experience the present moment as the continuous upheaval of the self's relation with the world. Identity is felt as elusive, the unity of the self disappearing amidst the perpetual flux of sensation. The world loses its solidity, the present its stability. The excruciating awareness of time, in Woolf, finally reveals a subjectivity profoundly aware of its fragmentation and insufficiency, its inability to present itself with a continuous image through time. If the intensity of certain moments promises a unity and fulfillment that speaks of eternity, this promise is immediately denied as characters are thrown once again into the world of time and fluctuation, into "the incessant sliding of the mutations of being and desire." The vulnerability and fragility of the self that Woolf conveys is very close to Freud and Lacan's sense of "the division and precariousness of human subjectivity itself."[33]

Although the realm of the Imaginary is ultimately illusory, it is nonetheless persistent and compelling. Mrs. Ramsay sits in the window, embodying the possibility of desire finding its reflection in the world. She is the source of fecundity, providing images with which the others adorn themselves. Irresistible in her beauty, she offers herself as the image of wholeness that will complete the other's desire. For her husband she is the very spray of life whose continuous power of creation nourishes his faltering image of self and gives him the strength to maintain his heroic stance against darkness. For her children she literally becomes a maker of images as she transforms the frightening animal head into a myriad of magical forms: "how it was like a mountain, a bird's nest, a garden, and there were little ante-

lopes" (172). Others, too, are transformed in Mrs. Ramsay's presence. The awkward, sullen Tansley, who is filled with feelings of inferiority, suddenly experiences his entire being transfigured as he walks with her, and for the first time in his life, he feels "an extraordinary pride." Seductive in her promise of harmony and peace, Mrs. Ramsay makes William Bankes feel, as he looks at her, that "the reign of chaos is subdued" (74). Her very beauty, however, suggests the limits of the reflected image. Lily later tells us that "beauty had this penalty—it came too readily, came too completely. It stilled life—froze it" (264). Identification with an image involves a certain fixity and rigidity that is invariably diminishing. But Lily, too, is incapable of resisting Mrs. Ramsay's charm. Despite her conflicting emotions toward the older woman, Mrs. Ramsay awakens in Lily a powerful desire for unity, holding out the promise of "intimacy itself."

Although Mrs. Ramsay takes the world of human relations as her domain, she nevertheless knows all too well "how flawed they are, how despicable, how self-seeking" (65), how they inevitably take place on a stage where human specters respond to each other through the mirror of reflected desire. She knows that Paul Rayley asks Minta to marry him because Mrs. Ramsay herself "had made him think he could do anything" (119). She recognizes that what her children feel for her is "quite out of proportion to what she was" (123). She also knows that her own motives are suspect and that she is guided by vanity and the desire for admiration. And in spite of the reverence she feels for her husband, she realizes that their relationship cannot bear the scrutiny her instinct for truth turns upon it. She gives her tacit agreement to the silent arrangement by which she answers to her husband's need to be renewed by the waters of life, and he provides her with an image of contracted strength and lonely vigilance, "marking the channel out there in the floods alone" (69). Both create and substantiate definitions of the masculine and the feminine, but Woolf underlines the degree to which these are constructed images that ground the relation in a certain falsity at the same time that they offer comfort and security. Each accepts the remoteness of the other, what they could not share, the small untruths. And a dismal flatness creeps into the sound of the two notes sounding together. (62)

Out of this knowledge, Mrs. Ramsay turns to the solidity of the inanimate world for a relationship untainted by the impurity of her relations with those around her. The stillness of the branches of the elm tree offers her a mirror image of her own

desire for permanence that her existence rooted in time and flux continually denies. And in her meeting with the lighthouse beam, her desire for "a coherence in things, a stability" that "shines out . . . in the face of the flowing, the fleeting, the spectral" (158), is fulfilled. The moment passes quickly, however, and the knowledge that the light "was so much her, yet so little her" (99) reflects her awareness that she dwells in the sphere of Imaginary identification. The desire to find her reflection in the stillness and stability of a completed form is irrealizable, for human consciousness cannot be reduced to the contours of a fixed image. The belief in an invisible core of being, a "wedge of darkness" that would be a reflection of the true self, is no less a matter of the Imaginary than the apparitions by which we are known to others and ourselves.

Nonetheless, the degree to which the image can infuse form and meaning into the fragmentation of human experience should not be discarded as mere illusion, for as Lacan insists, without such coherent images, human development would be impossible. Moreover, the Imaginary realm is the indispensable path to the Symbolic; in fact, as we see in the scene around the dining table, the two registers are not entirely separable. Under Mrs. Ramsay's sway, the dinner begun in disharmony, separation, and disillusion gradually takes on composition and form. With the lighting of the candles, the disparate individuals are transformed into a community, united against the fluidity without, defined by the image that they are not: "here, inside the room, seemed to be order and dry land; there, outside a reflection in which things wavered, vanished waterily" (147). In this moment of Imaginary identification, the mood changes from uneasiness to exhilaration and expectation which is fulfilled in the appearance of Minta and Paul, irresistible in their newly declared love. The occasion becomes a celebration, the dinner a social ritual in which opposite emotions are brought together. Mrs. Ramsay feels both the profound seriousness of the occasion and a sense of irony toward the lovers who must, as they partake of the sacramental and illusory nature of love, "be danced round with mockery, decorated with garlands" (151). In the joining together of Paul and Minta, the ceremony of marriage in all its ambiguity is celebrated. This moment thus brings us beyond the Imaginary into the Symbolic Order where the ambivalence of feeling is translated into the structures of social form and points to the concern with the Symbolic Order that dominates the last section of the novel. The passage from the Imaginary to

the Symbolic is crucial, but, as the conclusion of "the Window" demonstrates, the Symbolic is also the necessary extension of the Imaginary.

The privileged sphere of the mother is ultimately illusory. The fullness of her presence is inseparable from the certainty of her absence. The infant achieves this knowledge through the rhythm that structures his or her earliest experience of life: the appearance and disappearance of the breast. Freud's account of the child's game with the bobbin recounts the same knowledge.[34] Throwing his toy away and then recovering it, the child plays out the knowledge of his mother's disappearance and return. Through the symbolic gesture, however, he comes to terms with her absence and gains further mastery over the situation through a second level of symbolism: the enunciation, with each gesture, of the words *fort* and *da*. The Symbolic Order thus provides the individual with an alternative to the acute, often painful, life of immediate sensation and fragmentation. This Order reigns over the last section of *To the Lighthouse* where the figure of the father presides. Its central actions, the ritual voyage to the lighthouse and Lily's effort to complete her painting, are symbolic gestures that attempt to come to terms with painful and contradictory emotions across the distance of time and space. James, most obviously, is in the crucial throes of negotiating his own boundaries in relation to his conflicting feelings toward his mother and father. But Lily, too, must work out her ambivalent feelings, not only to the mother figure, but to Ramsay as well. Cam's role is subsidiary; she is primarily the witness of her brother's struggles and the diviner of her father's thoughts. Although her conflicting emotions toward brother and father, and her split loyalty, emerge, her position is already formed, her place between the two men given. An object caught in the patriarchal quest, subject to the paternal law, Cam is nonetheless fortified by the presence of the father and shares the triumph of both James and Ramsay.

The last section is calmer, quieter than the first; "The Lighthouse" does not have the same intensity as "The Window" where the immediacy of feeling and sensation prevails. The struggle for meaning continues, but the approach is no longer mainly intuitive, for the process of symbolization is "the difficult and tortuous emergence of thought, a thought which filters life through the prism of sensation, affectivity and intuition and which pushes it towards a beyond of a quite different order."[35]

If the first section is dominated by the figure of the mother

and the last, the father, the middle section embodies the death and sacrifice that marks the passage from one to the other. "Time Passes" records the symbolic debt that must be paid if the individual is to gain entry into the Symbolic Order. One must confront the death of the mother, which is not the absence of the literal referent but the end of a certain kind of relationship that characterizes the mirror phase. The human subject must give up the seductive and narcissistic comforts of the Imaginary in the recognition that the desire for immediate fulfillment, the dream of finding an answer on the beach is "but a reflection in a mirror." The middle section reveals the unalterable knowledge that makes contemplation, for the moment, unendurable: "the mirror was broken" (202).

The second section presents us with the Imaginary realm in the threat of dissolution and points to the ambivalent offerings of the pre-Oedipal stage.[36] The "profusion of darkness" creeps into the Ramsay house, swallowing up the distinct forms and sharp edges of objects, confounding pieces of furniture. The disappearance of individualized boundaries extends to the human world as well: "There was scarcely anything left of body or mind, by which one could say, 'This is he' or 'This is she'" (190). The Imaginary mode, predicated on the ability to perceive unified forms, veers toward extinction, falling back into that state of nondifference for which characters so deeply yearn in the novel's first section. The danger of this regressive desire (the undifferentiated state of mother and infant) emerges with hallucinatory intensity as fragmentation, chaos, and confusion sweep through the house and nature, and we come to understand that alienating as the mirror stage is in the series of false images it offers men and women, it is essential if they are to gain a unified representation of the self.

The threat of the absolute disintegration of the Imaginary realm hovers over the second section of the novel. At times it is uttered in the fragmentation, chaos, and confusion that sweep through the house and nature, at others in the "air of pure integrity" that reigns, utterly indifferent to anything tainted by humanity: "So loveliness reigned and stillness, and together made the shape of loveliness itself, a form from which life had parted" (195). Men and women, who know nothing of such absolute purity and integrity, are left in pain and doubt with no image "bringing the night to order and making the world reflect the compass of the soul" (193). Instead they are offered fragments of the desired vision: "the hare erect, the wave falling;

the boat rocking" (192). The lighthouse beam, once promising connection between the individual and the world, now turns back on itself in unabashed narcissism: "light bent to its own image on the bedroom wall" (196). Glimpses of life and rebirth appear: Mrs. McNab, spring, summer, but spring is "fierce in her chastity" (198) rather than bountiful in her fecundity, and the strange intimations and persistent dreams brought by summer echo most resonantly in the news of Prue Ramsay's death in childbirth. With the desolation brought by war, the images reach a nightmarish intensity: "There was the silent apparition of an ashen-coloured ship, for instance, come gone; there was a purplish stain upon the bland surface of the sea as if something had boiled and bled, invisibly, beneath" (201).

Woolf's language, straining to articulate the unsayable, to utter the desecration and decreation of the world, attempts to reach beyond the laws and logic of language and ends up, as Spivak suggests, veering toward a discourse of madness. Spivak describes "Time Passes" as the "story of unhinging," which is told "in the place of the copula or the hinge in the book."[37] This unhinging emerges most emphatically in the image of the broken mirror:

> That dream of sharing, completing, of finding in solitude on the beach an answer, was then but a reflection in a mirror, and the mirror itself was but the surface glassiness which forms in the quiescence when the nobler powers sleep beneath.... To pace the beach was impossible; contemplation was unendurable; the mirror was broken. (202–3)

Not only is the mirror broken, but the mirror itself is revealed to be the most inferior of instruments. The order that it, however questionably, legitimizes, is unhinged, and all forms intersect without distinction: "Night and day, month and year run shapelessly together." The imagery signals the unbinding of sexual repression and the confusion of sexual identity: "The winds and waves disported themselves like the amorphous bulks of leviathans whose brows are pierced by no light of reason, and mounted one on top of another, and lunged and plunged in the darkness or the daylight . . . in idiot games, until it seemed as if the universe were battling and tumbling, in brute confusion and wanton lust aimlessly by itself" (203). There is no resistance, no principle of order or restraint, as nature thrives in its very fecundity and insensibility: "Nothing now withstood them; noth-

ing said no to them. Let the wind blow, let the poppy seed itself and the carnation mate with the cabbage" (208). The merging of species and forms points again to the disintegration of the Imaginary, indeed the end of visual perception: "the trees and flowers looking before them, looking up, yet beholding nothing, eyeless and so terrible" (203).

The basis of the dual relation is inalterably undermined. With Mrs. Ramsay's death, the consolation offered by the dual relation is no longer possible, and the self is forced to accept the boundaries of its own being and the absolute distance that separates it from the other. The third section thus begins with characters trying to come to terms with feelings of irreparable loss and abandonment and the strangeness of their presence in the world. Instead of the affirmation of the first part of the novel, Part III immediately presents the experience of absence, of questions that seem to contain within themselves the very impossibility of answers, of inadequacy and frustration. The order and unity assured by the presence of Mrs. Ramsay give way to feelings of estrangement. The promise of the expedition to the lighthouse is at last to be fulfilled, but there is no sense of joy, no unity of purpose: the children go off unwillingly, Mr. Ramsay self-pityingly. Lily feels cut off from the others, from the house, from the morning.

The density of relation woven into the first part of the novel disappears, and all movement and speech become self-conscious questioning "as if the link that usually bound things together had been cut, and they floated up here, down there, off anyhow" (219). The overwhelming sense of absence, expressed, in part, through the gap between feeling and its articulation, leads to an increased self-consciousness toward the symbolization of experience: "(Alone she heard him say, 'Perished' she heard him say) and like everything else this strange morning the words became symbols. . . . If only she could put them together, she felt, write them out in some sentence, then she would have got at the truth of things" (219). "The Lighthouse" is distinguished from "The Window" by the conscious attempt to find a meaning that is other than the intuitive truth of the moment. This quest for wholeness, for an order that will resolve all fragments (past and present) into a meaningful vision, is the informing structure of the last section of the novel. Its action, the voyage to the lighthouse, and Lily's effort to complete her painting are symbolic gestures that attempt to infuse the present with a sense of wholeness and permanence by binding it to the past. These ef-

forts are far more complex than any act represented in Part One where the image of the window, the promise of transparency and reflection (and self-reflection), reign. The lighthouse signals the necessity of more complicated effects of light. The appropriate metaphor here perhaps would be refraction: the deflection of energy from a straight and linear path through another medium that irreparably disrupts its continuity. These metaphors underline the fundamental difference between traditional notions of reflexivity and the distinctive Freudian conception. As Shoshana Felman writes:

> Self-reflection, the traditional fundamental principle of consciousness and of conscious thought, is what Lacan traces back to "the mirror stage," to the symmetrical dual structure of the Imaginary. Self-reflection is always a mirror reflection, that is, the illusory principle of symmetry between self and self as well as between self and other; a symmetry that subsumes all difference within a delusion of a unified and homogeneous individual identity. But the new Freudian mode of reflexivity precisely shifts, displaces, and unsettles the very boundaries between self and other, subverting by the same token the symmetry that founds their dichotomy, their clear-cut opposition to each other.[38]

In Part III of the novel, the energy and desire binding two characters or images is inevitably interrupted by an Other, a third. It is not surprising, then, that "The Lighthouse" takes its structure from the figure of the triangle, refusing the consolation of the dual relation and the mirroring effects it holds. Thus, the tower of the third part of the novel, in spite of the seeming solidity of its presence, cannot be inscribed in the usual phallic proportions that linearity and unity proclaim.

"The Lighthouse," then, records the movement through which the individuals take their distance, both spatial and temporal, from their immediate experience and approach it through the mediation of the symbol. Through this passage the subject constitutes itself as a singular subject, liberated from both the comforts and restraints of the dual relation. In Part III characters must find their way in relation to opposing points of the triangle and so come to know themselves as constituted by difference and as assuming positions in a larger network of symbolic relations.[39] For Lily, James, and Cam, the plenitude of relation symbolized by Mrs. Ramsay's presence must give way to the more arduous pleasures of the Symbolic Order.

Lily, on the lawn, struggles between her attempt to recover the

presence of Mrs. Ramsay and her vision of Mr. Ramsay across the bay. Although her concern with Mrs. Ramsay predominates, at crucial moments (such as her vision of Mrs. Ramsay sitting calmly on the chair casting her shadow on the step), Lily's mind immediately turns to Mr. Ramsay: "And as if she had something she must share, yet could hardly leave her easel, so full her mind was of what she was thinking, of what she was seeing, Lily went past Mr. Carmichael. . . . Where was that boat now? And Mr. Ramsay? She wanted him" (300). Both the lighthouse and Lily's canvas continually mark points of a triangle that constitute her divided gaze as she negotiates the distances of near and far both in time and in space. The tension in her body as she reaches toward Mr. Ramsay is not unlike the strain involved in the recovery of Mrs. Ramsay: "For the Lighthouse had become almost invisible, . . . and the effort of looking at it and the effort of thinking of him landing there, which both seemed to be one and the same effort, had stretched her body and mind to the utmost" (308). Furthermore, the sense of release that Lily feels at the end, which is directly related to her ability to complete her painting, comes not only from her vision of Mrs. Ramsay but from her sense of having at last been able to give Mr. Ramsay the unexpressed feeling that she had been unable to share earlier that morning (308). To ignore the importance of Lily's consciousness of Mr. Ramsay as she attempts to come to terms with her ambivalent feelings toward Mrs. Ramsay is to lose sight of an important part of the novel that Woolf gives us.

It is almost as if Lily realizes the danger of weaving a creation that only takes account of the seductive and painful mysteries of the mother-daughter relation. No matter how irritating Lily finds Mr. Ramsay's self-absorbed presence and his demands for sympathy, no matter how arduously she struggles to situate her own identity in relation to the maternal presence, finally she must take into account that her own relation to Mrs. Ramsay can only be inscribed in the symbolic system that includes, for better or for worse, her husband. This is why Lily is compelled to re-create a moment of the past that insists on the undeniable "curious shock" (294) that she had seen pass between Mr. and Mrs. Ramsay, "to smooth out something she had been given years ago folded up" (295), in an act that is not merely invention but not pure repetition either. Thus she imagines the details of an old-fashioned scene in which Mr. Ramsay gallantly proposes marriage, and Mrs. Ramsay graciously responds. In spite of her critical spirit, Lily is left thinking: "Time after time the same

thrill had passed between them—obviously it had" (294). The imperfections of the Ramsays' marriage, as Lily realizes, do not cancel out the mysterious otherness of that relation or the place that it holds in the larger network of social relations within which Lily must find her own place.

Cam, too, is pressured by the division of feeling, trying to maintain a balance between her loyalty to James and her desire to express her love and admiration of her father. Like Lily she experiences the difference between near and far as she watches the details of the island recede, simplifying into the form of a leaf and giving her a certain freedom to create; thus "the immense expanse of sea" (302) at her fingertips becomes the scene of her own stories of adventure and escape. Although Cam never mentions her mother, her presence is embodied in her echo of her mother's words (284); moreover, we see Cam assume the mediating position of her mother—though with more reluctance. Cam's role, however, is subsidiary; she functions primarily as a witness to and voice of her brother's struggles (perhaps reflecting Woolf's sense of the secondary roles sisters inevitably assume). James is, of course, the central player in the oedipal drama, forced to work through his complex feelings toward both his parents: to face the "everlasting attraction" of the world of truth and beauty that his mother represents and then to relive the absolute loss of that harmonious, but fragile, realm (276–78); to relive the hatred he feels for his father, his desire to destroy him, and at the same time to experience his need to identify with the father if he is to give up the Imaginary realm and assume his position in the larger world of civilization and culture.

The positions occupied by daughter and son strongly contrast, but what I want to emphasize here is the degree to which each is refused the comforts of the mirror relation in which identity issues out of unity with, or opposition to, the other. The triangular relation insists that this relation must be mediated, or thrown off center, by a third, thereby setting up a more complex network of feeling, which is forced to take into account distinctive oppositions. The Imaginary realm is always reduced to fixed contours, the space of self-reflection, and thus denies the unconscious elements within. The Symbolic, on the other hand, establishes an order in which the unconscious elements are contained: through the symbol they are named in the same act by which they are denied.

The function of the lighthouse is to figure forth the dimension

of the Symbolic. The lighthouse is certainly phallic, and there is no doubt that we are meant to identify it in part with the stark and austere figure of Mr. Ramsay.[40] More importantly, however, it represents the father's law, his prohibition against the mother-son dyad, and it is part of James's resolution of his Oedipus complex that he comes to detach the paternal law from the person of his own father: "it was not him, that old man reading, whom he wanted to kill, but it was the thing that descended on him—without his knowing it perhaps: that fierce sudden black-winged harpy, with its talons and its beak all cold and hard, that struck and struck at you" (273). This insight brings James to an identification with his father as he envisions "two pairs of footprints only; his own and his father's" on the "waste of snow and rock" (274). The presence of his mother continues to haunt him, but he knows the intimacy he desires is forever barred by his father's shadow: "all the time he thought of her, he was conscious of his father following his thought, surveying it, making it shiver and falter" (278). The desire to be all for the mother is sacrificed, and in its place appears the desire for the father's recognition. With Mr. Ramsay's praise of his son's steering, James's desire is fulfilled and his initiation completed. They arrive at the tower; the quest is completed in a movement that echoes the success of the masculine voyage that has been recounted from time immemorial.

However, to see the lighthouse and Mr. Ramsay simply as reflections of each other and both as an affirmation of the power of the male presence is to repress the irony with which Woolf portrays this father figure: to forget the arid depiction of his plodding struggle to reach the letter R, step by step, letter by letter. His identification with stark phallic objects in his self-conscious heroism and misery suggests a misunderstanding of the phallic function. At the same time that the phallus represents prohibition and the law, it is not unequivocally an assertion of ultimate certainty or truth. For Lacan, as Rose and Mitchell underline, the phallus is always a presence whose status is "potentially absent" and thus is fraught with irony. Its visibility is always a function of absence in that it is a "stand in for the necessarily missing object of desire."[41] Thus its place rests on the very notion of substitution and the recognition of the repression of desire. Rather than a unified representation of power, it is a symbol of the incontestability of lack. The phallus attests to the irremediable split in subjectivity and thus to the precarious nature of any identity and especially one formed

on the basis of its worth. Lacan's formulation of the phallus is not an "unproblematic assertion of male privilege."[42] And in no way is it sufficient to read the image of the lighthouse as symbolic of the strength and heroism of the male presence. As James approaches the lighthouse, he refuses to give up his childhood image of the lighthouse, the "silvery, misty-looking tower with a yellow eye" (276–77), in face of the present vision: "the tower stark and straight. . . . barred with black and white." Refusing to give up his distant image, "for nothing was simply one thing," he experiences the lighthouse as a symbolic presence embodying the interplay of opposites: a promise of unity (the opening and shutting eye reaching across the bay) that calls forth his primary relation with his mother and a stark and austere image that represents the world of the father. The lighthouse thus embodies the repressed desire at the same time that it represents its repression.

The most important function of the lighthouse is to figure forth the possibility of symbolic meaning, to represent to consciousness the symbol-making powers of the self. Thus, the lighthouse suggests the more ambiguous nature of the phallus as it simultaneously represents fixity of meaning and the gap or failure that inheres in the attempt to establish meaning. The lighthouse, like the phallus,"symbolizes the effects of the signifier in that having no value in itself, it can represent that to which value *accrues*."[43] As such it stands in opposition to the experience of absence that pervades the novel, for it fills space and denies lack—providing the only tenable response to the dreaded blank space of the canvas that Lily faces, a blankness that returns her to the emptiness within, her hidden fears and feelings of insufficiency:

> It was in that moment's flight between the picture and her canvas that the demons set on her who often brought her to the verge of tears and made this passage from conception to work as dreadful as any down a dark passage for a child. . . . And it was then too . . . that there forced themselves upon her other things, her own inadequacy, her insignificance, keeping house for her father off the Brompton Road. (32)

The lighthouse is the positive counterpart to the devastating state of insufficiency that plagues consciousness and provides the self with a symbol of its own continuity through time. Through James's double vision of the lighthouse, he becomes aware of himself as that principle of permanence which persists

through time and embodies different points of view, a self that contains the possibility of creating a symbol that encompasses contradictions and bridges distances. Through memory other characters likewise approach the past through the symbolic images of their creation and join past and present in a moment in which the self assumes a sense of continuity, stretching across the fluctuation of time. It must be remembered, however, that these representations, the echoing vibrations of memory, are always grounded in difference (repetition is never of the same) and thus never simply provide the comforting affirmation of a unified identity.[44]

Like the phallus, then, the lighthouse is a symbol erected on tenuous ground. For Lacan, and this is what is often missed by his critics, "the subject's entry into the Symbolic Order is equally an exposure of the value of the phallus itself."[45] It is constructed on a lack that is ever irremediable, ever present, as Lily finds when suddenly her sense of control is utterly destroyed as her body is unexpectedly pierced by the knowledge of Mrs. Ramsay's absence:

> To want and not to have sent all up her body: a hardness, a hollowness, a strain. And then to want and not to have—to want and want—how that wrung the heart, and wrung it again and again! Oh, Mrs. Ramsay! (266)

Entry into the Symbolic Order is simultaneous with the onset of repression. The original desire is contained within the symbolic form at the same time it is denied. Thus, in the same movement in which the Symbolic offers the human subject the sole means of creative participation in the world of civilization and culture, it testifies to the irremediable gap at the heart of desire. This is the insight that Woolf's novel embodies, affirming, it would seem, Lacan's insistence that the fundamental structural moment in the life of any subject—male or female—is the passage from the dual relation of the Imaginary to the triangular, mediated relation of the Symbolic Order, an order, however, whose ground is always in question.

Now I would like to briefly take up some questions that I have with recent interpretations of *To the Lighthouse* that attempt to chart a separate path of development for the daughter that would offer an alternative to the male's accession to the Symbolic Order. One difficulty is reflected in the fact that Homans and Abel

arrive at opposite conclusions in regard to the daughter's possibilities: for Homans, Cam, rather than Lily, comes closest to fulfilling the promise of escape from the paternal law through her "revolutionary and potentially antipatriarchal way of using language";[46] while for Abel, Lily's nonrepresentational form of painting offers the only alternative to the Symbolic Order that James's initiation entails.

Homans finds promise of escape from the Symbolic in what she calls the *literal* language voiced by Mrs. Ramsay when she puts her daughter to sleep (172–73) and which is then echoed by Cam when she repeats her mother's words years later looking back on the island. The problem with this distinction is suggested by Homans herself when she writes: "It *might seem* that Mrs. Ramsay's discourse with her daughter *depends on figuration,* as she is listing all the things that the wrapped skull might be like. . . . However, the aim of Mrs. Ramsay's talk is not to represent mountains or other distant objects, but rather to reassure Cam of her own sheltering presence" (my emphasis). The fact that the words have a soothing, rhythmic presence does not annul their referential capacity; what seems to me at stake is simply the fact that all language simultaneously moves along the axes of signifier and signified, and in some instances one pole is accentuated above the other, but to claim "that this is specifically a daughter's experience of language" does not seem to clarify anything while at the same time it encourages essentialism. Finally, Homans retreats to that seductive, but prediscursive, site of the mother's body as the region of this special language: "there is a gap between the signifier 'mountain' and an actual mountain, but there is no gap at all between Mrs. Ramsay's words and her bodily presence for her daughter."[47] But isn't it a matter of those soothing words closing the gap between their two ever-distinct bodies—which can only be joined through the Symbolic Order from which all words emerge? Thus, I am completely at a loss to understand how any language can be characterized as "a non symbolic mother-daughter language" or why "the pleasure Cam and Mrs. Ramsay share in the rhythm and feel of words" should be "distinctively female."[48]

Abel, on the other hand, sees no promise of escape from the Symbolic Order in Cam's position, underlining her painful and inescapable position in the boat, between the two male representatives of the law, barred from voicing her own desire. Lily, however, she suggests, provides us with an alternative: her painting functioning "as an alternative not to language but to Woolf's

account of language acquisition which she depicts through James and Cam as both compelling and dismaying."[49] While Homans sees Lily's painting as an attempt to represent the absent mother through memory and thus having a certain complicity with the son's acquisition of language, which is also founded on the loss of the mother,[50] Abel finds Lily's painting a means of representing "the boundary negotiations that characterize the mother-infant bond" and allowing Lily both to restore the mother figure and assert her own independence from her.[51]

In spite of their differences, both Abel and Homans are strongly influenced by Melanie Klein and the object relations school (Winnicott, Chodorow), which stresses the mother-infant relation and finds there the origins of human creativity as the infant negotiates its space between separation and unity. There is a certain irony in the fact that feminists today are using such theory to refute Lacan when, historically speaking, Lacan developed his theory in strong opposition to these very ideas that he believed dispensed with what for him was the crucial matter of Freud's theory: castration, paternal repression, and "a reintroduction of the concept of desire into the definition of human sexuality."[52] The self-contained dyad of mother and child leaves no space for the necessary but fatal intervention of the father's law that sets in motion the metonymic chain of human desire. It is thus not surprising that Abel's discussion of Lily's painting in the third part of the novel centers only on her relation to Mrs. Ramsay in spite of the fact that Lily's vision is divided between her vision of Mr. Ramsay in the distance and her recovery of Mrs. Ramsay on the beach. The triangular structure of this section of the novel insists that we see Lily as much as James negotiating the transition from the Imaginary stage to the Symbolic. Certainly there are differences between painting and language, but this does not invalidate the fact that painting— whether representational or abstract—involves symbolic gestures and reflects the need to mediate the fluidity of sensation through figures of spatial form. If Lily's efforts to paint, as Abel suggests, are a means of enacting her distance as well as her continuity with Mrs. Ramsay, how can this action be anything else but a symbolic means of expressing emotional conflict and thus reflect the subject's necessary entry into the Symbolic Order.

To differentiate the process of painting from language, Abel points to two passages that, she tells us, reveal Lily's sense of the difference between the two forms: "Lily contrasts the gestures of

painting with those of language, which 'fluttered sideways and struck the object inches too low,' and associates her art with 'a dancing rhythmical movement, as if the pauses were one part of the rhythm and the strokes another, and all were related.'"[53] However, one can find other passages that present Lily's experience of painting as involving the very same sense of frustration and struggle that writing does:

> "Phrases came. Visions came. Beautiful pictures. Beautiful phrases. But what she wished to get hold of was that very jar on the nerves, the thing itself before it has been made anything, Get that and start afresh; get that and start afresh; she said desperately, pitching herself firmly again before her easel. It was a miserable machine, an inefficient machine, she thought, the human apparatus for painting or for feeling; it always broke down at the critical moment." (287)

Painting is just as "exacting" a form of intercourse as language. Its demands are unyielding and the sense of defeat almost inevitable: "a fight in which one was bound to be worsted." In both cases the sense of the inadequacy of the human mechanism and the medium at hand to translate the exigencies of the body are overwhelming. Thus, I am not convinced that the novel differentiates this visual art from that of words in quite the way Abel suggests. If "the act of painting entails the separation that the language of paint is intended to heal," I would hold that the same is true of words, and that words, no more than paint, can simply be referred to as "a magical vanquishing of absence."[54] Moreover, the sense of completeness and resolution that Lily feels after the final stroke of her painting is foreshadowed in Mrs. Ramsay's response to the sonnet she reads:

> How satisfying! How restful! All the odds and ends of the day stuck to this magnet; her mind felt swept, felt clean. And then there it was, suddenly entire; she held it in her hands, beautiful and reasonable, clear and complete, the essence sucked out of life and held rounded here—the sonnet. (181)

Poetic language, it would seem, has the same powers of healing as paint, and both emerge from the coincidence of material sign and symbolic form.

Finally, Abel's distinction between language and painting suggests that language acquisition binds the subject unequivocally to the law of the father in a movement that irrevocably grounds him/her in a rigid and inflexible structure. For Woolf, as well as

Lacan, however, the signifiers of language are always shifting and unstable, the unconscious always threatening to rupture the law that binds signifier to signified and even sons to fathers. James's recognition that the lighthouse is both a connection to his mother and father's worlds insists that repression is never absolute. Language and the law of the father are not the monolithic structures that Abel would have us believe. Her insistence that James's double vision is ultimately renounced and simply "marks a stage within a psychological balancing act, not the conclusion of that process," which for Abel is inevitably and finally "the erasure of his mother's image," reflects this perspective. The last part of the novel, however, does not suggest to me that James successfully "consigns" his mother's image "to oblivion."[55]

Rather than seeing the lighthouse, as Abel does, as "the central figure" in a "system that mournfully salutes the presence it has lost," I understand the lighthouse as embodying that presence that is lost at the same time that it stands in for that loss, thus figuring forth the very meaning of substitution, namely, repression. The lighthouse is most importantly like the phallus in that it stands for the fundamental splitting of the self in the very moment it is formed. James's identification with his father and the law are not sufficient to move him beyond the cost of this division and the threat of the eruption of the repressed. The signs of language no more "seal maternal absence" than the signs of paint do, and "the shifting configurings of absence and presence" characterize the modulation of words as well as lines.[56] Lacan's emphasis on the Symbolic does not ignore the forces that undermine its hold, and as Rose underlines, "the symbolic is not, as has been argued, a rigid, monolithic structure, but unstable and shifting."[57] What is, in fact, distinctive about Freud's unconscious, according to Lacan, is that it cannot be silenced but continually speaks.

It is important to understand Lacan's insight into language as forever pulled in opposing directions because it is directly tied to his understanding of the failure of human sexuality. As Rose emphasizes:

Lacan's statements on language need to be taken in two directions—towards the fixing of meaning itself (that which is enjoined on the subject), and away from that very fixing to the point of its constant slippage, the risk or vanishing-point which it always contains (the unconscious). Sexuality is placed on both these dimensions at once.

The difficulty is to hold these two emphases together—sexuality as that which constantly fails.[58]

For Lacan, and for Woolf as well, the Oedipal configuration for both sexes most fundamentally involves the creation of an identity, linguistic and sexual, that coincides with nothing innate or natural and issues in patterns of gender relations that are invariably less than satisfying.[59]

To ground a psychoanalytical interpretation in the pre-Oedipal relation between mother and child and attempt to dispense with the third position of the triangle, the role of the symbolic father, is to refuse the very basis of psychoanalysis and, in fact, to ignore the essential feature of the analytic relationship which is to break through the subject's attempt to reenact the dual relation and find refuge in the Imaginary.[60] Only when the child is denied the comfort of his fantasy of self-completion in the other can she or he be thrown upon the axis of desire and have the opportunity to enact—if not necessarily to fulfill—that desire. The meaning of the phallus issues from this rupture. Thus, at the same time the phallus signifies prohibition and the law, it "signals to the subject that 'having' only functions at the price of a loss and 'being' as an effect of division."[61] This is the primary significance of the phallus even before it becomes a figure signifying sexual difference. Whether male or female, the subject takes up his/her position in relation to the phallus not primarily in terms of who has one and who does not but in terms that underline the difficulty and cost of any accession to the Symbolic Order. Neither primarily a symbol of truth or unity or male potency, the phallus reveals itself as rooted in fraud and failure.

I would offer that Virginia Woolf's image of the lighthouse likewise finally refuses the very associations—both male and female—that it draws upon. This looming tower most importantly figures forth the necessity and artificiality imposed on the subject as he/she takes up his/her sexual and human identity. Negotiating the shifts and boundaries between Imaginary and Symbolic realms, Woolf serves as a dramatic reminder that these maneuverings are not negligible, the matter being no less than the question of life and death.

Although Woolf believed that she had exorcised the presence of her mother with the writing of *To the Lighthouse,* this subject continued to haunt her throughout her life and figures prominently in the memoir left unfinished at the time of her death.

"A Sketch of the Past" once again reflects the tension between the Symbolic and the Imaginary, but it also provides added insight into the distinctive process of the girl's development. To pursue this subject, we turn to the artifact of the mirror, which serves both as a site of cultural meaning and as a means of entry into the specificity of the mother-daughter relationship. Before beginning, however, it is well to take heed of Woolf's warning in *To the Lighthouse:* "the mirror itself was but the glassiness which forms in the quiescence when the nobler powers sleep beneath" (202).

3

Reflecting Surfaces: Mirrors and Autobiography

SUBLIMELY paradoxical the mirror is perhaps our most intriguing artifact. Very early Plotinus stated its central mystery: "the semblance is in one place, the substance in another . . . full when it is empty and contain[ing] nothing while seeming to contain all things."[1] Irresistible in its promise of clarity and revelation, it gives rise to visions of eternal beauty and ideal reality. Nonetheless, the mirror is perennially suspect: mute, passive, creator of insubstantial and fleeting images, it seduces us with illusory presences.

From the ancient myth of Narcissus to Jacques Lacan's theory of the mirror stage, the human fascination with its own reflection has dominated Western consciousness. This propensity for self-scrutiny is reflected in the many variations of the mirrored image that pervade our culture: the reflection in the pool, the shadow, the double, the photograph. At different periods certain dimensions of the mirror's powers predominate, but recurring questions, though posed in variant forms, seem inscribed within its frame. Is the image in the mirror an idealized form or a deceptive lure, an entrée into higher realms of visibility and truth or a trap that leads us to value fleeting and delusory images that are the mere shadows of reality and truth? These matters preoccupy the religious sensibility of the Middle Ages, where the distinction between worldly attractions and spiritual ideals are often thematized in relation to the figure of the mirror, as well as our own psychoanalytically oriented culture. The romantic period provides its own variation on the looking glass motif by using the mirror to body forth the theme of the double that issues so dramatically in this individualistic and introspective age. At the end of the nineteenth century, the theme of the doppelgänger will find its fitting extension in the photograph, which will again transform our visual reflexes and habits of self-

questioning. The reflections of our own images are everywhere: provocative, reassuring, and disturbing. They testify to our presence in the world and the cohesiveness of our beings, but they also provide disquieting glimpses of the insubstantiality of our presences: vulnerable, unknown, and alarmingly mortal.

An exploration of the mirror's spell—its metaphorical power—testifies to the degree to which our culture is captivated in the visual mode. That the root of speculation is *speculum* or looking glass is not incidental. Whether the perspective is metaphysical, aesthetic, or psychological, we are bound by the notions of imitation and representation, speculation, and self-reflection. Whether the world is held up as the foundation of reality, and the mind and art are believed merely to provide reflections of it, or if the mind itself is given priority as the structuring element,[2] the principle of visual reciprocity remains in ascendance. Only the shattering of the mirror brings into being the crisis of representation that has long hovered at the edge of consciousness but has only become a prevailing question of intellectual inquiry in this century.[3]

The reflecting surface that I will be concerned with is that of autobiography, "a special case in the definition of subjectivity because it interiorizes the specular play between the producer/producing and the produced."[4] Here the subject's self-conscious immersion in creating images of the self becomes the very substance of the text; acknowledged to varying degrees within the genre, this concern has become increasingly the focus of autobiographical writing where fixed and coherent images vie with the unseizable reality the word embodies. The mirror—both a promise of truth and transparency and inevitably a reminder of the always less-than-perfect embodiment possible as soon as any truth is reduced to material substance—serves to reflect the tension with which life-writing is fraught. In particular, I will argue that the autobiographical texts of women offer us a mirror gaze that reaches an unforeseen intensity of effect.

Before turning to these works, however, I want to briefly sketch out some of the ways that the mirror embodies and perpetuates the major psychological and cultural concerns of particular epochs, many of which are directly or indirectly pertinent to questions of "autobiographics."[5] Both the figure of the mirror and autobiographical texts are doubly spectral: offering consolidated images of the body and self, they appear to guarantee the most personal and private aspects of the subject. However, a more probing look discovers that this intensely sin-

gular identity is inhabited by "invisible presences,"[6] and its uniqueness and unity are traversed by multiple and divisive cultural imprints.

In the Middle Ages, the mirror served as the perfect figure to disseminate the social, religious, and philosophical attitudes of the time just as in the eighteenth century the analogue of the mirror, and the mimetic theories of art to which it gives rise, will serve the very different ideological purposes of that historical moment. Terry Eagleton has underlined the degree to which the mirroring function of neoclassical literature was essential to restoring a disrupted social order and bringing the emerging middle classes into alliance with the aristocracy through the diffusion of "polite social manners, habits of 'correct' taste and common cultural standards."[7] The concerns of the highly controlled and hierarchical society of the Middle Ages were obviously very different. Here the figure of the mirror insisted on the distinction between the one ultimate truth and its multifarious, though inferior, varieties. All aspects of God's creation were seen as a faithful mirror of the Creator; the mirror of creation pointing us toward "the divine mirror in which only perfect truth was reflected."[8] The mirror thus beautifully conveyed the sense of existence as "a relation between paragon and image, between one Reality and its innumerable reflections." This crucial distinction between the objects of our immediate experience and the divine reality they represent led to an ambivalent attitude toward the looking glass, depending on whether its material or idealizing qualities are emphasized.[9] The mirror was recognized as a provider of ideal forms, even offering signs of the divine that "so-called scryers or *specularii*" claimed the power to read. Moreover, "at times the insubstantiality of the mirror's image was taken as a token of the purity of the dematerialized soul."[10] However, this same insubstantiality also made of the mirror a vehicle of deception, whose delusive images were thought to lead us away from the highest truths. Only when material nature and spiritual reality were joined would the mirror serve its most important religious purpose: "The mirror awakens our consciousness of the idea by translating it into sensible images. It shows us an image of eternal Beauty in the beauty of a momentary body. But that image is fleeting, it has no substance; and we must learn how to leave the mirror behind and love a being that is invisible and immutable." Beatrice will, of course, provide such a mirror for Dante as he learns "to love himself, not in an image, but as an image" of the divine presence. For the religious

thinkers of the Middle Ages, the myth of Narcissus was a re-
minder that if the mirror "gives to the soul its first captivating
glimpse of the ideal," it also insists that its reflected images have
no independent existence and that only by passing beyond its
frame can one avoid the tragic fate of this beautiful youth.[11]

The specular effects of the medieval mirror are also inscribed
in the tradition of courtly love and foreshadow questions of gen-
der that will become central in contemporary feminist theory.
The difference in emphasis, however, is critical. The alarming
moment when the lover faces the recognition that the ideal lady
of beauty and virtue to whom he dedicates his life, and on whom
his identity is founded, might be no more than a reflected image
of his own idealized creation undermines his own identity at
the same time that it questions his lady's substance.[12] Of greater
concern to modern readers is the implicit reminder that these
glorified representations of women mainly serve to uphold male
desire and substantiate the heroic images of men. Offered at the
cost of their own identities, these idealized women tell us noth-
ing of a woman's own needs and desires.

Leaving the middle ages for the Renaissance when more secu-
lar views prevailed, we see a dramatic change in orientation. The
human mind and its rational powers now occupy center stage.
Writers such as Descartes and Montaigne will turn the mirror
inward although they never lose their confidence in the visual
reciprocity between mind and world. In the seventeenth cen-
tury, the looking glass thus continues to serve as the central
figure in "this metaphorics of visuality," defining the way the
world was known: "human cognition was believed to function
like a mirror that reflects the world at the end of our gaze."[13]
The human mind was now granted a pivotal position, but the
image of Narcissus, though transformed, still prevails. As Paul
Zwieg puts it, "Descartes invoked a new god: the inward divinity
of the mind; a strangely spiritualized Narcissus."[14] Believing in
the specular relation between innate ideas and the world of mat-
ter, Descartes affirmed the "unblinking eye of the fixed gaze" as
he turned his mind to gaining access to the objects in the world
through the clear light of reason. The specular properties of the
mirror are thus translated into the human power of speculation
that "could mean the pure knowledge of self-reflection, a mirror
reflecting only itself with no remainder."[15] Montaigne, too, af-
firmed the transparency of the inwardly directed mirror and is
especially significant for us because such views provided the
foundation for his innovative form of the personal essay. In spite

of his awareness of the indisputably contradictory nature of the self, he never questions that "my book and I go hand in hand together" and "who touches one touches the other." Moreover, his statement that "every man carries within himself the entire form of the human constitution"[16] insists that the same transparency and reciprocity holds for the relation between self and other.[17]

This firm ground of subjectivity would dissolve, however, in the nineteenth century as obsessive self-reflection yielded increasing moments of self-doubt and contradiction. Once the Romantic age posits a "projective and creative mind,"[18] in place of the mirroring consciousness of classical theories, with its promise of objective and universal truths, it is only a matter of time before the celebration of the creative powers of the subject gives way to a more troublesome awareness of this very subjectivity, its fragmentation and instability. Whereas Rousseau, as Zweig underlines, never doubts his access to the truth and concentrates on convincing "the reader of what he, Rousseau, already knows," later writers engaged in such acts of self-inspection (his example is Stendahl) find that their efforts to divide themselves into subject and object doom them to the irresolvable conflict inherent in Narcissus's position:

> Narcissus, gazing into the water, is engaged in a painful vigil; the image he is looking for escapes him. The more he looks, the more he is filled with the sense of a painful lack. From the point of view of this inward vigil, no act he accomplishes "in the world" can give him satisfaction if it doesn't also point itself to the obscured image in the water. And yet that is the one thing it cannot do, for every life-movement ruffles the water, making the image less recognizable than before. The man who has given himself up to this inward expectation undergoes from minute to minute the ordeal of seeing the sought-for-image betrayed, not by some enemy who might, with effort, be defeated, but by the needs and passions of his own life. . . . A man who follows the secret movement of his life from day to day is apt to find the firm groundwork of his character continually dissolving.[19]

The quest for the essential and permanent image of the self inevitably leads to a sense of frustration, fragmentation, and estrangement. No wonder that during the agonizingly introspective romantic age, fantasies of the double—Narcissus as the beckoning but ungraspable phantom of the self—abound as never before.

This experience of doubleness, however, reaches back to the earliest times. As Guerard tells us, "Few concepts and dreams have haunted the human imagination as durably as that of the *double*—from primitive man's sense of a duplicated self as immortal soul to the complex mirror games and mental chess of Mann, Nabokov and Borges."[20] At once the promise of a purer being and the sign of a diabolic and uncivilized self, a manifestation of eternal life and a "messenger of death,"[21] the shadow—the earliest manifestation of our doubleness—incorporates within itself the paradoxical qualities of all figures of reflection. Whether image in the looking glass, doppelgänger or shadow, the duplicated other has the potential to elicit a sense of the uncanny, inspiring both fear and awe in its curious combination of strangeness and familiarity. The uncanny, Freud would tell us, is "the name for everything that ought to have remained secret and hidden but has come to light";[22] thus, "the weird familiarity"[23] of the double is inevitable because it represents what is first repressed and then projected outward by the subject. For the romantic writer, however, reaching beyond the socially defined self to the inner layers of personal being would often bring up images so alien and terrifying that recoil might be the most fitting response. To the unanticipated joy that Narcissus experiences in seeing his face reflected in the pool must be added the insurmountable horror that Frankenstein's monster feels when placed in the same position:

> I had admired the perfect forms of my cottagers—their grace, beauty and delicate complexions: but how was I terrified when I viewed myself in a transparent pool! At first I started back, unable to believe that it was indeed I who was reflected in the mirror; and when I became fully convinced that I was in reality the monster that I am, I was filled with the bitterest sensations of despondence and mortification.[24]

As the pool provides the monster with an alienating, though undeniable, image of himself, his presence, in turn, serves as a doppelgänger of Frankenstein, underlining the double's role as the embodiment of repressed instinctual drives and antisocial impulses. Yet, as frightening as this diabolical and destructive other is, the thirst to penetrate to the dark interiors of being continues to drive writers[25] to create alter egos to unearth the suppressed self that is both anticipated and feared as the true self. We again confront the mirror's promise to reveal an essential being beyond all masks and roles. Guerard links the preva-

lence of the double in literature with this obsession, which he sees as "the need to keep a suppressed self alive, . . . to keep alive not merely a sexual self or a self wildly dreaming of power or a self capable of vagrant fantasy, the self of childhood freedom— not merely these, but also a truly insubordinate perhaps illusory, original and fundamental self."[26] Although—or perhaps just be- cause—the peril of personal disintegration intensifies, the dream of an undivided and unfalsified self persists.

The use of the motif of the double in twentieth-century litera- ture is increasingly self-conscious in the light of Freudian reve- lations about our civilization and its discontents. But it is Jacques Lacan's reinterpretation of psychoanalytic theory that returns us concretely to the reflection in the looking glass and the relation between the image and the real. In his emphasis on the Mirror Stage, "the role of vision in the constitution of the self was given a hitherto unimagined prominence."[27]

For Freud the myth of Narcissus would supply symbolic form to his theories of infantile development. He would designate primary narcissism as the earliest stage in which the infant is in a state of absolute reciprocity with its environment. Experi- encing itself as self-contained and self-sufficient just because there is not yet any sense of difference between self and world, the infant is filled with a sense of blissful plenitude that it will attempt to sustain and recapture as the ego develops. Freud tells us that narcissism is dependent on the joining of the autoerotic instincts and the newly developing ego-interests,[28] and it is to this question of the formation of the ego that Lacan would give his attention.

Lacan translates Freud's theories of narcissism into the specu- lar metaphor of the Mirror Stage in which the subject's self- absorption in his or her own image provides the primary struc- turing element in the creation of the self. The myth of Narcissus is again marvelously applicable, as Jacqueline Rose underlines, for it is "especially apt to delineate that moment in which an apparent reciprocity reveals itself as no more than the return of an image to itself."[29] For Lacan the undifferentiated visual symbiosis that the infant experiences with its environment en- ables it to form a sense of a unified self by identifying with its reflection in the looking glass or its mother's image. Thus, Lacan postulates that "what Freud had called primary narcissism is achieved through the taking of an image for the reality of a coherent self."[30] The fact that the reflected image is, as this brief overview of the metaphoric implications of the mirror has re-

peatedly demonstrated, always in part illusory is not lost on
Lacan. What he will insist upon, as never before, is the degree
to which the very basis of the constitution of the self is a fiction
and that the ego is no more than a "fabricator and fabrication."[31]
The child's felicitous sense of having apprehended his or her
own identity is based on a helpless confusion between identity
and the act of identification;[32] moreover, as this moment of iden-
tification is simultaneously a moment of separation—the self
discovers itself only by being opposed to itself—the child's tri-
umphant act of recognition ironically records an alienation at
the very foundation of the self. This Imaginary dimension of the
psyche that the Mirror Stage initiates will continually under-
mine the subject's apprehension of the Real, for this stage inau-
gurates the individual's "assumption of the armor of an
alienating identity, which will mark with its rigid structure the
subject's entire mental development."[33] Thus begins the sub-
ject's propensity to confuse the line between self and other, to
deny the latter's radical difference, and to make of him or her
a specular double in a relation inevitably carrying the subject's
own aggressive instincts. Because the Imaginary relation is not
a relation of identity but a "relationship between ego and *alter
ego*" in which each is always trying "to take the other's *place*,"[34]
it is marked by aggression as well as love. Reducing the other to
an image of the self or experiencing one's own self in the light
of the other's gaze, the subject is thus immersed in the estrange-
ment and uncanny doubling of which the mirror warns. For
Lacan only the entry into the Symbolic will offer the subject
the means out of this double bind though this newly assumed
position is not without its own sacrifice. This passage is not
definitive, however; the Imaginary and its demands will continu-
ally haunt the developing subject.

Although Lacan underlines the degree to which our vision of
ourselves is formed by our sense of being the object of the
other's look, it will be left to Irigaray, his less-than-faithful stu-
dent, to bring out the implications of this insight in relation
to the question of gender. While Lacan himself pursues these
questions,[35] she will insist that he is helplessly bound within
the strictures of the male gaze and continues the privileging of
the visual—and the visible—that characterizes Western culture.
Giving a position of eminence to the phallic signifier and relegat-
ing women to the position of absence or lack, he, like Freud,
she argues, fails to grant woman either her distinctiveness or
full value. Furthermore, his speculations on the Mirror Stage

ignore the crucial distinctions between women and men that define our specular economy. What Irigaray will develop more fully than Lacan is that in the service of upholding the male ego, women are made to assume an additional mirroring function: "If this ego is to be valuable some 'mirror' is needed to reassure it and reinsure it of its value. Woman will be the foundation for this specular duplication, giving back man 'his' image and repeating it as the 'same.'"[36] This is not unlike the cultural prescription that we have seen operating in the courtly love tradition. Woman's identity thus becomes a function of masculine demands in more ways than one. She must give up her distinctiveness to validate the male image and substitute the reflected light of his image for her own. Milton's Eve serves as a perfect example. She, like Narcissus, is at first unknowingly enthralled by her own reflection in the water, but God insists that she flee such shadowy presences and exchange her own image for that of Adam: "I will bring thee where no shadow stays / Thy coming, and thy soft imbraces, he / whose image thou art, him thou shalt enjoy." Though we may feel a rightness in Eve's being turned away from the perils of self-love and are perhaps drawn into Adam's insistence on the perfect reciprocity of their relationship, "Part of my Soul I seek thee, and thee claim / My other half," we might simultaneously have a lingering sense of regret that Eve has had so soon to give up that innocent moment of blissful self-possession for an image she finds "less fair, / Less winning soft, less amiably mild" than her own. Thus she begins the long tradition of women's propensity to see "how beauty is excell'd by manly grace" and to conceive of their own identity in terms of masculine demands.[37] The male economy of representation is based on the denial of women's subjectivity; his self-presence necessitates her invisibility, and as Virginia Woolf ironically observes centuries later with blinding lucidity, women serve not only as mirrors but as magnifying glasses, which alone are strong enough to justify the most dubious of manly actions:

> Women have served all these centuries as looking-glasses possessing the magic and delicious power of reflecting the figure of man at twice its natural size. Without that power probably the earth would still be swamp and jungle.... Mirrors are essential to all violent and heroic action. That is why Napoleon and Mussolini both insist so emphatically upon the inferiority of women, for if they were not inferior, they would cease to enlarge.[38]

The looking glass scene is further complicated for women because our culture has traditionally placed such emphasis on beauty as the defining feature of the feminine. How crucially this fact affects women's relations to the Imaginary is poignantly recorded in Simone Weil's statement that "a beautiful woman looking at her image in the mirror may well believe the image is herself. An ugly woman knows it is not."[39] The disparity between the complex dimensions of subjectivity and the inevitably diminished form that results when the self is reduced to an object issues forcefully when the self-image is less than flattering.[40] But how difficult to resist the temptation to believe that the image of beauty revealed by the mirror is a faithful representation of one's essential identity. Encouraged by the world to value their appearance above all—and to form it in conjunction with male desire—and then accused of vanity for doing so, women struggle with the doubleness, disappointment, and deception that the mirror inspires in ways unknown to men.[41] The consequences, however, as Jenijoy La Belle, writing on the distinctive importance of mirrors in women's lives, points out, rebound on masculine desire with a vengeance: "the feminine selves produced as projections of male desires become objects of men's fears—as temptresses, terrors, monsters. The system of self-creation draws both parties into the whirlpool, the women who die into mirror images and the men who see their own deaths as the end of desire."[42]

The mirror thus reveals both women's power and vulnerability; it is a testament to her capacity for self-creation and a witness to the external forces conspiring to defeat such freedom. In either case, however, the self-scrutiny characteristic of the looking glass scene is bounded by the limitations of its visual—and visible—contours. Whether assuaged by assurance of its attractiveness to others or devastated by the signs of faded beauty, whether unconsciously forming its image in response to male desire or consciously rebelling against such unspoken demands, the subject is returned to herself as an objectified other and encouraged to detach herself from the fullness of bodily experience. Thus, I am less convinced than La Belle that the mirror might provide for women an entrée into "a state of consciousness defined through its constant commingling with corporeal being" rather than encouraging her, as it does men, to flee the mere image for a transcendent reality. What La Belle calls "corporeal existence," how women "look as physical objects to themselves and to others," is already only a very partial definition of

bodily experience, one that is predicated on the privileging of the visual above the other senses. It does not touch the way the body sounds, smells, and feels; nor does it record the textures and vibrations that find no correlative in the mirror's image. Self-consciousness is the undeniable terrain of the mirror, and although it is imperative that we realize that self-consciousness itself is "a profoundly cultural phenomenon,"[43] I do not see how the visual contours of the mirror frame can lead women to a more viable sense of their bodies that would then expand their understanding of the difficulties and contradictions inherent in their subjectivity.

For such exploration, I believe, we must turn to the power of the word—rather than the visual image—just because it inscribes within itself the tension between presence and absence, the conscious and unconscious, that the visual form ignores.[44] Only the Symbolic Order—in spite of its limitations—brings us to the threshold of language that offers the only means of escape from the solidification and "degradation into signs or images"[45] through the insistent ambiguity of words, the tension between signifier and signified. Thus, I will now turn to autobiographical texts that are simultaneously reflections of the Imaginary and Symbolic and that at times hint at an earlier and more sensuous apprehension of the world—whether as wish or reality. I have chosen to begin with Virginia Woolf because her "Sketch of the Past" suggests a subjectivity both grappling with the self-conscious questions of self-reflection and reaching toward the faintly heard and barely understood echoes of another dimension. At the same time, she raises important questions about the distinctiveness of female development and underscores the crucial place that the mother occupies in the looking glass, a site that has become increasingly marked in women's autobiographies. Two later texts, Jamaica Kincaid's autobiographical novel *Annie John* and Vivian Gornick's memoir *Fierce Attachments,* will serve as more recent examples grounded in the daughter's captivation within the mother's gaze. In choosing three different varieties of the autobiographical form, I hope to raise questions as to the relation of fiction and fact and the crossing of generic boundaries. In choosing women whose social, political, and ethnic backgrounds differ, I hope also to suggest the way some of these coordinates come into play with the matters of voice and form and finally to locate the position of the mother in relation to the patriarchal powers in force.

My interest in autobiography as a gendered genre stems from

the following line of inquiry: If we acknowledge that life-writing is primarily the matter of self-reflection, and we are therefore directed to Lacan's mirror phase, and his distinction between the Imaginary and the Symbolic, what can we infer about the different reflections and projections the looking glass offers to men and women? How do the parameters of the Imaginary create expectations and limitations that are particular to the young girl's development? And since autobiography is inevitably an acting out of self-creation, how will the very form of women's life-writings reflect her interrogations and struggles before the looking glass? Finally, how do those paradoxes, which we have seen operating all along—in full view of the mirror—play themselves out in self-reflecting texts of women: the irreconcilable contradictions of fullness and emptiness, strangeness and familiarity, truth and delirium, and captivation and captivity?

I would thus like to begin by grounding the specificity of the girl's development in the stage of the Imaginary where identity begins to emerge, and self and other are continually confounded in the effort to carve out the contours of a coherent self, rather than in a primordial phase of unity and bliss, which some feminists offer as the privileged sphere of the mother-daughter relation.[46] As we have seen, this crucial moment of human development takes place when the undifferentiated relation between mother and infant gives way to an identification with a reassuringly stable, though invariably falsifying, visual image: the mother's face and/or the child's own reflection in the mirror. This identification and its difficulties will be compounded for the young girl when she enters the Symbolic, the world of language and culture, because here she is returned to the image of her mother as she becomes a gendered and individualized being unlike the male whose separation from the mother is radical and whose identification with the father is biologically encouraged and culturally enforced. Threatened by the conflation of the Imaginary and Symbolic, the girl is thrown into a play of images that menaces the fragile self just coming into existence.

Because for many women the gaze into the looking glass inevitably calls up the mother,[47] I would suggest that the very form that she chooses for autobiographical reflection might reveal her struggle with this nourishing and disfiguring image, at once captivating and terrifying. In fact this preoccupation, and even obsession, rises with increased urgency in recent life-writing and at times takes the form of a more generalized suspicion of the

visual image's claim to embody the real. This is not to suggest that only women struggle with the conventional structure and sense of closure of autobiographical form but that they have a heightened sensitivity to these concerns, a more urgent need to rebel against the fixity of image and form as they face with greater awareness the power of the mother's reflection to captivate and imprison. The image of longed-for love as well as resentment and hate, the mother presides over the Imaginary realm, offering a reflection that is contained (and containing), static, and, at its most extreme, dead; inviting interminable reflection and endless introspection, her shadow is cast.

LIFE-WRITING, THE BODY, AND THE MIRROR GAZE: VIRGINIA WOOLF'S "A SKETCH OF THE PAST"

> I perceive that the art of biography is still in its infancy or more properly speaking has yet to be born.
> —Virginia Woolf

Virginia Woolf's personal history, as she herself recognized, cannot be understood apart from the Victorian patterns of upper middle-class family life and registers the effects of her father's contradictory attitudes toward women. Intellectually liberal, Leslie Stephen placed no restrictions on his daughter's desire to read and write and yet had little sympathy with women's desire for a university education or an existence not centered in the domestic sphere. As for his own wife, he simultaneously idealized her, assuming her moral superiority, and never questioned that she be submissive to his own will and desires. Beautiful, a magnetic presence in her own right, and dead by the time Woolf entered adolescence, her mother remained an ungraspable phantom—an image of what she herself would never concede to be and yet a longed-for presence whose lingering hold on her was inextinguishable.

This ambivalence is the ground on which her late memoir "A Sketch of the Past" is written. Although the presence of her mother is so pervasive that it threatens to displace her own centrality, the writer's resistance to the tyranny of the Imaginary mode is forcefully articulated in form as well as content. This resistance can be seen most readily in her efforts to distinguish her own self from that of her mother; however, it also emerges in her refusal to locate autobiographical truth in the stability of

images drawn from the past and her insistence that the attempt to grasp the experience of the body in lived time is an important part of the autobiographical process. In this way she suggests possibilities for life-writing as yet to be born.

Woolf, as if drawing on the implications of Proust's technique of involuntary memory, grounds the effort to write her life in the recognition that the present instant of creating that memory is as much the crucial matter as the past event itself. For her the present is the most dramatic terrain of life-writing, the immediate plot that transforms the life at the very moment it is being written: "While I am writing this," she tells us, "the light changes; an apple becomes a vivid green. I respond— how?" (114).[48] If we see this emphasis as contesting the autobiographical premise that a life can be seized and presented directly through the representation of past events, Woolf's evocation of her earliest memories further signals a refusal of conventional notions of representation and a resistance to subjecting her life to the static quality of the visual image. This resistance under- lines her sense that the reality of a life cannot be contained in a "picture" that is incapable of conveying the body's experience in time. While others wonder to what degree autobiography is a matter of self-definition *(autos)*, the signifying text *(graphia)*, or the facts of a life *(bio)*,[49] Woolf knows that in autobiography, as elsewhere, all such questions are subsumed by the fact that life is foremost a matter of the body.[50] For this very reason, in spite of the heightened self-reflexive quality of Woolf's memoir and her self-consciousness in respect to the very questions raised by theorists of autobiography today[51] (the split between she who writes and she who lives, the elusive and illusory qual- ity of the past, the tenuous boundary between fiction and fact, imagining and remembering, and, finally, when all is said and done, the irrecuperability of the self), at moments her "Sketch" attains a force and penetration that carries us past such theoreti- cal questions to an engagement with the mystery and immediacy of a "life."

This strong sense of bodily presence in Woolf's work most forcefully calls attention to her rejection of the Imaginary regis- ter as the privileged terrain of life-writing. The Imaginary is inevitably a particularly inviting realm for the writer of autobiog- raphy as she/he spins out proliferating images of self-reflection, carving out the contours of a self that differentiate it from other selves. Woolf, of course, cannot escape the lure of the Imaginary (as I will later show), but neither will she entirely submit to its

boundaries. What I would like to suggest is that the power of Woolf's memoirs comes from her ability to engage us simultaneously on the levels of the Imaginary and Symbolic while at the same time directing us toward the Real. As a writer of autobiography, she is inevitably grounded in the Imaginary space of self-reflection, but as a woman aware of the tenuous balance of subjectivity, she points us backward toward a realm that predates the self-consciousness of the mirror gaze and forward to the crucial transition which is the entry into the Symbolic.

Woolf's stance as she begins her "Sketch" is a divided one: her rational inquiry into the complex issues involved in life-writing is combined with an impatience with the constraints of logical connection and a desire to break free of the strictures of biographical form and to speak from the deepest layers of bodily experience. She has, after all, taken up her own life in part "as a holiday from Roger" and the "horrid labor" of trying rationally and deliberately to compose a life, that is, Roger Fry's biography. In her own memoirs, she indulges in the luxury of a looser form, and although she is fully cognizant of the enormous, almost impossible, difficulties of the autobiographical venture (the great many things remembered, the disparate ways such memoirs might be written), she proceeds with a certain sense of liberation, perhaps even elation, as she begins without a clear sense of conscious choice or direction: "without stopping to choose my way—it will find itself or if not it will not matter—I begin: the first memory" (64). Especially in the initial pages, there is a sense of freedom from restriction: the pleasure to wander, to court contradiction, to expand at will, to digress and to delight in the act of dispersing and diffracting the self. There is a relaxed acceptance of, and lack of fuss about, the impossibility of circumscribing either self or past event as though this awareness has long been grounded in bodily experience.

Let me say immediately that I am not approaching Woolf from the question of *écriture féminine* and positing a privileged site of woman's writing that would yield access to a pre-Symbolic discourse.[52] Neither do I believe we can reduce the question of the body to that of gender. As Gilmore reminds us, "the female body is not so much a permanent location of feminist representation and action as a concept that in both its literality and figurality is caught up within historical and discursive formations."[53] However, while I recognize that it is impossible to speak about the body innocently—as if cultural assumptions and pre-

scriptions are not already inscribed within its meaning—I would still argue that we do have a sense of our bodies that survives such invasions and appropriations, and it is here that Woolf's writing begins.

Woolf again and again suggests that life begins with the sensations that connect the body to the world, and although she never reduces it to this dimension or offers this earliest state of consciousness as a paradisiacal realm to be recaptured (in language or otherwise), neither does she ever lose sight of the fact that our "human being" in all its power and vulnerability is grounded in this experience. Since bodily sensation denies the space that differentiates subject and object and insists on the degree to which we are rooted in a world of temporal flux, it is no wonder that Woolf often voices her sense of the inadequacy of the visual image, static and contained as it is, and so points to the limits of the Imaginary stage well before Lacan.

"Sounds indistinguishable from sights"

Most striking in Woolf's earliest memories is the attention to sound and the resistance to the sharp contours of visual experience. Sounds fill the air; images carve out space.[54] "Hearing provides the experience of temporal duration, a salient example being a melody, which intertwines past, present and future in a meaningful whole."[55] Sight offers us the promise of stasis and simultaneity, an escape from time and change. The emphasis on sound in Woolf reflects her intense awareness of shifting patterns of sensation and movement that cannot be reduced to fixed images. Therefore she offers us a space where the sharp delineation of the fixed image does not yet exist and where the fullness of sensation ensures the body of its connection to the world. Her most important memory, Woolf tells us, is of lying between sleep and wakefulness in the nursery at St. Ives:

> It is of hearing the waves breaking, one, two, one two, and sending a splash of water over the beach; and then breaking one, two, one two, behind a yellow blind, It is of hearing the blind draw its little acorn across the floor as the wind blew the blind out. It is of lying and hearing this splash and seeing this light, and feeling, it is almost impossible that I should be here; of feeling the purest ecstasy I can conceive. (65)

The careful modulation of sound in this passage, its repetitions and contrasts, and the rhythmic phrasing echoing the movement of the waves and leading to the crescendo of the last sen-

tence, all create a sensuous medium that moves the reader close to the rapture that Woolf describes. In the imagined memory, the sounds of the waves and the blind wrap the child in a space that light enters but does not define, an experience that Woolf later describes as "lying in a grape and seeing through a film of semi-transparent yellow" (65).[56] The blurred contours and imprecise boundaries accentuate Woolf's attempt to render a state between conscious and unconscious life ("lying half asleep, half awake") where distinctions between self and other dissolve in the fullness of sensation. The memory points to the earliest stages of consciousness, evoking intimations of a pre-Imaginary realm in which the visual mode has not yet become the dominant means of experience and where the raw outline of space does not yet intrude between subject and object.

A page later Woolf again tries to seize the immediacy of these first impressions and again insists that sight alone, even if one were to attempt to render the scene through the medium of paint, would not suffice:

> Everything would be large and dim; and what was seen would at the same time be heard; sounds would come through this petal or leaf— sounds indistinguishable from sights. Sound and sight seem to make equal parts of these first impressions. When I think of the early morning in bed I also hear the caw of rocks falling from a great height. The sound seems to fall through an elastic, gummy air; which holds it up; which prevents it from being sharp and distinct. (66)

Everything is "large and dim" and "semi-transparent" because images are synaesthetically connected to sounds that fill and hover in the air. On the next page, describing another highly sensual memory of flowers, apples, and bees compressed within "some membrane," she again remarks on the inadequacy of the word "picture" to convey the experience: "but sight was always then so much mixed with sound that picture is not the right word" (67). The reason I emphasize this attention to sound and its capacity to create a plenitude of sensation is because Woolf is so often associated with the visual and painting, and I think it is important to see that there is simultaneously, and primordially, a resistance to the experience of space that the visual demands. For only then do we understand how costly, yet how necessary, is the acceptance of that space between subject and object for her. The distinction between the visual and auditory modes that I draw here leads us very concretely to Lacan's theo-

ries of the pre-Imaginary, Imaginary and the Symbolic, and be-
cause Woolf is a woman, it is especially interesting to see the
way she herself articulates the passage between these stages.
Woolf's ambivalence toward the visual marks, I believe, her
awareness that the coherent images of the Mirror Stage always
misrepresent the experience of the body at the same time that
they are a crucial necessity in the formation of individual iden-
tity. Finally, they point the way to the Symbolic Order that alone
can offer a defense against the body's vulnerability without
freezing the subject in alienating images of his or her own
making.[57]

"the invisible and silent part of my life as a child"

Woolf's attempts to render the earliest sensory impressions
evoke the ecstasy of a pre-Imaginary state where mother and
infant are not yet differentiated—where, as Woolf puts it, "I am
hardly aware of myself, but only of the sensation. I am only the
container of the feeling of ecstasy, of the feeling of rapture" (67).
However, if this perspective momentarily suggests a utopian vi-
sion, Woolf quickly disabuses us of that view. These first "mo-
ments of being" must be connected to those later exceptional
instants or "violent shocks," for what is stressed in each case is
the passivity and powerlessness of the self that yields to over-
whelming sensation. Whether an intensely pleasurable moment
(the experience in the garden) or a horrifying one (hearing that
a man had killed himself), such experiences always begin in an
act of surrender that is potentially terrifying: "I only know that
many of these exceptional moments brought with them a pecu-
liar horror and a physical collapse; they seemed dominant; my-
self passive" (72). To vibrate in response to sense impressions
promises great intensity and pleasure, but the intensity can also
be devastating. The only way out is through an act of differentia-
tion in which the subject takes its distance from the event—
allows space to intervene so that the clarity of vision can take
place—and accepts the contours of its own being as distinct from
the other.[58] No longer a passive victim to the throes of sensation,
the subject enacts its own separation and selfhood. As Woolf
puts it: "In the case of the flower I found a reason; and was
thus able to deal with the sensation. I was not powerless. I was
conscious—if only at a distance—that I should in time explain
it" (72). In this way the experience, the "blow," becomes espe-
cially valuable; the basis of revelation, it provides the means by
which Woolf finds the power to assert her identity. As she tells

us, "the shock-receiving capacity is what makes me a writer" (72).

The order of response described here suggests the subject's entry into the Symbolic Order and recounts the same progression that Freud's grandson makes when he adjusts to his mother's vanishings through his symbolic game and utterances.[59] Woolf's response allows her a similar mastery over a threatening situation in which she first confronts her own passivity and powerlessness. And like the child she asserts her control through language: "I make it real by putting it into words." The event achieves a sense of "wholeness," and its pain dissolves into "the strangest pleasure known, the same "rapture" that is found in writing when disparate elements are brought together (72).

As Woolf struggles to articulate the significance of this central intuition—"that there is a pattern hid behind the cotton wool"—she suggests her awareness of the importance of the Symbolic Order in her own life. She tells us that this conception is the key to her own identity; in fact it provides the needed "scaffolding" to understand, in her case, the most elusive question in the life of a writer and one that is seldom discussed in biographies: Why does one spend an "entire life writing stories" (73)?

Woolf's "Sketch," as her novels, recounts the lure of the pre-Imaginary, the world associated with the earliest connection to the mother; the inadequacy of the unified and alienating forms of the Imaginary; and the necessary, though costly, passage to the Symbolic Order, which alone grants the subject the possibility of asserting his/her mark on the world. Otherwise there is only the vulnerability of the body, the instability of sensation, and the insecurity of those images that the self creates for refuge.[60] At any moment the mirror might be broken, and the body's image shattered by the flux and upheaval wrought by time. Nowhere, it seems to me, do we experience the brutal effects of the human subjection to time and sensation more intensely than in the following passage, which delivers us without warning (reminiscent of the parenthetical allusion to Mrs. Ramsay's death in *To the Lighthouse*) to the most critical moment in Woolf's life. As she summarizes the way she has shaped "that space of time," the first thirteen years of her life, into a "rough visual description," Woolf once again underlines the inadequacy of the static quality of the visual image:

> But somehow into that picture must be brought too, the sense of movement and change.... One must get the feeling of everything

approaching and then disappearing, getting large, getting small,
passing at different rates of speed past the little creature; one must
get the feeling that made her press on, the little creature driven on
as she was by growth of her legs and arms, . . . driven as a plant is
driven up out of the earth, up until the stalk grows, the leaf grows,
buds swell. That is what is indescribable, that is what makes all
images too static, for no sooner has one said this was so, than it was
past and altered. How immense must be the force of life which turns
a baby, who can just distinguish a great blot of blue and purple on
a black background, into the child who thirteen years later can feel
all that I felt on May 5th 1895 . . . when my mother died. (79)

With great delicacy and merciless directness, Woolf summons
images and rhythms of life quickening and expanding, only to
drop us into the abyss and chill of death.

Again I want to underline that it is just because Woolf is so
excruciatingly sensitive to the vibrations of the body and its
inability to sustain a coherent image in time that she realizes
the only viable option to the body's experience of fragmentation
and vulnerability is the Symbolic Order. Even if passage to this
realm takes place under and enacts the law of the father, it still
offers to the daughter, as well as the son, a freedom and possibil-
ity that could not be achieved otherwise.

In Woolf's memoirs, despite the intense anger expressed
against her father's brutality, there is no doubt that he still rep-
resents a position that alone offers his daughter the means of
achieving a selfhood beyond the conventional images offered by
society. Downstairs, as she tells us, was "the drawing room and
George's gossip," and upstairs, completely unconnected, was the
place of language and culture, her father's study. There she
would borrow books and discuss them with her father, and then
after "feeling soothed, stimulated, full of love for this unworldly,
very distinguished, lonely man," she would find herself again in
the utter vacuity of the social scene below. Between the two
rooms, "there was no connection" (136).

The fact that the patriarchal order has, historically and cultur-
ally, taken forms that lead to the oppression of women (over and
above the submission that the Symbolic Order requires of both
sexes) is certainly undeniable. But that fact does not mean that
this crucial passage to the Symbolic Order can, or should be,
eliminated, and the power of Woolf's writing has always seemed
to me to come from this awareness that never, however, entirely
controls her sense of herself as a woman, or as a living body.
The Symbolic is never the monolithic order that some critics

portray; the earliest bodily experience is repressed, but its truth is uttered, if unconsciously, through the very language that demands its silence.

<center>

"it was partly that my mother's death unveiled and intensified"

</center>

I would like now to examine more carefully the way the mother's death is linked to the entry into the Symbolic. What I find especially revealing in "Sketch" and what is not usually remarked upon is that, along with emphasizing the devastating effects of her mother's death, Woolf equally insists on the heightening of her own vision as though painful as the loss is, it provides the space necessary for her own perceptual powers to develop.[61] It is as if the final rupture of the consoling relation, symbolized by the immediacy of the mother's presence, gives way to an order in which the unprecedented power of language is suddenly exposed. Woolf here offers us two memories that are linked to her mother's death—the only two distinct moments "in the muffled dulness that then closed over us." The first involves a trip to Paddington station where the "magnificent blaze of colour" coming from the dome leads her to draw an analogy between this luminous sight and the new clarity of vision she experiences after her mother's death. Woolf writes: "My mother's death unveiled and intensified; made me suddenly develop perceptions, as if a burning glass had been laid over what was shaded and dormant." The second memory too involves an instant of heightened perception; this time the words of a poem suddenly become transparent and "altogether intelligible." Trying to articulate this "queer" experience, Woolf again turns to the metaphor of writing: "It matches what I have sometimes felt when I write. The pen gets on the scent" (93).

The tragedy of Julia Stephens's death gives her daughter acute insight into the drama of the Imaginary and Symbolic. There is no compensation for this loss just as there is no recovery of the primordial relation between mother and infant. The subject must accept the loss of the immediacy of presence and the substitution of the word for the thing. But only through the acceptance of this space separating subject and object does the possibility of deepened awareness emerge. Only through the assumption of the contours of its own being does the subject achieve a sense of identity, power, and the possibility of resisting the threatening and invisible forces that abound. This is the

knowledge that Woolf articulates as she once again summons up the images of death that plagued her early life. Refusing the role of victim that has been cast upon her, she insists on her own resistance or countermovement. Life had, after all, engaged her in a mighty battle, "the real thing," and she must meet this challenge with a response of equal force. Life thus takes on an unanticipated dimension; it becomes "something of extreme reality," and her own life acquires a new dignity. "Not in relation to human beings; in relation to the force which had respected me sufficiently to make me feel what was real" (118).

The assertion of selfhood, a sense of her own power and even self-importance, reflects Woolf's assumption of the Symbolic Order, the means to create herself as a heroine, and the power to make herself a writer.[62] As a woman, however, she will remain distant from the particular forms that the Symbolic Order has taken in the patriarchal culture of her time, and she will be acutely sensitive to the differences that that Order thrusts on men and women. Before I turn to that matter, however, I want to look more closely at the way the Imaginary register appears in Woolf's "Sketch," and the implications it has for our understanding of the complex and difficult relation between mother and daughter.

"there was a small looking glass in the hall"

Woolf first mentions her memory of the looking glass to illustrate its difference from those earliest memories where sensation is all, and self-consciousness has not yet been allowed to intrude. She herself, then, signals the radical change that the Mirror Stage initiates.[63] The reduction of the body's boundless sensations to a fixed form is immediately experienced as a diminishing. Self-consciousness, shame, guilt replace the earlier feeling of rapture, and the more Woolf tries to account for the reasons for these feelings, the less certain she feels that she has "got at the truth" although she has "no motive for lying about it" (69). Thus, she dispenses with the myth of autobiography as a privileged mode of representation and aligns it instead with the fictions of the Imaginary.

Her first attempt at explanation points to the resistance of the body to identification with a fixed gender identity.[64] She supposes that as a child she did not want to identify with the idea of the feminine represented by mirror-gazing, that such female vanity would be a travesty of the tomboy code to which she and

Vanessa adhered. Although here the mirror image insists that the body is less than it wants to be (unrestricted by gender), her next attempt at explanation suggests that feelings about the body are also subject to an image that exceeds what the body feels itself to be. Reflecting on the Puritan feelings of shame that she has doubtlessly inherited from her father's family, she notes that her "natural love for beauty was checked by some ancestral dread" when her own body was at stake. She realizes that her experience of her body begins from images existing long before she was born. She develops this idea further when, in describing Gerald Duckworth's violation of her body, she invokes an instinctive sense that certain parts of the body should not be touched, concluding that the identity of Virginia Stephen was indeed uncircumscribable:

> It proves that Virginia Stephen was not born on the 25th January 1882, but was born many thousands of years ago; and had from the very first to encounter instincts already acquired by thousands of ancestresses in the past. (69)

The mirror image offers the comfort of a unified experience of the self, but the identity is always in part alien, created by the image that comes from the other. Woolf's most penetrating depiction of how terrible that violation of subjectivity can be is her memory, or dream, of the horrifying animal face that appears in the looking glass where only her own reflection should be. Whether this other is a real presence or a hallucination, perhaps representing her stepbrother's sexual transgression, her own guilty response to instinctual impulses, or simply a more generalized fear of her body being subjected to and imposed upon by alien forms, is impossible to know. In any case, however, we feel how strongly she felt the body's vulnerability to the invasion of forms that captivate and dominate from without.

Later Woolf more generally describes the "invisible presences" that constitute the Imaginary Order and formulate individual identity: "This influence, by which I mean the consciousness of other groups impinging upon ourselves; public opinion; what other people say and think; all those magnets which attract us this way to be like that, or repel us the other and make us different from that" (80). These words emphasize the Imaginary's proclivity to cast the subject in the play of reflection, forming his or her identity along the dialectic of similarity and difference. What is worthy of notice here is that in the Imaginary

relation "the identity and difference of 'the other' lacks the full dimension of otherness, for what is at stake is "a relationship to objects, not to subjects."[65] As I have suggested earlier, the Imaginary is a particularly inviting realm for the writer of memoirs because autobiography is inevitably a matter of constructing images of the self, and often these rebound off other selves. Therefore, it is not surprising that Woolf, in spite of her recognition of the limits of the Imaginary, composes a self-portrait that is in large part created in view of her own similarities to and differences from the formative presences of her childhood. Of these the most dramatically significant is her mother. These memoirs, ostensibly directed toward the writing of Woolf's own life, thus become increasingly embedded in excavating the mystery of her mother's being.

That Woolf herself cannot shake free from the constraints of the Imaginary is reflected at the beginning of "Sketch" when she is enumerating the difficulties inscribed in any attempt to write memoirs. Insisting that her difficulty in portraying herself is exacerbated by the fact that she does not have a sense of "how far I differ from other people" because she had had no schoolmates and therefore no "standard of comparison," she asks: "Was I clever, stupid, good looking, ugly, passionate, cold—?" (65). These reflections call attention to themselves first because the constraining logic of the binary oppositions seems inappropriate to the subtlety of her previous reflections, and second because one would think that the inevitable place that such comparisons would be made would be within the family. Perhaps, though, Woolf's very point is that her family is so much she that she must go beyond those borders if she is to see herself clearly at all. As she says in another context: "if I were to describe myself at fifteen, I should have to describe Nessa and Thoby; both in great detail; for they were as much my life as anything" (107). In any case it is curious that a memoir that begins with a disclaimer of being able to make comparisons, devotes, at least implicitly, much space to composing a portrait of the self based on comparison. Although after the intimate opening pages Woolf spends a good deal of time describing other family members, she is, in fact, circumscribing a vision of her own self by drawing attention to the way she is similar to or differs from them. In this regard I want to look first at the portrait of her mother and then at the image of Thoby she offers.

The mother-daughter relation is fraught with difficulty, for her image is never completely absent from the daughter's own

reflection in the mirror. Although the male child breaks through the dual structure of the Imaginary when he accedes to the Symbolic Order, the girl is always haunted by the captivating image of the mother through which she must compose her identity. If the closeness that the similarity of gender offers promises the continuation of intimacy, it also signals the arduous struggle for separation that must enfold. In a case such as Woolf's, where the mother's overwhelming presence as the "angel in the house" (both victim of and collaborator in the Victorian culture that molded her) had suffused the entire space of childhood, the temptation to surrender to that image and the urge to resist provide the ground for nearly insurmountable conflict. Should that mother die just when the daughter is verging on womanhood, the problem is raised to yet a higher degree, for no matter how ambivalent the daughter's emotions, one thing is certain: her own identity is inconceivable without that maternal presence. The extremity of that position is dramatically articulated by the adolescent narrator in Jamaica Kincaid's *Annie John*:

> If my mother died, what would become of me? I couldn't imagine my life without her. Worse than that, if my mother died, I would have to die, too, and even less than I could imagine my mother dead could I imagine myself dead.[66]

No wonder, then, that in spite of Woolf's belief that she had exorcised her mother's hold on her after completing *To the Lighthouse,* she once again delves into that relation here.

From the dispersed and generalized presence that her mother was for her in her childhood, Woolf tries to discover the person herself, not the person who is known from anecdotes or photographs, but someone more substantial. Her reflections on the difficulty of this project have the curious effect of immediately setting off her own life from that of her mother's, as she asks, "what reality can remain" of someone who has left no art or literature behind, nothing other than her children and the memory they have of her, something "to bring it to ground with" (85). The reader is thus brought immediately to mark a crucial difference between Woolf and her mother and to note the traces of a competitive tension as well: she herself, although childless, will have her books to leave behind.

The inclination to see their relation in terms of comparisons and contrasts is set up earlier when Woolf comments on the way her own laugh echoes her mother's (81) and the complete

dissimilarity in the way mother and daughter's fingers are shaped. But most telling is Woolf's continual return to the one hard fact that invites her more than any other into the mystery of her mother's life: "that she married two very different men" (85). Her first marriage exercises a continual fascination on Woolf as the great romantic love of her mother's life, what Woolf describes as "the most important thing that ever happened to her" (89). Again one cannot help but think that the daughter's captivation in this image (and perhaps this is why she sees an unknown man sitting at her mother's deathbed) mirrors the lack of passion that characterized the beginning of her own marriage. She tells us: "What my mother was like when she was as happy as anyone can be, I have no notion" (89). Woolf's words directly refer to the fact that "not a sound or a scene has survived from those four years" but also remind us that she cannot herself identify with that glow of being in love. Woolf in her writing repeatedly comes back to the rapturous moment of first love: most memorably in *To the Lighthouse* and here in her description of Stella's engagement. This vision of romantic love, which she associates only with "respectable engagements" and never with "unofficial love," offers her a "standard of love" that she finds impossible to give up: "It was to me like a ruby; . . . glowing, red, clear, intense. . . . nothing in the whole world is so lyrical, so musical" (105). No matter how deeply loving and satisfying Woolf's own marriage was[67] and no matter how passionate her responses to others might have been, she had never experienced this particular ecstasy, though her mother, most emphatically, had; and her mother's image must always be a painful reminder of this lack in her own life.

However, to the image of her mother that she composes from her first marriage must be added the equally intriguing fact that she had subsequently married a man absolutely different from the first; this difference restores to Woolf a mother with whom she can identify. The very same woman who would "love the simplest, the genial, the normal ordinary type of man, in preference to the queer, the uncouth, the artistic, the intellectual" (90) would in her second marriage choose the latter type. This difference allows Woolf to create another image of her mother, of a more complex, skeptical, and serious woman and one capable of unforeseen depths. Furthermore, the mother's second marriage would reflect the choice of a man not totally unlike Woolf's own husband. These comparisons are, of course, not

spelled out, but they are there implicitly, a continual reminder of a mirror that will not be broken.

The specular relation exercises a narcissistic hold on the daughter; the face of the mother at once promises to validate her own identity and threatens it with extinction. If the mirror of the mother's face becomes hardened, like steel, refusing to reflect her daughter's needs and desires, the daughter's own identity falters. Such is the image of the mother's face that Woolf gives us at the moment of her death:

> Her face looked immeasurably distant, hollow and stern. When I kissed her, it was like kissing cold iron. Whenever I touch cold iron the feeling comes back to me—the feeling of my mother's face, iron and cold, and granulated. (92)

The mirror becomes hard metal, absolutely opaque at death, but even in life her mother's face would take on this severity and sternness, especially in relation to the oldest daughter, Stella. And when her husband protested this hardness, Woolf tells us, his wife would reply "that she was hard on Stella because she felt Stella 'part of myself'" (96). The dangers of the Imaginary are almost inescapable as, either too distant or too close, mother and daughter engage in the sometimes deadly play of reflection. For Woolf, Stella is a constant reminder of the sacrificial and life-denying position of the daughter: "They were sun and moon to each other; my mother the positive and definite; Stella the reflecting and satellite" (96). Affectionate, devoted, passive, and unquestioningly dependent, Stella is what Woolf herself will never be. That is why, perhaps, when Julia Stephens dies, despite the incurable pain that this daughter feels, she also intuits that a change in this specular relation can bring about a yet unrevealed intensity of light. Through metaphor the image of the mirror absorbs the burning light of the dome at Paddington station:[68] "Also it was partly that my mother's death unveiled and intensified; made me suddenly develop perceptions, as if a *burning glass* had been laid over what was shaded and dormant" (93). The transfiguring light points to the possibilities beyond the self-reflecting relation of mother and daughter and the need to go beyond the self-enclosed space of the Imaginary.

"the glory and burden of being a man"

Beyond the Imaginary is the Symbolic Order that makes itself manifest in our culture through the norms of patriarchy. Al-

though I have accentuated Woolf's recognition of the necessity
of passage to this realm, I would now like to suggest the ironic
distance that keeps her on its margins. Although we know the
resentment she feels at not having been allowed, like her broth-
ers, entry into the best schools of England, in her final "Sketch"
the emphasis is elsewhere: here she hints at the disabling effects
that such an education, any education that perpetuates the pa-
triarchal machinery for that matter, brings. Moreover, in creat-
ing an image of her brother Thoby, she once again, through
implicit contrast, composes an image of herself that vies, not
unsuccessfully, with any figure of that regime.

In "Sketch," then, Woolf goes beyond the idealization of her
brother that characterizes some of her other portraits of him.
The prematurity of his death, as Woolf herself points out, indel-
ibly marks any attempt to capture the young man on the verge
of manhood: "I never saw him, as I now see him, with all his
promise ended" (120). Nevertheless, here the romanticized im-
age of the gifted young man cut off in his prime already begins
to show his subjection to the traditions of patriarchy. Composed,
having a certain magnetism and a remarkable sensibility, Thoby
is also in ways unapproachable. He is "amazingly reserved. Not
a word of feeling was allowed to escape him" (109). He refuses
to speak either the names of the dead or of the troubling relation
of Vanessa and Stella's widower Jack. "His general attitude was
aloof, judicial, conventional" (123). In spite of his marked sensi-
bility, there is something disappointingly conventional in the
image Woolf draws of him. During those gloomy years, he, unlike
his sisters, unquestioningly accepts that they must go to parties
with George and walk with their father when he wishes. Had he
lived, Woolf implies, although not becoming the "typical En-
glishman" (120), he would have been formed in the mold of the
public male tradition, which she describes in another context
as a machine that produces sixty-year-old professional men who
"are as far from "natural human beings" as "a plough horse gal-
loping wild and unshod in the street" (132).

Although Woolf emphasizes the closeness of brother and sister
in their youth and the natural curiosity and attraction they felt
for each other (118), she also marks their differences. Thoby
brought his education home to his sister, introducing her to
the Greeks and then later discussing the books they both were
reading. How dissimilar the adolescent boy and girl appear in
these pages. Sheltered though her own life and education had
been, Woolf emerges as the more open and searching reader.

"Bubbling, inquisitive, restless," she refuses to simply accept her brother's all-knowing assertions and offers her own questions and interpretations. In contrast, Thoby's response to literature is described as aggressive and colonizing: "He had consumed Shakespeare, somehow or other, by himself. He had possessed himself of it, in his large clumsy way" (119). So they argued, Woolf refusing to yield her "genuine feeling" (119) but also recognizing that Shakespeare passed down to her brother a world in which he could easily situate himself and "relish his inheritance" in a way that she could not. She imagines Thoby on the Underground with "a look of one equipped, unperturbed, knowing his place, relishing his inheritance and his part in life, . . . already, in anticipation, a law maker; proud of being a man and playing his part among Shakespeare's men (119–20).

To be excluded from this patriarchal inheritance, however, is not all bad, for "the glory of being a man" carries its burden too (117). Recovering the memory of Thoby successfully bringing in the sailboat under her father's watchful gaze, Woolf comments: "He was feeling, rather earlier than most boys, the responsibility laid on him by father's pride in him" (117). The father's patrimony carries the law of an identity that is often as disabling as it is one-sided; in the case of Leslie Stephen, that law produces a severe and crippling image of masculinity. Woolf's penetrating insight into the causes and effects of the division and silencing that characterize her father's identity leaves no question as to the ambivalent, if not dubious, worth of the son's inheritance. Trying to understand the "barbarous violence" (125) of her father's tantrums, she underlines the disparity between the sharpness of his analytical powers and the crudeness of his response to life. Woolf blames this on the "crippling effect" of both his education at Cambridge and his intense professional work. Without outside interests he had become "almost completely isolated, imprisoned. Whole tracts of his sensibility had atrophied" (126). He is thus left at sixty-five without any insight into his own feelings or those of others.

The effects of such cultivated egotism and insensitivity are as deadly for the Victorian father as for the daughter; in fact, in spite of their victimization, some daughters, at least, are in a better position to escape, for they are not totally blind to the law that binds them.[69] With splendid lucidity Woolf analyzes why the shameless rage of such repressed men always has woman as its object and never emerges in front of male company. It is not simply because of the assumption of the obvious inferiority

of the female, for that does not "explain the self-dramatization, the attitudinizing, the histrionic element, the breast beating, the groaning" (125) displayed during her father's scenes. Such behavior is rather a reflection of his own sense of failure in his life's work that forever gnaws at him and continually calls out for consolation and that, above all, must never be admitted in front of men. What a pitiful image of the towers of patriarchy, and if that image yields in the next generation to less remote figures, the image is no less appalling. In the likes of Woolf's stepbrother George who is less towering and more feeling a creature, we find men whose "abundance of emotion" (130) without intelligence leads to absolute conventionality on the social level and unhesitating perversity on the personal. The patriarchal machinery of Victorian England churns along unchallenged, and Woolf and her sister are fair game:

> And so, while father preserved the framework of 1860, George filled in the framework with all kinds of minutely teethed saws; and the machine into which we were inserted in 1900 therefore held us tight; and brought innumerable teeth into play. (131)

Observers and victims of the laws of Victorian society, Virginia and Vanessa would, with the death of their father, venture into the unconventional world of their brothers' artistic and intellectual circle. Liberating and exhilarating as this change was, however, Woolf, in writing her memoir of "Old Bloomsbury," will again suggest that the male image leaves something to be desired: "They still excited me much more than any men I met with in the outer world of dinners and dances—and yet I was, dared I say it or think it even?—intolerably bored." Woolf finds that these men can only offer her friendships that are curiously "deadening" and that leave her feeling hopelessly inadequate. The reason, as she herself realizes, is "that there was no physical attraction between us." The company of homosexual men, Woolf tells us, ultimately had something barren about it: "Something is always suppressed, held down" (172).[70] No matter how intelligent and honest the conversation, there is no space for the spontaneous and the expansive. Patriarchy constructs men in its own image, and rebellious or not they remain in its grip. To remain on the margins of this order, Woolf implies, is not entirely undesirable, and perhaps, as Germaine Brée suggests, yields a privileged position for discovery and effecting change:

Women, because until now they have had little occasion, therefore little inclination, to "construct meaning" on a grand scale, are in a better position to see beyond the constraints of our conceptual representations, beyond our dichotomies and abstractions (not the least of which is the male-female dichotomy) and to look to the "multiplicity of the real."[71]

"Shall I ever finish these notes—let alone make a book from them . . ."

It is just the "multiplicity of the real" that Woolf offers us in "Sketch." Registering the effects of the images, social and sexual, that we impose upon ourselves, she remains aware of their artificiality and inadequacy, thus continually calling into question the autobiographical venture that she has embarked on. Always acute to the sensations that connect the body to the world, she insists that writing about the past can never be understood apart from the present moment in which it unfolds: "While I am writing this, the light changes; an apple becomes a vivid green. I respond—how?" (114) However tenuous that present is, however unarticulated its vibrations remain, recognition of its power must be acknowledged: thus Woolf imagines herself "afloat (in an element) which is all the time responding to things we have no words for—exposed to some invisible ray" (114–15). To this ray must be added those other "invisible presences" that tug the subject of any memoir "this way and that"—the images that are offered by family and society along with the larger political and economic forces that vary according to time and class. "If we cannot analyse these pressures, we know very little of the subject of the memoir; and again how futile life-writing becomes." The enormity of the autobiographical project is daunting, "I see myself as a fish in a stream; deflected; held in place; but cannot describe the stream" (80). Nevertheless, Woolf begins. Struggling to maintain a balance between past and present, a present made urgent by a sense of her advancing age, the threat of war, and the possibility of suicide should the enemy arrive, Woolf experiences the past as a means of giving added dimension and depth to the present: "I write this partly to recover my sense of the present by getting the past to shadow this broken surface" (98). However, the past threatens to encroach completely on the present, promising a reality "more real" because it seems capable of an existence independent of the self to whom it belongs (67). The trepidation with which she at one point speaks of her de-

scent into that "cold stream" suggests the danger that the return to the past implies. In the end the force with which the captivating images of the dead beckon to her, much as she tries to compose an image of herself that resists them, suggests the precarious nature of the Symbolic that she inscribes in her own life.

IS THERE LIFE BEYOND THE LOOKING GLASS?
VIVIAN GORNICK'S *FIERCE ATTACHMENTS*

Woolf's struggle to resist the Imaginary records the potential difficulty for the girl torn between the need to assert her own subjectivity and the captivating force exercised by the mother's image, especially when her presence is irreparably denied through death. Object of loss and desire, her absence continually threatens the daughter with the temptation of her own dissolution, the only means to recover that primal state of unity she craves. However much Woolf attempts to reach her mother's subjectivity, she cannot escape the confines of the mirror gaze in which the mother is relegated to the position of the self-reflected image, object of overwhelming nostalgia and nearly irresolvable conflict.

Is there any way, then, for the daughter to identify with her mother as subject rather than as the object of longing or resentment? How does she find the woman beyond the maternal role, beyond the gaze of her own reflection? Is it even permissible for the daughter to conceive of her mother in sexual terms? How does the question of sexuality make itself felt between mother and daughter? As jealousy? As fear of the vulnerability and danger that sexuality holds for women in a patriarchal society? These questions are addressed in Vivian Gornick's *Fierce Attachments,* which brings us to new territory, both geographically and socially, and marks unchartered possibilities in autobiographical form.

Leaving the upper-class, intellectual world of Woolf's British childhood, where the deepest feelings remain unspoken, for the richly ethnic and immigrant working-class territory of Gornick's memoir, a largely Jewish section of the Bronx in the 1930s, is to enter a more explosively verbal setting though the grammar is faulty and the intonation imperfect. In contrast to the monumental position assumed by Woolf's father, Gornick's father is

hardly present, and here it is well to remember the weakened position of the father in many immigrant families because of economic and linguistic difficulties and the lack of respect granted him by the dominant culture. Consequently, the mother's presence becomes all the more important. Such is the case within Gornick's family where the fierce attachment of mother and daughter attains intense volubility as it is allowed to develop over time rather than being frozen prematurely at the moment of death, as with Woolf. Nonetheless, this daughter's struggle to differentiate herself from her mother's image is no less harrowing and the stakes equally high. As the daughter wryly remarks during one of their more fierce entanglements: "One of us is going to die of this attachment" (110).[72] That the site of this intense battle is the shattered glass of the locked bathroom door gives added resonance to the scene.

Gornick's memoir emerges with great immediacy, partially because of the techniques that she borrows from fiction. Rejecting chronology and sequential development, mixing past and present freely, she concentrates on the careful rendering of dramatic scene and dialogue. The attention to voice, the abruptness with which the reader is thrust into a starkly depicted scene, with little regard for context, and the lack of logical transitions between passages all align this autobiographical text with the experimental narratives of contemporary fiction rather than the familiar conventions of life-writing.

The memoir begins without introduction or ceremony in the eighth year of the writer's life as she witnesses a conversation between her mother and a neighbor in which sex is posited as the woman's only, though distasteful, alternative to the masculine world of work: "'Drucker, you're a whore,' my mother says. Mrs. Drucker shrugs her shoulder. 'I can't ride the subway,' she says." The narrator wryly explains: "In the Bronx 'ride the subway' was a euphemism for going to work" (3).

Thus begins the young girl's confrontation with the fact of sex and the division between the man and woman's world, the daughter's initiation into the circumscribed realm of her mother and the intense division that plagues her. For although the mother accepts with skill and conviction her unquestioned authority in the domain allotted to her, the kitchen, and even "became affectionate to her own animation" there, she also feels like a "collaborator" in her own victimization. "How could she not be devoted to a life of such intense division?" her daughter

asks. "And how could I not be devoted to her devotion?" (16).
The troubling identification begins, and the struggle to free her-
self from her mother's constraining image weaves through the
daughter's adult life without interruption.

The daughter at first delights in the woman-centered world
where her mother attains distinction because of her unaccented
English, and she experiences the first signs of intelligence as
gossip is converted into knowledge, but she equally becomes
aware of her mother's scorn of this limited space and her hunger
for the larger world of work, ideas, and political activity. At times
warm and generous, but also sarcastic, judgmental, and given to
hysterics, the mother imprints on her young daughter an image
of regret, frustration, and, most of all, denial. Haunted by the
knowledge that she had not lived her life, the mother nonethe-
less refuses to entertain the possibility that things could have
been different. Even more disturbing for the daughter is the
recognition that her mother's insistence on the transfiguring
power of "Papa's love" exists alongside a curious denial of sexual-
ity, a realization thrust on her by the fact that her parents slept
in the "open territory" (22) of the living room rather than one
of the smaller bedrooms. Although the father does not assume
a large role in the memoir, except in the dramatic effects of his
sudden death, his symbolic presence is distilled in the magic
formula of "Papa's love" and becomes the raison d'être of the
mother's life—its rationalization as well as its justification.
"Countless sentences having to do with all in her life she found
less than satisfactory began: 'Believe me, if I didn't love your
father'" (23). However, the relation of the transcendent quality
of this love to the image of "their bed [riding] around chastely
about in open space" (30) is a source of continuing vexation to
the narrator, especially as she increasingly realizes that "every-
thing from work in the kitchen to sex in the bedroom was trans-
formed by Papa's love, and I think I knew early that sex did have
to be transformed" (23). This denial of sexuality will neverthe-
less make itself felt later in the mother's jealousy of her daugh-
ter's blossoming womanhood and the battering questions and
charges with which she assaults her daughter when she begins
to go out with men.

As with Woolf, the issue of sexuality enters into the question of
mother-daughter identification and gains significance with the
appearance of Nettie, the other woman, who threatens to desta-
bilize the mother-daughter relation radically. Not Jewish, ada-
mantly undomestic (with "no gift for mothering"), beautiful,

provocative, and suffusing an undeniable aura of sexuality, Nettie moves into the tenement, and the nine-year-old Gornick immediately responds to her allure and is awakened to the first stirrings of desire: "She radiated a kind of promise I couldn't stay away from, I wanted . . . I wanted . . . I didn't know *what* I wanted" (37). Nettie symbolizes the dangerously potent force of sexuality that Gornick comes to see as the indelible mark of her difference from her mother as well as the sign that this daughter will eventually betray her: "With all her extraordinary focus on romantic love, . . . she nonetheless knew that something was loosed in me that had never been loosed in her; that she and I were not allies here in a common cause" (110). Torn between the images of Nettie and her mother, who both, in opposite ways, adamantly insist on the defining role of masculine desire in a woman's life, Gornick will be indelibly marked by the disjunction they represent. To choose the figure of Nettie is to betray Mama and to relinquish Nettie is to give up sex (120). The choice becomes increasingly excruciating and irresolvable as the narrator realizes the dark and destructive side of Nettie's power:

Sexual malice ran so deep in her it was an essence: primitive, calculating, stubborn; enraged at the center, made reckless by some burning imperative that pushed against a shifting outer limit, wholly determined by how bad she felt about herself and her life on any given day of the week. She knew of no other way to make herself feel better than to make people want her. She knew that when she swayed her hips, raised her eyelids slowly, brushed her hand languorously through her red hair, promise stirred in the groin. She *knew* this. It was all she knew. (99)

Nonetheless, Gornick cannot rid herself of this beckoning and seductive image, even after Nettie's death; years later unhappily married and reflecting on her less-than-fulfilling sexual relations with her husband, she realizes that between herself and him, "Nettie hovered in the air. Her image was quick to the touch, warm and alive. I was right up against it, no obstructions, no interference. The thing was, I could imagine her. She was real to me, he was not" (154).

The force of these two pivotal figures on Gornick's identity cannot be overestimated although the mother is the more crucial figure. Even after Nettie drives the first substantial wedge between mother and daughter, Gornick's struggle for self-differentiation will not be easy, and as she knows only too well, the odds are stacked against her: "However much I sought to

differentiate myself, I seemed always to end up like mama, lying on the couch staring into space" (188). Consciously rejected, the mother's image nevertheless continues to meet the daughter's gaze. At its most extreme, it can totally vitiate her own identity as when during her adolescence Gornick's father suddenly dies, and her mother's self-indulgent mourning threatens absolute suffocation: "My skin crawled with her. She was everywhere, all over me, inside and out. Her influence clung, membrane-like, to my nostrils, my eyelids, my open mouth. I drew her into me with every breath I took" (79).

Equally terrifying to her own identity, however, is the threat of abandonment, and so the teenage Gornick becomes obsessed with keeping her mother in sight. Many years later Gornick again confronts the power of her mother's felt absence to annihilate her own being as the older woman refuses to respond to her daughter's need or even listen to her words: "She doesn't even know I'm there. Were I to tell her that it's death to me, her not knowing I'm there, she would stare at me out of her eyes crowding up with puzzled desolation" (104).

Like Woolf, then, Gornick forcefully registers the impact of the Imaginary sphere on the daughter's development. Conscious rejection serves no purpose, as Gornick underlines, for it is just the reverse side of identification and equally imprisoning: "each of us identified a collection of undesirable character traits in the others from which she separated herself, as though dissociation equaled deliverance" (114). Deliverance from the Imaginary is not to be easy, but Gornick's memoir, like Woolf's, reflects on the formal, as well as the thematic level, the daughter's valiant efforts to break out of that static frame. Thematically the possibility of liberation is couched in the figure of a small rectangular space that Gornick suddenly experiences within herself at moments of heightened perception (similar to the ones Woolf experiences directly after her mother's death): "That rectangle of light and air inside, where thought clarifies and language grows and response is made intelligent" (102). For Gornick, like Woolf, these instants of concentration and self-affirmation suggest a vision beyond the narcissism of the mirror gaze and are associated with writing: "My insides cleared out into a rectangle, all clean air and uncluttered space, that began in my forehead and ended in my groin. In the middle of the rectangle only my image, waiting patiently to clarify itself. I experienced a joy then I knew nothing else would ever equal. . . . Inside that joy I was safe and erotic, excited and at peace, beyond threat or influence" (152).

On the level of form, Gornick also reveals her efforts to escape the confines of the Imaginary register. She subtly works into this memoir, seemingly trapped in a mother-daughter fixation, a countermovement that palliates our sense of that overarching past. In a strategic choice that brilliantly suggests the openness of all stories—not the least being that of her own life—she punctuates her evocation of past events with present scenes in which she and her mother walk and talk, and the dynamics of physical movement and verbal exchange resist the sense of closure and constraint.[73] The continual interruption of the daughter's attempt to grasp and solidify the past is almost exhilarating as the sudden jolt into motion and the immediacy of the mother's voice and presence make us face the static quality of any image of the past in relation to life lived in time. Gornick gives to autobiography an unsuspected dimension by not only insisting that the past cannot be understood apart from the present, but by inscribing in her text moments lived in time that transfigure that past at the very instant we are reading about it.

In addition, this strategy allows Gornick to break out of the compulsive and repetitive patterns of this claustrophobic relation because it frees both mother and daughter from those fixed images elsewhere imposed upon them. In Gornick's depiction of the fierce attachment between mother and daughter fueled by years of intimacy, love, hostility, and explosive anger, the focus is largely on the mother as object of resentment, bitterness, and source of Gornick's own ineffectuality and failure in relationships. In those passages where the mother is allowed to speak in her own voice in the present, however, her subjectivity is restored. As they walk along the streets of Manhattan, the two women once again return to the events and stories of the past. Old stories are re-created, their meaning transformed, for the mother repeats, but the daughter now poses the troubling questions that she had not dared before. At first the mother recoils and resists, but then often becomes quiet and uncharacteristically thoughtful as though a new and unsuspected reality had just cut through her long-established and codified vision of the world. At these moments the daughter's anger and resentment are not conclusively resolved, yet we feel her pleasure in the fact that her mother is able to surprise her and jar that long constructed image that she has forged. Capable of "enormous changes at the last minute,"[74] the mother becomes a source of pleasure rather than bitterness, and the daughter's own growing recognition of the affinities the two women share is no longer

entirely a source of irritation. In spite of knowing that "it is precisely because we *are* mother and daughter that our responses are mirror images" (46), she gradually is able to reach a certain distance and detachment. With "this little bit of space [that] provides [her] with the intermittent but useful excitement that comes of believing I begin and end with myself" (200), their relationship achieves new promise and poignancy:

> She neither confirms nor denies my words, only looks directly into my face. "Remember," she says. "You are my daughter. Strong. You must be strong."
> "Oh Ma!" I cry, and my frightened greedy freedom-loving life wells up in me and spills down my soft-skinned face, the one she has given me. (48)

The "violent derealization of the other," characteristic of the Imaginary and resulting from the effort to achieve a strong sense of identity at the expense of "reducing the other to an image of the self," here gives way to a relation based on the recognition of "the ineradicable otherness of the nonself." This is finally the only means to viable relations with others, for "only when the other is truly separate from the self can the self benefit from its recognition."[75]

Gornick's liberation from the narcissistic bondage of the mirror phase is further demonstrated in her re-creation of her mother's voice. Here one again feels a certain pleasure and love as the writer gives voice to the Yiddish accent and intonation, sarcasm and wit that she herself will echo through the memoir. In lines such as, "an idea of marital happiness suffused the atmosphere my mother and I shared that made simple reality a circumstance not worthy of respect" (22), we understand the degree to which she has inherited her mother's native Yiddish: "the language of irony and defiance" (203). Thus, Gornick suggests the extent to which her mother is not only the deadly reflection in the looking glass but simultaneously exists as that voice that is origin and source of her own writings, that voice that creates and re-creates itself in time, boundless and without image.

AUTOBIOGRAPHY: INNOCENT POSE OR NATURALISTIC LIE? JAMAICA KINCAID'S *ANNIE JOHN*

With Jamaica Kincaid's *Annie John*, we are situated in a very different cultural and political context—the colonial world of a

Caribbean island where British education and manners compete with native tradition and ritual. Here we also enter the hybrid genre of autobiographical fiction and must face more directly the question of the relation between fiction and fact in life-writing. The distinction between the autobiography and novel form, at one time sacredly upheld, has been increasingly undermined. With Robbe-Grillet's recent confession that in spite of his radical theories of depersonalization, he has never written about anything but himself, the possibility of the novel as the embodiment of a neutral impersonality has perhaps received its final blow.[76] As far as the supposedly truthful nature of the revelations promised in autobiography, one need only reflect on the self-contradiction inherent in the assumption of innocence in relation to the autobiographical project of self-representation. A recent statement made by theater-artist Robert Wilson in a different, though not unrelated, context makes the point succinctly: "I hate naturalism. Naturalism is a lie. To act natural on the stage is always artificial."[77] Likewise, the autobiographical position inevitably carries with it the notion of posing that the unannounced revelations of fiction are more likely to escape.[78] Moreover, as the earlier remarks on the deceptive, duplicitous, and diabolical forces inscribed within the mirror's frame reveal, the unconscious is a force that must be reckoned with as soon as any project of self-scrutiny is at stake. For these reasons I would offer that Kincaid's novel *Annie John* is as revelatory as any autobiography,[79] just as Gornick's memoir in large part gains its power from its fictional techniques.

Kincaid herself emphasizes the inadequacy of factual documentation when it comes to trying to register the "truth" of a life. Underlining the temporal discontinuity that informs the autobiographical subject, she tells an interviewer: "To say exactly what happened had a limited amount of power for me.... I like the idea that when something happens it has a more powerful meaning than the moment in which it actually happened."[80] Finally, then, the matter of autobiographical truth has less to do with revelations of the objective and absolute reality of a stable and singular subject than with the efforts and negotiations of a subject in the process of inventing and creating a self to understand what this thing called a human life is. Truth, then, is not what autobiography unambiguously yields, but "a conceptual problem that may be addressed, if not exactly solved."[81] As such the autobiographical site is an authentic one, attesting to the agency of the subject who creates itself in the

process of the autobiographical venture at the same time that it registers the self as a construct formed by a multiple of cultural forces.

Within Kincaid's novel the matter of autobiographical truth is taken up in an episode that serves as *a mise en abyme* of the novel's position in relation to self-representation. When Annie is asked to write an autobiographical essay in school, she self-consciously mixes reality and fiction although fiction seems an inappropriate word to express her sense of the inadequacy of literal truth. Her essay recounts the now lost idyllic phase of her relation with her mother when the boundaries between them were hardly distinguishable:

> When we swam around in this way, I would think how much we were like the pictures of sea mammals I had seen, my mother and I, naked in the seawater, my mother sometimes singing to me a song in a French patois I did not yet understand, or sometimes not saying anything at all. I would place my ear against her neck, and it was as if I were listening to a giant shell, for all the sounds around me— the sea, the wind, the birds screeching—would seem as if they came from inside her, the way the sounds of the sea are in a seashell.[82]

She goes on to record her feelings of physical and emotional abandonment when her mother swims out to a distant rock and then her relief at her mother's return and reassurances "that she would never ever leave me" (45). Nevertheless, Annie tells us in her essay, the daughter is haunted by a recurrent dream of this scene with the difference that her mother never does return. Despite this discomforting note, Annie's narrative ends happily; she reveals the dream to her mother, whose consoling words and promises permanently cast out the nightmare. The autobiographer then comments: "I didn't exactly tell a lie about the last part. That would have happened in the old days" (45). The fact of the matter is that her mother is not terribly sympathetic and suggests the dream is due to her inappropriate eating habits. Annie's version of her life is not exactly false, however, because its words reflect a truth of an earlier period—and one that lingers as wishful reality—and reveal her reluctance to ascribe to lived time the sharp distinctions that we invent with such notions as past and present. Moreover, because the reality of her present—the time of writing—is her inability to accept this dramatic change in her relation with her mother, her giving expression to this conflict is indeed the authentic truth of her life.[83] This episode touches on other aspects of the uneasily re-

solvable nature of the autobiographical project as well. Accentu-
ating the inevitable pose—and unconscious motivation—of
the autobiographer of any piece of life-writing, the narrator
concludes by underlining the disparity between Annie's original
interpretation of her act of self-creation and her later under-
standing: "I placed the old days' version before my classmates
because, I thought, I couldn't bear to show my mother in a bad
light before people who hardly knew her. But the real truth was
that I couldn't bear to have anyone see how deep in disfavor I
was with my mother" (45).[84]

Kincaid's understanding that "truth," whether applied to fic-
tion or autobiography, is always characterized by a process of
selection that is never wholly innocent and must be approached
through indirection and stylization rather than a bondage to
literal notions of truth and realism emerges in her remarks
about the way she was first drawn to the idea of writing:

> The idea of a story—or anything—being realistic, the idea of repre-
> senting something as it is, was absurd. I could never even imagine
> doing that here. And then I read Alain Robbe-Grillet.... some of
> his short stories. I cannot describe them except that they broke
> every rule. When I read them, the top of my head came off and I
> thought, "This is really living!" And I knew that whatever I did, I
> would not be interested in realism.[85]

It is notable that along with emphasizing the importance of
Robbe-Grillet's texts on her own writing, Kincaid insists that
they left her with a sense of absolute liberation and the recogni-
tion that she would never return to her native Antigua,[86] a re-
turn that would bind her once again to the power of her mother's
spell. As in the case of Woolf and Gornick, the creative act of
writing—an affirmation of the subject's place in the Symbolic
Order—signals the most viable means of the daughter's escape
from the Imaginary and the pleasures and torments of the
mother's gaze.

In Kincaid's novel, then, the mother-daughter relation is
equally as intense as in *Fierce Attachments,* although it is
marked by certain differences. Set in the colonial world of Anti-
gua in the 1950s, this relationship is particularized by its cul-
tural and historical matrix. H. Adlai Murdoch has underlined
the degree to which the racial mixing characteristic of the West
Indies and the paradoxical familial structure, which is matriar-
chal at the same time that the culture is male-dominated, form
the essential background on which the Oedipal paradigm is

played out.[87] Although the father's position is privileged in terms of social and economic power and sexual freedom, the mother is unquestionably the authoritative presence within the family, and the fact that Annie John's mother is racially and culturally different from herself—her lighter skin and creole characteristics marking her as Dominican rather than Antiguan—accentuates the tensions of Annie's struggle for identity.

This mother-daughter relation is perhaps the most poignant of the three considered because we are given a taste of its absolute sweetness and bliss before the inevitable disappointments and betrayals begin. Then the lies, antagonisms, acts of cruelty, and humiliation become so fierce that, as Annie John recognizes in a dream, only one of them can survive. Unlike the other two writers discussed, this daughter must, and will, leave her native land although this act of independence carries a certain irony since Annie is reenacting her mother's own departure from home a generation earlier.

The daughter's obsession with her relation to her mother—at first paradisiacal and then unbearably painful as the mother insists that their mutual identification must end so that Annie can become a "young lady"—seeks to take control of Kincaid's plot as Annie undertakes the difficult quest toward self-differentiation. However, we gradually discover that the dimensions of this autobiography/novel refuse the parameters of both the conventional *bildungsroman* and the mirror gaze. Although chronologically organized, this narrative offers little continuity from one scene to another; instead we are directly immersed in stylized scenes of such dramatic intensity that at times they seem almost hallucinatory. Furthermore, whereas the reality of the novel seems fixed in the specular relation of mother and daughter, we discover a more elusive layer of reality embedded within the narrative that insists on the significance of what cannot be seen, presences that cannot be fixed or contained but that are experienced as having a power beyond the contesting wills of this tortuous relation. This sense of otherness, of invisible and uncontrollable forces, that hovers throughout is connected to the obeah rituals and can be translated as the mythic attempt to represent the life of the unconscious. One is thus left on the threshold of the real that refuses to be contained within the space of the mirror, powerful as that captivation is.

For Annie this mysterious otherness manifests itself in dreams—which she tells us, "were not unreal representations of something real; my dreams were a part of, and the same as,

my real life" (89)—in evil spells cast by women jealous of her
mother, and, most pervasively, in the shadow of death that
haunts all living forms. This reality that cannot be grasped or
reduced to a stable image invests experience with an otherness
so palpable that the boundary between the visible presence and
the threatening shadow is never firmly drawn. From the first
page of the novel, Annie is obsessed with death, and the first
chapter presents the young girl's gradual approach to this fright-
ening and tantalizing specter. Told by her mother that the dead
might show up at any time and carry the living off with them,
she is both terrified by the dead and intensely curious about
them. The child's initial innocence is beautifully conveyed
through Kincaid's rendering of the successive stages of her
awakening to the inalterable facts of death: first she discovers
that not "only people I did not know died" (3) and then that
children are not exempt from death. Death approaches even
closer when the mother of a girl with whom she is acquainted
dies and then a neighbor whom she knows very well. The prom-
ise of knowledge remains unfulfilled, however, for Annie is not
allowed to go to this woman's funeral, and so she begins secretly
to seek out such forbidden ceremonies and finally succeeds in
seeing what a dead person looks like. Nonetheless, she remains
dissatisfied, for since she had never actually known these people
alive, she cannot formulate any instructive comparisons. She
must therefore wait for a girl her own age to die for her curiosity
to be fulfilled. Trying to figure out exactly what this thing called
death is, Annie notes that the dead girl looks the same as when
she was alive except for her closed eyes and absolute stillness,
yet she knows that in spite of what some say, she does not look
as though she is sleeping. Finally, she comes up with a staggering
metaphor to mark the critical difference that death makes:

> When the View-Master worked properly, all the scenes looked as if
> they were alive, as if we could just step into the View-Master and
> sail down the Amazon River or stand at the foot of the pyramids.
> When the View-Master didn't work properly, it was as if we were
> looking at an ordinary, colorful picture. When I looked at this girl,
> it was as if the View-Master wasn't working properly. (11)

What Annie's analogy emphasizes is that the crucial dimension
of depth is lacking; the fullness of being has been reduced to
the flatness of a photographic image.

In spite of Annie's attempt to master the facts of death, its

power cannot be dispelled so easily, and its presence continues to haunt her throughout the rest of the novel. She imagines her own death and her mother's, and she compulsively reenacts with a male playmate a much talked about local scandal: a crime of passion, its judgment in court, and the final sentence—death by hanging. The game suddenly moves dangerously close to reality when one day the boy cannot undo the noose tightening around his neck, and Annie inexplicably simply stands there. The tragedy is averted by the appearance of the boy's mother, but the figure of death will not be exorcised. It threatens again when the unbearable weight of Annie's emotional conflicts issues in a long and mysterious sickness. This critical illness is simultaneously the symbolic enactment of Annie's own death and an attempt to deny the passage of time which demands that she become an independent young woman. The specter of death thus embodies a reality more pervasive and powerful than even the mother's image.

The exorcism of death will eventually come, not through the loving care of her mother, torn between modern medicine and the older cures, but through the healing power of her grandmother, deeply acquainted with the ways of death through her immersion in the obeah rituals. The sudden presence of the grandmother will allow for the necessary distance between mother and daughter and the imposition of a reality that, at least temporarily, limits the hold of the mother-daughter fixation. Annie recovers and is more than ever adamant in her desire for a definitive separation between herself and her mother, a liberation from all the psychological and cultural forces that have imposed themselves on her identity. Nevertheless, it is still not certain that geographical distance will put an absolute end to the binding spell of the Imaginary.

There is no denying the force of the specular relation between this mother and daughter, registered on the symbolic level in Annie's telling remark: "She was my mother, Annie; I was her daughter Annie" (105). The absolute and narcissistic identification which at first infuses every moment of the daughter's existence with delight and a sense of her own importance ends when she is told she can no longer choose the same dress material for herself and her mother. "'You just cannot go around the rest of your life looking like a little me'" (26), her mother tells her, and she feels the earth give way beneath her. As their relationship grows increasingly hostile, teeming with duplicity and efforts at manipulation, the latent aggressivity of the mirror phase[88]

emerges in full force in the either/or scenario of a dream that Annie has: "as I walked these words would go around in my head: 'My mother would kill me if she got the chance. I would kill my mother if I had the courage" (89). Yet even this confession reveals only part of the more complex hold the mirror gaze exercises on Annie. Hatred and fear of the mother are insufficient explanations of her feelings and in no way account for the double bind her own identity rests on:

> But to say hate—what did I mean by that? Before, if I hated someone I simply wished the person dead. But I couldn't wish my mother dead. If my mother died, what would become of me? I couldn't imagine my life without her. Worse than that, if my mother died, I would have to die, too, and even less than I could imagine my mother dead could I imagine myself dead. (88)

Thus, in spite of this daughter's growing detachment from and hostility to her mother, her transference of love to girlfriends, and her engagement in forbidden games that are simultaneously acts of rebellion against her mother's demands and refusals to accept the gender distinctions inscribed in her culture,[89] she cannot completely move beyond her captivation within her mother's gaze. When Annie sees her face reflected in a shop window, she is appalled in part by the alarming changes that adolescence has brought—her image strange, unexpectedly large, and ugly—but also because she sees herself through the eyes of her mother's disapproval and therefore identifies with Lucifer in his fallen state, "lonely and miserable" (95). Again and again we see her reduced to the either/or possibilities of the mirror phase: either her mother has deceived and betrayed her or she herself is guilty and responsible for the separation that has taken place. One moment her mother looks "tired and old and broken" (102), and the next it is she who "was tired, old and broken" (103) and her mother beautiful; again her craving to beg forgiveness and find comfort in her mother's arms competes with feelings of hostility and resentment, but her vacillation within the alternatives offered by the mirror results in paralysis, and she does not move.

What Annie feels as her mother's cruelty and betrayal is compounded by her mother's efforts to educate her in the manners of an English young lady; thus, the mother is identified with the patriarchal order that in the context of the politics of the novel is associated with the humiliation of colonial rule. Going to an

English school, pledging allegiance to an English Queen, and studying English history and literature leave Annie feeling confused and bitter. As she puts it, not without a little irony, "Of course, sometimes, what with our teachers and our books, it was hard for us to tell on which side we really now belonged—with the masters or the slaves—for it was all history, it was all in the past, and everybody behaved differently now" (76). Part of Annie's difficulty with her mother, then, stems from her feeling that she has been co-opted by British ways, as Kincaid makes explicit in an interview: "my whole upbringing was something I was not: it was English."[90] Therefore, it is not surprising that Annie's most serious act of rebellion at school, her desecration of the illustration of Christopher Columbus, is an act that brings her mother's most intense disapproval; however, there is a certain irony here because in this scene Annie is also identifying with her mother by repeating her earlier words of rebellion against the oppressive force of her father's patriarchal position. The words that Annie writes below Columbus's picture, "The Great Man Can No Longer Just Get Up and Go," are an echo of a statement made by her mother when she learns that her father has become incapacitated. Although the personal and the political come together in this episode, for Annie's mother, they obviously remain apart.

This mother, then, passes on to her daughter a questionable legacy, the knowledge that to become a woman is to inherit a certain doubleness and duplicity: "So now I, too, have hypocrisy, and breasts (small ones), and hair growing in the appropriate places, and sharp eyes, and I have made a vow never to be fooled again" (133). In terms of the Freudian scenario, Annie thus successfully, if somewhat ironically, identifies with her mother as she will again when she reenacts her mother's rebellious departure from home a generation before. The novel thus completes the oedipal initiation symbolically represented in an earlier scene when Annie comes upon her parents in bed and is mesmerized by the circling motion of her mother's hand on her father's back. Repelled by this "white and bony hand" that seems not her hand and yet "could only be her hand" (30), an image of death and sexual awareness, a symbol in Lacanian terms of her own castration (i.e., the ultimate deprivation of the power to be all to her mother), she gives voice to the radical change that this primal scene institutes: "I was sure I could never let those hands touch me again; I was sure I could never let her kiss me again. All that was finished" (32). The acute sense of

betrayal that Annie experiences here, as Murdoch points out, is compounded by her awareness of her racial difference from her mother, foregrounded in the emphasis on the whiteness of her hand, suddenly experienced as a purely negative phenomenon.[91]

Later when Annie is walking to the pier with her parents, as if to underline the daughter's acceptance of her position in the Symbolic Order, she remarks: "And so there they are together and here I am apart" (133). And yet we cannot but feel that with the ambivalent emotions that plague her at the moment of leaving, she is not entirely dispossessed of her captivation in the Imaginary, both hungering for and disdainful of that claustrophobic love that is all consuming. To become a woman she must identify with her mother, yet she does not seem to be able to do so without imprisoning herself within the confines of the Imaginary. Unlike Gornick, the daughter in Kincaid's novel cannot yet experience her mother as a subject in her own right but only as an object of her own longings and resentment.

Kincaid, then, like Woolf and Gornick, attempts to come to terms with the almost irresolvable conflict initiated in the Mirror Stage by creating a form of life-writing that challenge the confines of the specular relation at the same time that it testifies to its hold. The urgency of the predicament emerges in Annie's frightening recognition that for her entire life she might not "be able to tell when it was really my mother and when it was really her shadow standing between me and the rest of the world" (107).

The next chapter brings us yet again to an autobiographical work that immerses us in the mother-daughter relationship. Marguerite Duras's *The Lover* is the most experimental of the autobiographical works considered, thoroughly undermining traditional notions of representation as well as willfully ignoring conventional distinctions between fiction and life-writing. In fact the text—centered as it is on a photograph that was never actually taken—calls into question the status of all visual images. The photograph is thus the artifact that serves as our point of entry into this text, providing a cultural and historical context for the crisis of representation that defines our own era. As Walter Benjamin insisted, the arrival of photography transforms our relation to the art object as well as restructuring the way we perceive the world.[92] In the context of the present chapter, photography might be viewed as an extension of the image-reproducing function of the mirror, providing the mechanical means of duplicating the self and offering new opportunities for experiences of self-estrangement.

4

The Image and the Word, History and Memory in the Photographic Age: Marguerite Duras's *The Lover*

Ecrire, ce n'est pas raconter des histoires. C'est le contraire de raconter des histoires. C'est raconter tout à la fois. C'est raconter une histoire et l'absence de cette histoire.
—Marguerite Duras

We photograph things in order to drive them out of our minds.
—Franz Kafka

THE advent of photography, as Walter Benjamin underlined, produced a dramatic shift in our perception of the world as well as in our attitudes toward art. It is especially significant to contemporary concerns because it prefigures the more advanced technology of film, video, and computers that abounds in our own era, threatening to completely overwhelm human consciousness with fabricated images and relegate us to the borders of virtual reality. By providing the mechanical means that could so persuasively remove an object from its original setting, photography initiates the process whereby copies are no longer importantly distinguished from the originals, and the very proliferation of copies increasingly detaches us from any notion of the real, particularly one that is grounded in time and history. Although Benjamin was drawn to the liberating possibilities of the new technology, he also recognized the danger of destroying what he called the aura of the art object, its unique presence and authenticity, which is inseparable from its grounding in a cultural context. Thus, at the same time he celebrated the end of the traditional aesthetic view that imbued art with a "cult

value" and mystifying authority, he also recognized the risk of dispensing with the aura that made the art object a vehicle of cultural transmission.[1]

The ambivalent attitude that Benjamin registers toward photography continues to characterize contemporary consciousness. Although its effects are somewhat tame in comparison to the more aggressive assaults of film and video as far as the dissemination of visual images is concerned, the photograph continues to intrigue us for several reasons. First, historically it announces an age in which notions of reality will be thoroughly permeated, indeed created, by mechanical equipment. Second, the photograph forces us to rethink our ideas about the nature of art in the light of considering its own pretensions to artistic value. Although the stillness of the photograph invites comparisons with painting, the fact that the "eye looking into a lens" now assumes the artistic function that once belonged to the hand calls into question traditional notions of authority and authenticity.[2] It is worth remembering that this stillness is also what distinguishes the photograph from the later forms of film and video, which rely on sequential rather than fixed images, and thus involves us in a dimension of response untouched by moving pictures. Finally, because the personal camera has for so long been available to the public at large, making everyone a potential photographer, its effects have already impregnated our sense of ourselves as subjects moving between private and public places.

For these reasons the photograph becomes an irresistible object for reflection. Its powers of seduction are omnipresent in everyday life and attest to our captivation in images that return to us our own identities as well as those of others, giving us access at once to the familiar and the exotic, the known and the as yet undiscovered, the past as well as the present. The photograph is tantalizing in its invitation to be taken up as incontestable evidence of the real, no mere representation or copy, but an artifact that is a veritable emanation of the object itself. It thus offers us a somewhat magical possession of reality, both responding to and further stimulating our desire to know and understand. To what extent the photograph is able to fulfill the promises it offers, however, is another question. For every assurance and affirmation it offers, the shadow of the negative lurks beneath. The desire to find in the photo either confirmation of one's own identity or the reassuring presence of another must ultimately confront the very anxiety and lack of stability the

coherent surface seeks to deny. The wish to find in this static image the means of neutralizing time, and the experience of loss and mortality it holds, inevitably comes up against the disquieting temporal dimension at the very point where one hoped to escape it. In the end the photograph brings us to ironies and paradoxes not immediately suspected in the smooth texture of its surface. Thus, at the same time photography serves to structure our vision along lines that reflect and perpetuate certain aesthetic and ideological preconceptions, it suggests that all photographic prints are to some degree double exposures.

In its ability to capture instantaneous images and unexpected angles and juxtapositions, the camera promises to provide us with a privileged access to reality, disclosing what is invisible to the naked eye alone. As Benjamin emphasizes, "photographic reproduction, with the aid of certain processes, such as enlargement or slow motion, can capture images that escape natural vision."[3] Immediately, however, one faces the first in a number of troubling questions: To what degree is the reality presented a manifestation of the quintessence of the world or the particular perspective and creative talent of the photographer? The very enticement of photographs, as Susan Sontag tells us, comes from their capacity to "trade simultaneously on the prestige of art and the magic of the real."[4] Always on the border of the consciously created and the accidentally found, the photographic image cannot be neatly placed either in the category of the world or of art. This ambiguity is related to the divided and sometimes contradictory desires of photography: to document reality or to beautify it. To what extent does the photographer simply capture, interpret, embellish, or even betray the real? At one extreme photos offer themselves up to us as "pieces of the world," but at the other they prove as vulnerable as their paper, subject to retouching, cropping, and other technical manipulations. Thus, they easily distort and falsify the world even as they create the very borders that define our notions of the real.

Photography's power to condition our forms of perception functions on the social as well as the aesthetic level. Bourdieu reminds us not to diminish the social importance of the photograph and its role in documenting, consecrating, and perpetuating the values and norms of society, presenting these as the objective facts of human existence. As an important social rite, the photograph validates those familial and social experiences that reinforce the cohesiveness and solidity of society. The family album is the perfect example of the power of the photograph

to certify the real, a public attestation to the unquestioned value and continuity of domestic life, providing new initiates with a thorough vision of the family's history. This popular use of photography is far removed from any "introspective 'search for lost time'" and in a strange way "exorcises the past by recalling it."[5] Paradoxically, the emphasis here is more on the present than the past and the consecration of the family's present identity through the establishment of its links to an earlier time. The photos gathered together harbor no secrets or betrayals and proclaim the triumph of unity, cohesiveness, and the historical record. It is not without a certain irony that "photography becomes a rite of family life just when, in the industrializing countries of Europe and America, the very institution of the family starts undergoing radical surgery."[6] If the age of photography announces "an explosion of the private into the public" sphere,[7] the view offered, we must remember, will always be a finely selected one.

But what exactly is the new relation of the public and private domains announced by photography? If the age of photography in bringing the private realm into the area of public consumption creates a "new social value,"[8] does it simultaneously mark the borders between the two all the more emphatically? Does the emergence of photography paradoxically bring to our attention the immense difference between the real of the "spatial continuum" that the photo represents and the reality of memory images that Kracauer warns us will always "be at odds with photographic representation," because in memory a filtering process is always at work that registers the complex and selective workings of consciousness and is inseparable from the human act of bestowing significance?[9] One is reminded of Proust's assertion that we remember people more vividly and satisfyingly in thinking of them than in looking at their photos.[10]

In leading us to believe that we can grasp the world by collecting it in fragmented though often bewitching images, does photography attest to and encourage our resistance to trying to make sense of human experience? Sontag emphasizes the acquiescent, as well as the acquisitive, stance that the photograph encourages: "Photography implies that we know about the world if we accept it as the camera records it. But this is the opposite of understanding, which starts from *not* accepting the world as it looks. All possibility of understanding is rooted in the ability to say no."[11] In offering us the fullness and materiality of the visual image, the photo seduces us with the promise of unexpected

beauty and truth, but it gives us at best only "a semblance of wisdom" because these frozen images are divorced from the dimension of time, which alone can provide the context for understanding: "In contrast to the amorous relation, which is based on how something looks, understanding is based on how it functions. And functioning takes place in time, and must be explained in time. Only that which narrates can make us understand."[12] Nonetheless, the photo creates desire, inviting speculation and fantasy, its flatness suggesting invisible riches beneath the surface. But again we are led to a paradox, as Barthes points out. Because of the very certitude inscribed in its presence, the photograph ultimately resists the act of interpretation. Because it testifies so assertively and incontestably to the existence of a thing, it "cannot be penetrated" and "teaches me nothing." The only means of escaping its violent thrust of reality is to close one's eyes.[13] In opposition to words that merely deliver objects to us in a somewhat vague fashion, the photo forces the presence of the object on us so emphatically that our responses are left as immobilized as the image itself.[14] How far reaching this dogmatic quality of the visual image is, is suggested by John Fowles in relation to the offspring of the photograph, cinema, and television. "Atrophying a vital psychic function: the ability to imagine for oneself," these media have an impact that he describes as no less than "totalitarian":

> They sap and leach the native power away; insidiously impose their own conformities, their angles, their limits of vision; deny the existence of what they cannot capture. As with all frequently repeated experience, the effect is paradigmatic, affecting by analogy much beyond the immediately seen—indeed, all spheres of life where a free and independent imagination matters.[15]

From whatever angle we approach the photograph, we are led to the way in which it unquestionably appropriates the right to render the world in "objective" fashion, that is, to turn all being into objects. This is finally what is most disturbing about the photograph's claim to embody the real. The photograph is ultimately a variation of the Mirror Stage, reducing its subject to a unified and coherent identity, fixed and knowable and eminently false. Like the person in front of the mirror, the viewer feels a certain amount of reassurance, pleasure, even fascination, but the experience is ultimately one of division and fragmentation even more pronounced than the one before the

looking glass: "In front of the lens, I am at the same time: the one I think I am, the one I want others to think I am, the one the photographer thinks I am and the one he makes use of to exhibit his art."[16] The living presence that the camera so boldly promises to deliver ultimately offers us little that is either vital or authentic.

Approaching this matter from a slightly different angle, Bourdieu analyzes the sociological implications of the objectification of the self that the camera records. He directs us toward the position of frontality that the conventional photo demands and points out that this pose represents the acceptance of socially constructed norms and values rather than offering us the means to a unique and personal identity. The photograph is thus a direct testimony to an essential reality of social life: the degree to which the subject accepts his/her identity as constructed by the gaze of the other. Looking directly at the camera, the subject asserts his/her claim to the values of honor and respect so highly sanctioned by society and reveals his/her need for the camera to accord such deference and dignity. Such a portrait is thus a means of both affirming and "effecting one's own objectification" and makes visible not the individual reality of the subject but "the constant fear of the judgment of others" that defines social relations.[17] Ultimately, the dignified look of so many frontal portraits reveals only too sharply the death mask of "a subject who feels he is becoming an object."[18] The greatest irony then is that as we flee to photos for evidence that life can be made eternal, we reach instead the certain knowledge of our own mortality.

Barthes develops this paradox further. Attempting to seize the distinctive nature of the photographic image, he concludes that there is a universal inscription on every photo and that it is disturbingly double: at the same time the photo certifies that something was incontrovertibly there in the past at a particular place and time, it attests just as adamantly to the fact that this presence no longer is. Thus, whatever pleasure the photograph brings, it simultaneously casts us into a certain malaise, not only because we inevitably feel ourselves being reduced to devitalized objects but because we become simultaneously specters and spectators of our own deaths. In studying a childhood photograph of his mother after her death, Barthes is startled into this recognition. Suddenly the conventional boundaries of time uncannily dissolve, and he finds himself thinking, "she is going to die." It does not finally matter whether the subject is living or dead, he tells us, this impending tragedy, "this catastrophe"

is the alarming revelation of every photo: "the imperious sign of my future death."[19] The photograph, that invitation to images that would give us access to the eternal as well as the real, inexorably returns us to the face of death. Like all human symbols, it proves to be the embodiment of the repressed as well as the witness of its repression. As early as 1927, Kracauer, reacting to the proliferation of photographs in popular magazines, acutely captures the way this new compulsion witnesses the return of the repressed:

> What the photographs by their sheer accumulation attempt to banish is the recollection of death, which is part and parcel of every memory-image. In the illustrated magazines the world has become a photographic present, and the photographed present has been entirely eternalized. Seemingly ripped from the clutch of death, in reality it has succumbed to it all the more.[20]

Fifty years later, Sontag again reminds us of the extent to which the urge to photograph the world is a defense against the sense of depletion and anxiety that plague contemporary consciousness. Furthermore, she, like Kracauer, also signals the somewhat discomforting correspondence between the temptations of photography and the needs of capitalism:

> A capitalist society requires a culture based on images. It needs to furnish vast amounts of entertainment in order to stimulate buying and anesthetize the injuries of class, race, and sex. And it needs to gather unlimited amounts of information, the better to exploit natural resources, increase productivity, keep order, make war, give jobs to bureaucrats. The camera's twin capacities, to subjectivize reality and to objectify it, ideally serve these needs and strengthen them. Cameras define reality in the two ways essential to the workings of an advanced industrial society: as a spectacle . . . and as an object of surveillance. . . . The production of images also furnishes a ruling ideology. Social change is replaced by a change in images. The freedom to consume a plurality of images and goods is equated with freedom itself. The narrowing of free political choice to free economic consumption requires the unlimited production and consumption of images.[21]

Sontag's attention to the ways in which the camera is complicit with ideological concerns is taken even further by Kracauer. In both the industrial mode of capitalism and the technology of photography, he tells us, human life is turned into inert elements of nature divorced from meaning. In its assault

on awareness, memory, and human significance, he suggests, photography will lend itself all too easily to an alarming means of thought control: "Never before has a period known so little about itself. In the hands of the ruling society, the invention of illustrated magazines is one of the most powerful means of organizing a strike against understanding."[22]

Is it exaggerated to see the photograph as anaesthetizing our response to the world rather than sensitizing us to its particularities? Sontag suggests that just as photography stimulates our sensorial appreciation of the world, encouraging an aesthetic awareness, it deadens our moral consciousness, acclimating us to the pain, the horror, and the unconscionable brutality.[23] Is Kracauer right in perceiving that photography is complicit in forging the direction of capitalist culture toward a world abandoned by consciousness in which neither history nor memory has a chance of survival?[24]

How is it possible to counter the ideology of images shaping our lives, beckoning to us with the perpetual promise of beauty in unforeseen places, making us all aesthetes of immediate experience? Are we unregenerate victims of the frame imposed by the photo, enclosed in these borders of perception that become more real than the "real" itself? Will we forever hunger for dazzling angles, long-distance panoramic shots, and study close-ups with intense fascination—addicts of the photographic fix, searching for immediate revelations? Will our idea of reality gradually be reduced to the arbitrary recording of the spatial spectrum that has little to do with memory or history? Are we doomed to forget that what is "most brutally moving, irrational, unassimilable, mysterious" is "time itself"?[25]

These concerns emerge in recent novels, creating what might be called an aura of suspicion around the photographic legacy, directing us to the dangers of a consciousness immersed in the seductions of the photographic age. In Kundera's *The Book of Laughter and Forgetting,* the photo becomes a symbol of the ease with which history can instantly be rewritten. In 1948, Kundera tells us, the birth of Communist Czechoslovakia is celebrated in a greatly publicized photo of the party leaders. However, when one of the men falls out of favor with the communist regime four years later, he is simply air-brushed out and ceases to exist either in reality or history.[26] This matter of historical record epitomizes Kundera's contention that history has become "as light as individual human life, unbearably light, light as a

feather, as dust swirling into the air, as whatever will no longer exist tomorrow."[27]

Kundera further warns us that our tendency to celebrate the transient and ephemeral quality of human experience, the very attitude that the camera fosters, encourages a "profound moral perversity," for "in the sunset of dissolution, everything is illuminated by the aura of nostalgia, even the guillotine." Nostalgia, a favored domain of photography, tempts us to evade serious moral questions as the narrator of *The Unbearable Lightness of Being* realizes when one day long after the war, he is looking at a book about Hitler. Suddenly he experiences the "most incredible sensation" of feeling strangely reconciled with the fascist leader when he finds himself "touched by some of his portraits" because they are bathed in the light of his own childhood.[28]

Finally, although he does not mention the photograph explicitly, Kundera's attack on kitsch reflects an abhorrence for the perspectives and parameters that the camera perpetuates and echoes Kracauer's vision of "a world abandoned by consciousness." When Kundera tells us that kitsch "has its source in the categorical agreement with being," seeks confirmation of received ideas, and is the denial of everything that is "essentially unacceptable in human existence,"[29] one is reminded of Sontag's emphasis on the conservative position latent in the pleasures of photography, and how in its consecration of appearances, it encourages us to applaud the status quo and calls for a "redemption and celebration of the body of the world."[30] When he further defines kitsch as "the transformation of the stupidity of received ideas into the language of beauty and feeling,"[31] one feels increasingly placed in the realm of photography. In the way that it precludes questions and interpretation, kitsch, like photography, seeks to silence doubts and veil what is unintelligible in human existence; ultimately it, too, is "a folding screen set up to curtain off death."[32] The photograph is thus a fundamental part of contemporary culture's propagation of images and fantasies that discourage difficult and probing reflection and lure us instead into the erotics of the beautiful surface and the taking of the part for the whole.

Michel Tournier's *The Ogre* directs us toward the dangers of a world formed by photographic consciousness in a very different way. In a novel set against the background of the Third Reich, the possibilities of photographs inspiring fantasies and of images becoming symbols and symbols being transformed into myth all take on horrific significance. The relation between

photographic image and fantasy, at first articulated through the rather innocent practices and reflections of the strange though engaging narrator, eventually reveals itself to be anything but benign. The narrator, a somewhat obsessive amateur photographer, readily admits the possessive and predatory nature of picture taking but also claims for the photograph a new imaginative power, because at the same time that it "is indisputably an emanation of reality," it is "consubstantial with my fantasies and on a level with my imaginary universe." In other words "photography promotes reality to the plane of dream; it metamorphoses a real object into its own myth."[33] His fascination with the negatives of his prints directs us to the far reaching implications of such myth making. Relishing the way these negatives, in their "perpetual denial of our visual habits," offer an inverse world, he also finds security in the fact that his dabbling in this dark and murky reality is "without real malignity" because these images "can be put right again whenever we wish."[34] Thus, the evil spells and alchemical procedures of the darkroom are alluring but not finally dangerous. However, as this narrator finds himself propelled by the "malign inversions" of his own fantasies that are being indelibly inscribed in history, although they are finally no more than the fantasies of another deranged mind (Hitler's), he begins to understand that the images and symbols that are produced by a culture can themselves assume control of that culture, assuming an indisputable, irreversible, and diabolical reality. In this novel, then, the seductive powers of the photograph are disturbingly entwined with the dangers inherent in the reification of images and fantasies, symbols and myths and alert us to the treacherous entanglement of history and myth that defines this century.

If these novels remind us that photographs are always (like Sabrina's paintings in Kundera's novel) double exposures: "on the surface an intelligible lie; underneath, the unintelligible truth"[35] and reveal the repressed aspects of the photograph in the form of the negative and the retouched print, the novel that I want to deal with in greatest detail takes the most extreme position in challenging the mimetic theory of representation that the photograph so promisingly seeks to fulfill. With Marguerite Duras's *The Lover*, many of the questions that have been brought up in relation to photographic consciousness are raised to an acute degree and take up their place in relation to memory and history. Grounded in the image of a photograph that was never taken, this work is haunted by the failure of representa-

tion on both the personal and historical levels; moreover, it
forcefully reminds us that the political and the private cannot
be separated. I use these two words in the sense that Barthes
gives them when he tells us, "the 'private life' is nothing but
that zone of space, of time where I am not an image, an object.
It is my *political* right to be a subject which I must protect."[36]

Before I turn to *The Lover,* however, I shall cite one further
incident involving a photograph in which memory and history,
the private and the political, are horrifyingly brought together.
It is not surprising that this most extreme test of the efficacy of
the photograph comes in the context of the holocaust, the his-
torical event that beyond all others shatters our conventional
notions of representation and testimony. In *Testimony,* Sho-
shana Felman recounts the story of a survivor who as a child of
five is sent out of the Plashow labor camp by his parents in an
attempt to save him from the coming extermination of children.
His mother gives him a photograph of herself to keep to which
he will turn again and again. After the war he is miraculously
reunited with his parents only to find that the event is utterly
bereft of joy. Unable to identify these people with the photograph
and the internalized image he holds, his sense of reality is newly
violated. Having sustained himself up to this point on the photo-
graph, he falls apart when "the mother comes back different,
disfigured and not identical to herself."[37] He cannot bring him-
self to call his parents anything but Mr. and Mrs. and falls victim
to a terrifying recurrent nightmare.[38] Can there be a more har-
rowing testimony to the great divide between the reality offered
by the photograph and the real?

Duras's *The Lover,* I would suggest, is situated on this divide;
a text that turns on the image of a photograph never taken, it
immediately calls into question any notion of the visual image's
claim to embody the real.[39] Although it seems a book far re-
moved, both geographically and historically, from the holocaust,
its resonances echo most forcefully when considered in terms
of the crisis of representation and witnessing of which the
events of the Second World War speak. My initial reflections on
the text did not at all focus on such questions. I was at first
intrigued by the tension between the image and the word so
strongly evident in the new kind of "*écriture*" Duras felt she
had achieved in this text.[40] This focus was given new impetus,
however, by my coincidental reading of Susan Handelman's
book, *The Slayers of Moses,* which traces this tension back to
formative differences between the Jewish and Greco-Christian

worldviews.[41] Handelman's analysis of the special meaning of writing and the word in the Hebrew tradition provides a suggestive background on which to cast Duras's own curious identification of writing with the position of the Jew.[42] Inevitably connected to the events of the Second World War, Duras's fascination, even obsession, with the place of the Jew provides an unexpected point of entry into *The Lover* and reinforces the sense that the silent but resonant spaces of this text are traversed by the traumatic events of World War II as much as the haunting scenes of a childhood in Indochina.

Perhaps it would be even more accurate to say that the horrific events witnessed by Duras as a grown woman served to reinforce in the most radical fashion the sense of danger, exclusion, and defeat that had entered her life as a young girl. The atrocities of Hiroshima and Auschwitz in some undeniable way corresponded to her childhood intimations of uncontainable instinctual and malignant forces and a use of power that was totally corrupt. Born in the French colony of Indochina in 1914, she grew up speaking Vietnamese among the native children and exploring the wild and often cruel beauty of the natural world around her. An awareness of violent and mysterious forces, associated with the jungle as well as the tortuous relations within her own family, permeated her sense of existence and would only be equaled by the sense of social injustice she developed at the same time. Witness to both the colonizers' inhumane treatment of the peasants and the hopelessness of her mother's state as she was cheated again and again by the administration over a plot of land she had bought for the cultivation of rice, Duras developed a distrust of political authority that would last throughout her life. A member of the Resistance during the Second World War, she was, nonetheless, disconcerted by the brutal behavior of the victors that followed the liberation. Although she later joined the Communist Party, once she recognized the sacrifice of liberty demanded by Marxist ideology (especially for the writer), she left and disclaimed all political allegiance thereafter. Whether in literary matters or in politics, she refused adherence to any group (although despite her disclaimers, she is presented as a founder of the *nouveau roman*), insisting on the power of the word alone to grasp the truths of human existence all too frequently ignored. Extreme as Duras is in the demands she brings to writing—with respect both to herself and to her reader—it is not surprising that she under-

mines the most cherished of cultural traditions: the regime of the visual.

How better to challenge our susceptibility to the lure of representation, our belief in the visual image as the privileged access to truth, than to center a novel in a photographic image, that of an intriguing and provocative girl, but a photograph that in fact never existed. In *The Lover,* Duras gives voice to the seductive power that the image exerts at the same time as she absolutely denies the possibility of truth being captured by the mirror image, the copy, or any re-presentation of reality that grounds identity and knowledge exclusively in the visual mode. *The Lover* takes as its moment of origin a point that radiates outward in an expanding circular movement much as the vibrations of the sound of a stone against water issue in a pattern of concentric circles; however, the original moment, the compelling image of the girl on the threshold of transformation, can neither be fixed nor contained, and it can only be known through its effects.

It is not purely coincidence that draws me to the image of the stone striking water; what is appealing in this example is the confluence of sound and sight that mitigates against the stabilizing quality of visual representation alone. In contrast to vision that seems to affirm our access to the complete presence of a thing, sound offers us a more hesitant avowal: "a moving vibration that both is and is not there."[43] It suggests that the real is a function of the tension between presence and absence and that we can best approach it through pattern rather than static presence. Revelation, it then might be argued, is more closely related to the resonance of voice, to hearing the word, than to fixing the image.

This emphasis on the power of the word, which cannot be embodied in or reduced to an abstract concept, Handelman presents as the distinctive contribution of the Jews, who believed that the word was "an aspect of the continuous divine creative force itself" and thus took its material reality very seriously. Such an approach runs counter to the central impetus of the Greek and Christian traditions that give priority to the figural rather than the literal, the vision beyond the word rather than the word itself, and encourage the belief that "the image partakes of the essence of the thing itself, participates in its reality." In the Hebrew tradition, by contrast, truth is never to be identified with what is accessible to sight, but what is invisible, the word that simultaneously reveals and conceals its meaning and whose

significance is embedded in a complex structure of verbal patterns and ambiguities. The letter itself can never be deposed or fulfilled through some higher concept for this Hebrew mind whose "lack of interest . . . in the photographic appearances of things or persons, a lack of interest in representation as copy or plastic image," is one of its most striking aspects.[44]

This nonmimetic approach to reality is central to my understanding of Duras's text. Though some critics have understood *The Lover* primarily in relation to the fascination with the image, even identifying the image of the girl as a fetish object,[45] I would argue that such a reading ignores the equal fascination with the word, its sounds, textures, and rhythms, the pattern of vibrations it creates, and the irreducible life force it generates. It is not that readers have ignored Duras's special linguistic and poetic effects, but they have not always connected these to the question of representation that the novel raises. Just as for the Jews, "it is precisely the cancellation of the sign or word for the thing that is idolatrous,"[46] for Duras the reification of the sign and the refusal to grant a certain primacy to the word bespeaks a fetishism that is absolutely counter to her approach to the real. Writing for Duras is the attempt to capture the elusive feelings that can only be experienced through the power of words to reverberate in the mind of the reader, a process inevitably betrayed by the formulation of fixed images. The delicate balance that Duras tries to achieve between what is uttered and what remains unsaid can never be captured by a visual image alone, as she reminds us in an interview where she distinguishes the power of writing from film: "When I say the words, 'the child with grey eyes,' it conveys much more than any image on the screen possibly can."[47]

For Duras, there can be no image in which all significance occurs. The gap between the word and the image cannot be banished in an unmediated vision of truth. That gap is intrinsic to the act of writing and reading, and the silence that is so often evoked in relation to Duras's work reflects her power to give voice to that space and the experience of otherness it embraces. The circular movement that pervades *The Lover,* as it continually approaches but never reaches the center, again aligns the text with the mysterious, but ungraspable, power of the word and affirms that this power is, as Handelman emphasizes, "not descriptive but generative, re-productive instead of re-presentative." The elliptical, nonchronological pattern of the novel provides a vibration of echoes that insists that vision is a

matter of "hearing the word" and that the word "must be inter-
preted, respoken, heard again and again."[48] "So, I'm fifteen and
a half," the narrator tells us in the opening pages of the text (5,
9),[49] only to repeat the phrase intermittently as if each time
beginning again, drawing us toward the crucial moment in the
story of her life, the moment of the river crossing, only to affirm
that this moment owes its power to the fact that the image never
achieves the status of an icon, never becomes detached and fixed
as photographic representation. "And it's to this, this failure to
have been created, that the image owes its virtue: the virtue of
representing, of being the creator of, an absolute" (10). Lest we
misunderstand the word "absolute" as offering us the definitive
key to this life, the narrator has already dispelled that illusion
elsewhere: "The story of my life doesn't exist. Does not exist.
There's never any center to it. No path, no line. There are great
spaces where you pretend there used to be someone, but it's not
true, there was no one" (8). There is no center to this life that
can be seized and solidified; there is only the generative power
of words whose meaning is poised on the edge between presence
and absence, the enigmatic silence between word and image.

This insistence on the limit of representation does not, how-
ever, deny the possibility of either writing or autobiography; in-
stead it transforms our understanding of both.[50] The recognition
of the impossibility of representation does not nullify figuration
but rather invites it.[51] Autobiography then itself becomes a form
that privileges writing above the "objective" events of a life in a
reversal of our conventional expectations. The life must be cre-
ated anew as it writes itself out in the present, divided between
the immediacy of the moment and the whisperings of the past,
the effort to remember and the will to forget. One's life, as Duras
reminds us, refuses to stay still: "The story of my life is pulver-
ized each day, at each second of each day, by the present mo-
ment, and it is totally impossible for me to perceive clearly what
is called one's life."[52] The author of his or her own life can never
be sufficiently outside of that life for its meaning to achieve
clarity, but she can restore its breath. Duras seeks not to literally
transcribe past events but to grasp their echoes. Buried deep
within inaccessible regions, these traces "resurge in the form of
sensation; they pass once again through the body. . . . It is a ques-
tion of discovering the traces left by the past, transformed by
time, memory and the imagination."[53] For Duras, it is never a
matter of seizing the truth, nor is she hampered by the fear of
misrepresentation, for representation is never the issue. Having

finished one account of her childhood years, she is ready to immediately take up this history again. The truth of the story of her life can only be multiple and ongoing; her only fidelity is to the fundamental power of words, which is that of "infinite proliferation."[54]

Now I must come back again to the question of why I associate Duras's position in regard to representation and writing with that of the Jews.[55] Is there any justification, one might ask, for aligning a non-Jew with this tradition? There is first of all Duras's suggestion that for her the question of Judaism is deeply associated with the matter of writing.[56] In the same way that Derrida writes of Judaism as "the birth and passion of writing . . . the love and endurance of the letter itself,"[57] Duras identifies writing with the figure of the Jew in exile whose only country is that of the word, which simultaneously becomes the sign of irremediable loss and the mark of a presence experienced with incomparable force: "Jews are those who leave and, in leaving, carry off their native land with them; the violent hold that this land has upon them is stronger than if they had never left." The exiled state, then, becomes a metaphor for the radical experience of division and otherness that is always at stake in the act of writing, the place where one faces what Duras calls *"l'ombre interne,"* the internal shadow "that each carries within and that can only emerge and become exteriorized through language."[58] The tension between the word and the reality it seeks to embody speaks for the irresolvable estrangement that the writer is doomed to enact as she reaches toward a center of being that is forever elusive.

The place of the Jew figures forth for Duras the absence and otherness that are the space of writing. With the events of World War II, however, that place is experienced as the ground of a transgressive violence so shattering that neither self, history, nor writing can recover. Duras herself puts it very simply: "As far as I am concerned, the death of a Jew at Auschwitz, permeates all aspects of the history of our time." Beyond what can be conceived in human terms, the precisely ordered extermination of the Jews transforms the very meaning of the word human. Again, to quote Duras: "No, the place of the Jew, I cannot resolve it or connect it in even the most distant way to any conceivable aspect of our lives." Its incomprehensibility, however, simultaneously amounts to a revelation of such intense clarity for Duras that the otherness symbolized by the Jew assumes a new magnitude that she again relates to the site of writing:

> I think that the Jews, this excruciating problem that appears before me with such searing lucidity—is not unrelated to the difficulty faced in the act of writing. Writing is a matter of searching in the world for reflections of what is already within. The tragedy of the Jews serves to bring together in a new way the latent horror that I see spread throughout the world. It allows one to see horror in its quintessence.[59]

Cryptic as this passage is, I believe it suggests the degree to which for Duras both the events of the war and the act of writing lay bare the violence and deathly desire that traverse all being and all culture. The inhuman, yet all too human, capacity for evil brought to an abysmal degree in the Nazi horrors attests to the newly visible power of violence and death that we as human beings harbor within. For Duras, this recognition is especially sharp because it has a certain resonance with her earliest childhood memories of victimization and violence in Asia,[60] and, I would add, the devastating experience of brutality personified by her older brother that she presents so unflinchingly in *The Lover*. Furthermore, it is not completely unrelated to the deathly hatred felt by resistant fighters, of whom she was one, when they got their chance to turn "*notre instinct criminelle*" against the guilty. Thus, the meaning of the word Jew takes on a sharper focus, signifying the force that the death instinct occupies in the human position and the crucial importance of recognizing this legacy:

> The word Jew signifies both man's arbitrary appropriation of the power to inflict death and our realization of this. Because the Nazis failed to *recognize* this horror within themselves, they committed such atrocities.[61]

The act of recognition, of bearing witness to the unmitigated brutality of the Nazis, as Felman underlines in her recent book on the holocaust, although it demands the impossible in terms of traditional notions of representation, is nonetheless crucial if we are to escape the always potential fate of perpetuating such brutality ourselves.[62]

Felman's analysis of the crisis in representation and witnessing brought on by the undeniable, though unavowable, acts of the war is suggestive in regard to *The Lover* because it articulates the radical shift in consciousness that is embodied in the novel. Felman insists that the horrific events of the war place writers in an "age of testimony," which demands that they bear

witness to the absolute failure of all traditional frames of cultural reference to make intelligible the absolute defilement of human life that took place. This period is marked by witnesses, she underlines, who no longer can take comfort in clear-cut distinctions between the guilty and the guiltless, barbarism and cultivation, the human and inhuman, and finally, life and death. Moreover, they are placed in what seems an irreconcilable self-contradiction: the imperative to bear witness to what we have no capacity to witness. Finally, if the only *real* witnesses are those who have not survived, and the stories of survivors are themselves voices speaking from the other side of what we conceive to be the parameters of human possibility, then where do we begin? How does one deliver and how does one receive a testimony that insists we can never have access to its truth at the same time it tries to indelibly mark us so that we will never forget? Whereas writers like Camus, whom Felman uses as her prime example, more directly explore in their novels the contradictions that permeate the historical situation they have witnessed, Duras, in *The Lover,* I would argue, also attests to the radical change in the ideas of testimony and representation that must be performed if the effects of the holocaust are allowed to vibrate in history and narrative. The fact that her text is so far removed from the events of the war or anything that might be read as a direct gloss on its horrors or threats (as in the case of Camus' *The Fall* and The *Plague*) makes it all the more fascinating as a revelation of the extent to which one who has been penetrated by the unassimilable shocks of these times must register those effects in her writing. As Felman tells us, "Testimony is itself a form of action, a mode not merely of accounting for, but of going through, a change."[63] For Duras, the matter is very clear. She tells us that although she almost never wrote about this experience, the discovery of the concentration camps in 1945 was for her a vision of almost hallucinatory clarity: "Very clearly, I became another person."[64]

What then is this inescapable legacy that presents itself so pervasively in *The Lover* ? In what ways does this text substantiate Felman's claim that "the cryptic forms of modern narrative and modern art always—whether consciously or not—partake of that historical impossibility of writing a historical narration of the Holocaust, by bearing testimony, through their very cryptic form, to the *radical historical crisis in witnessing* the Holocaust has opened up"?[65]

I will draw on Felman's analysis to underline the ways in

which the inadequacy of our traditional notions of approaching the real (epitomized by the photograph[66]) can no longer be evaded for the postholocaust consciousness. I might add that, not surprisingly, these insights are to a large degree shared by critics associated with both deconstruction and the new historicism. I do not pretend that these perceptions are necessarily altogether new, but that they have been brought to a pitch unexperienced before in history.

First, we have the recognition of the utter failure of our cultural frames of reference as a means of approaching "the real" and a suspicion of imposing intelligibility on events that would reduce them to a false transparency and thus dispel their originary, and sometimes, traumatic character. Related to this is the perception of our inability to ever grasp the totality of what is happening, on a historical or personal level, and thus a realization of our susceptibility to blindness and our collusion in forgetting, which now marks the meaning of history as much as remembering.

Second, the holocaust conveys, as never before, the contradictions involved in the act of witnessing. Along with the recognition of the degree to which all notions of objectivity have dissolved in relation to this act, comes the uncomfortable avowal that all witnesses, whether victims or victimizers, are already inscribed in the very system that they attempt to observe, describe, or evaluate and thus are to some extent molded by the very system from which they seek to distance themselves. In this regard Felman's attention to the fact that survivors hold the secret belief that the judgment of guilt imposed on them is somehow warranted is especially striking. No longer is there a witness "who could step outside of the coercively totalitarian and dehumanizing frame of reference in which the event was taking place, and provide an independent frame of reference through which the event could be observed." No longer is there a way around the fundamental contradiction of the human position in history, brought to new urgency by the events of the war: "the historical impossibility of witnessing and the historical impossibility of *escaping* the predicament of being . . . a witness." There is, as Felman underlines, a huge difference between being "present in, but not to, what was taking place."[67] The gap between being involved in events and assimilating or comprehending or making sense of them looms large. Unfortunately, our consciousness of history's makings always lags behind reality; in the case of the holocaust that divide may never be filled.

Third, the ethical implications of the holocaust involve one in what seems like an untenable position. If the word innocence no longer can be comfortably and absolutely distinguished from guilty, how are principles of morality to be affirmed at a time when it seems more crucial than ever to do so? If the "very essence of the holocaust" is to make impossible "a position of self-righteousness and rightness," as Felman tells us,[68] how are we to rethink questions of ethical responsibility?

Finally, in the wake of events witnessed, the position of the writer takes on a new sense of urgency, but equally potent are the feelings of utter incapacity. Left with "a debt of knowledge" that seems unpayable,[69] the writer's task is one of self-contradiction, voiced so simply and eloquently by Samuel Beckett: "I can't go on, I'll go on."[70] If the reassuring distinctions between guilt and innocence, remembering and forgetting, the human and nonhuman, the real and the lie no longer correspond to lived experience, how does the writer testify to this rupture in her writing? How can a writer evoke in her work the silence of which the holocaust so resonantly speaks, a silence that voices the limits of the powers of representation as well as embodying the powerful and deadly consequences of failing to hear and willing to forget? "What does it mean to *inhabit history* as crime, as the space of the annihilation of the Other?" Felman asks.[71] This is the very question that plagues Duras after the war as she faces self-recrimination for not having recognized or asked the significance of the yellow star her Jewish friends were suddenly obligated to wear,[72] a question that will haunt the space of her writing. More difficult than ever before, the writer's task is simultaneously more crucial than ever before:

> to open up in that belated witness, which the reader now historically becomes, the imaginative capability of perceiving history—what is happening to others—*in one's own body,* with the power of sight and insight offered by one's own immediate involvement. To experience that radical dis-continuity—the crisis—so that life is forever inhabited by that passage.[73]

This sense of radical discontinuity and crisis, I will argue, is the very force that permeates *The Lover.* Although it might seem a text far removed from the holocaust, and it might seem questionable to speak of a blatantly personal crisis in the same breath as this incommensurate historical event, I can only repeat Duras's assurance that even when what she is writing about is far

removed from the world of the concentration camps, the anguish of that time had so penetrated her existence that this dimension is nonetheless implicitly present.[74] Accounting for the power of *The Lover* through focusing on the personal elements alone does not suffice to register its force. Something more radical seems to me to be at stake that I find I can only articulate through situating the text in the historical crisis of testimony and representation of which the holocaust so harrowingly speaks. Furthermore, have we not learned that the separation of the personal and the historical, history and narrative is no longer viable?

Duras's ability to make us viscerally experience the degree to which all stable and comforting notions of humanity and its representations dissolve, and her capacity to register the irresolvable violence, contradiction, and silence that structure human existence are for me inseparable from her avowal that with the discovery of the abominations of the war, she became a different person. Perennially haunted by the situation of the Jews though hesitant to speak or write about it, she knows only too well that this matter, beyond all others in the demands it makes on our imaginations, will remain forever inaccessible to efforts of direct representation. Nonetheless, *The Lover,* in its insistence on engaging us in a continual struggle between "the integrative scope of words and the unintegrated impact of events," is without question a dramatic example of the "literature of testimony."[75]

> Everyone says you were beautiful when you were young, but I want to tell you I think you're more beautiful now than then. Rather than your face as a young woman, I prefer your face as it is now. Ravaged. (3)

The Lover begins with an image of the narrator's face that refuses to be an image. No contours of features, angles, or lines are described; it is almost as if the very presence of that face is denied as it is uttered. The promise of representation is unfulfilled, and instead we are returned to the powerful thrust of a word: "ravaged." Coming at the end of the paragraph, a sentence unto itself, the force of the word assumes an unforgettable presence that cannot be grasped or assimilated because it cannot be translated into a concrete image easily retained; instead it hovers on the edge of consciousness, vibrating through the pages

that we read, asking to be absorbed though not quite allowing us to do so. And in later readings, the word loses none of its unnerving power, always surprising and in excess of what we can take in, expectedly, yet shockingly, there at the end of the first paragraph.

The first paragraph is a fitting entry into the elusive reality presented in the text. We are given no solid foundation or point of view that would allow us to stabilize the scenes evoked. "Ravaged," for example, is at first the mark of the narrator's aged face, but then it is almost immediately associated with the dramatic transformation of the young woman at eighteen:

> My ageing was very sudden, I saw it spread over my features one by one. . . . The people who knew me at seventeen . . . were surprised when they saw me again two years later, at nineteen. And I've kept it ever since, the new face I had then. (4)

However, as we await the unfolding of the transformative experience that took place between seventeen and nineteen, we are instead decentered, situated on the ferry crossing of the Mekong River in the girl's fifteenth year, the season of the Chinese lover, which becomes yet another image that lures us onward, its significance to be deferred again and again, only to be taken up once more as if for the first time.

The yoking of the older face "laid waste" (5) with the effects generated by the girl's sexual awakening is foreshadowed in the English translator's choice of ravaged for the French *devasté*. Although the sense of utter ruin and finality that the French carries is lost in the translation, ravaged is more aggressively physical and carries the sexual connotations that are called forth by the play on ravished (also an echo of the earlier *Ravissement de Lol V Stein*) and signals the yoking of sexual ecstasy and deathly desire that is Duras's favored domain. Both words, however, carry the force of an absolute and ineradicable rupture that suggests the inability of conventional forms of representation to embody this face, this self, this subjectivity, which from very early on experiences itself in terms of division and discontinuity. Aware of her sudden aging at eighteen, the narrator writes: "But instead of being dismayed I watched this process with the same sort of interest I might have taken in the reading of a book" (4). The same sense of dislocation is voiced when she tells us: "Very early in my life it was too late" (4). We have, then, a very fitting introduction to a text in which "autobiography becomes," as

Hewitt notes, "a game of hide-and-seek: 'I' does not wholly coincide with the past 'she,' nor is 'I' completely distinct from 'her.' The reader is positioned in the pronominal gap."[76]

The text continually situates us in a space of fragmentation and disruption, the narrative moving us without signal from the present of the younger self, rendered in the first person with a camera-like objectivity and detachment ("I'm fifteen and a half. Crossing the river.") to an adult reflection on that life: "It's the end of some school vacation, I forget which" (9). We never feel comfortably established in one point of view (which without warning also switches from first to third person) before it is discarded or made ambiguous by the continual interweaving of past and present, the lack of differentiation among the multiple selves that constitute the "I," the alternating angles of an almost camera-like objectivity and the unabashed intrusiveness of the adult narrator. Added to this is the sense we have of continuously starting again with each break in the text, without a hint of direction other than the silence that resonates within and between the lines. These gaps, however, allow the words to reverberate and discourage us from relegating them to fixed meanings. Rather than assimilating them to what is already known and sayable, we grapple with the sense of the word as if for the first time and hover on the verge of what is unseemly and forbidden in human experience: incest, madness, unavowable desire, and a brutality that is inconceivable. In a sense what Duras strives for in her writing is the same disjunction between word and image that characterizes her films. In the films, however, this lack of coincidence between the words filling the space of the theater and the visual images on the screen is easier, despite the viewer's initial resistance, to exploit. The separation between the two in the written text is obviously more difficult to attain because all we have is language, and our immediate inclination is to translate the word into significance as quickly as possible. But Duras's purpose is to make us aware of the disparity between the word and the visual image in writing just as she does in the cinema. As she tells an interviewer, she is never concerned about the sense of what she writes but only with the word that "counts more than the syntax."[77] Her purpose is to rescue the word from its fluidity, and thus erasure, in common speech and restore its resonating field, its "champ sonore,"[78] so that we may experience its sound and echoes as if for the first time. What Duras says about the way she reads the scripts for one of her films might be used as a general commentary on her writing:

The slowness, the inattention to punctuation, it's as if I were un-
dressing the words, one after the other to discover what was under-
neath, the isolated and unrecognizable word, stripped of all relations
and identity, as if abandoned.... Everything must be read, the
empty spaces too. Everything is to be discovered again. In speaking
and listening to words, one notices how easily words can crumble,
how easily they might turn to dust.[79]

Duras's aim is to make identities dissolve, first the identities of
words and then the gradual dissolution of the comforting and
stable identities of her readers who become "echo-chambers" of
the text,[80] letting themselves be penetrated by what they would
resist if they were left in control.

The particular force of *The Lover* and its silences sharply
emerges when one compares it with two other novels that draw
from the same early autobiographical material: *The Sea Wall,* a
conventional novel published thirty years before, and *The North
China Lover,* a few years after. Duras tells us that in the earlier
work she was still immersed in telling a story, whereas in *The
Lover,* the only subject was that of the writing.[81] What is missing
from the more conventionally realistic novel is the experience
of silence, the blanks or gaps found in *The Lover.* This difference
partially reflects the writer's reticence to transgress certain
moral codes, but it is also a matter of Duras not having yet devel-
oped the style necessary to translate that forbidden matter into
her writing in a way that would allow its scandalous effects their
intensity. The narrator of *The Sea Wall* speaks from an authori-
tative position, confronting us directly with the cause of the
mother's despairing state and the daughter's feelings toward the
Chinese lover. Both make sense in relation to the humiliation
and exploitation that the mother has suffered at the hands of
the colonizers. There is no question of a responding passion on
Suzanne's part; the terms of the lovers' relationship, from the
daughter's perspective, is entirely economic, and she torments
him without remorse. The portrait of Joseph, the brother, is
equally intelligible and undisturbing. He is a conflation of the
two brothers who appear in *The Lover* but representing neither
the extreme state of love nor hate found in the later novel. He
is strong but gentle, much adored by and protective of his sister,
with only a hint of the aggressiveness and brutality that com-
pletely takes over the later characterization of the older brother.
Moreover, the daughter is portrayed with none of the ambiguity,
that curious blend of innocence and jadedness, that will consti-

tute her fascination in *The Lover*. In fact, it would seem that certain aspects of the sister/narrator's experience in *The Lover* are here projected onto Joseph. It is the brother in *Sea Wall* who speaks of his inevitable betrayal of his mother and in whom the combination of alcohol and desire produces a state of heightened passion and intelligence that he recognizes as having long been inscribed within him. What is unavowable is thus projected onto the brother in this novel, and Suzanne herself remains rather unremarkable. Both the psychology of the characters and the meaning of events are relatively clear and, though at times painful, easy enough to absorb. As Selous writes, the novel can be "read in a relatively unproblematic way as the coherent manifestation of the desires of a narrator who can be easily conflated with the implied author."[82] Finally, it should be noted that the mother dies at the end of the earlier novel, a means of escape that the later Duras can no longer offer herself, for she, even more than the lover, is the text's haunting presence that cannot be exorcised.

Within the text of *The Lover* itself, Duras draws attention to the more scandalous nature of this book: "Before, I spoke of clear periods, those on which the light fell. Now I'm talking about the hidden stretches of that same youth, of certain facts, feelings, events that I buried" (8). I would suggest that what is so remarkable about this work is that by giving all her attention to "writing" rather than storytelling, Duras discovered a style capable of making us continually feel the visceral impact of the forbidden material she uncovers. Whether one thinks of the suggestion of incest between brother and sister, the intimations of the mother's madness, or the inconceivable brutality of the older brother and the mother's complicity in his actions, in *The Lover* the reader is continually trying to understand what exactly is at stake, on the verge of recognizing the scandalous nature of an event, what seems unthinkable, but never quite sure that this is indeed what is being said. The consequence is that we are left in the face of the unspeakable without being able to reduce it to an assimilable reality and thus to dispose of it. A great deal is thus lost, I would argue, in the more explicit statements of *The North China Lover*. When we are told without a doubt of the incest between brother and sister or the triangular relation the girl desires between Hélène Lagonelle, her lover, and herself, or presented directly with the girl's fear that the older brother will kill the younger one, the effect is less shocking than the not quite substantiated hints that we get in *The Lover*.

Here because we do not quite get a sentence or a scene into focus before it dissolves, we cannot absorb and then dismiss it. We are never allowed the comfort of a sense of closure. Because we are made to feel that what is voiced is unseizable, unrepresentable, unreproducible, we viscerally experience the real as transgressive or nonhuman, and as it defies our attempt to understand, we feel the degree to which this reality violates our understanding of human reality as we know it. However, at the same time, since the utterance hovers on the edge of consciousness as desire or dream, wish or nightmare, it is no longer simply a distant reality, the reality of the other, but in some way our own, and our own implication in this otherness can less easily be put off. The unavowable desires and hatreds, the radical otherness of human "being," are upon us with an unprepared for immediacy as we are poised on that edge that resists representation.

This approach to the real obviously lies counter to the sense of reality embodied in the photograph, but only through directing us toward photographic reality can Duras withdraw its substance and solidity. In the text, she presents us with three photographs that actually had been taken. Toward the end of the narrative, she evokes a professional photograph taken of her mother when she is quite old and desirous of memorializing her life as death draws near. What the narrator stresses, however, is the degree to which this photo, which attests to the desire to eternalize the individuality of an existence, instead has the effect of denying such particularity. What is striking about these professional photographs is that no matter who the subject, all result in a leveling down of what is distinctive in each face:

> It wasn't just because all old people look alike, but because the portraits themselves were invariably touched upon in such a way that any facial peculiarities . . . were minimized. All the faces were prepared in the same way to confront eternity, all toned down, all uniformly rejuvenated. (97)

Her mother's expression thus wears the same noble expression found in other photos of this genre, although this dignity, Duras suggests, is synonymous with a kind of erasure: "Noble, some would say. Others would call it withdrawn" (97). This example marks an extreme case of the phenomenon we have seen lurking within all acts of photography, the ease with which the photographic image becomes a death mask. Ostensibly taken to pro-

long and intensify life, the photo instead takes from the person all that its vital and so provides a reproduction of life that is, paradoxically, on the side of death. Celebrated as the form that has the most potential to represent reality, that in a radically new way brings to fulfillment the efforts of art to imitate life perfectly, photography instead witnesses the extent to which its very success constitutes its failure. As one of Duras's commentators writes:

> The photo does not imitate nature, as the common definition of art would have it, but faithfully reproduces it. As a duplication of the real, the photo does not represent because that would require distance. Essentially, it is a dead presentation. More than any other process photography brings about the ruin of representation.[83]

It is just because the photo fulfills its purpose of delivering reality to us as a static presence that it cannot partake of that irreducible movement of presence/absence that is the domain of the real. The question is not whether or not the photo is adequate to the task of representation, but, as Beaujour underlines, "the deathly power that it embodies."[84] In this context it is not surprising that although Duras understands the allure of the photograph and reminds us of how indispensable photography had come to seem by the end of the nineteenth century—her mother's photos of her children, for example, constituting a veritable sacred presence for her—she also affirms without hesitation that in contrast to what people believed and still believe, "the photo helps us to forget. This is its function in the modern world."[85]

A second reference to a photo of her mother is noteworthy because of its insistence that the photograph cannot be read literally; whatever reality it is capable of registering will emerge obliquely rather than through direct representation. Here the mother is surrounded by her children in the courtyard of their house in Hanoi. Here too, however, the reality of the mother's existence does not emerge in the representation of her face although her expression reveals a certain fatigue and boredom with the photographic procedure. For the narrator, the truth about the mother can only be read through an act of displacement in which she focuses not on her mother but on the children, whose manner of dress reveals the absolute incapability of the mother to cope with the essentials of everyday life and testifies to her utter desperation in the face of living. For this

reason, the narrator tells us, "I recognize her better in that than in more recent photos" (13).

The third, and perhaps the most provocative, reference to an existing photo comes in conjunction with the narrator's reflections on the absence of a photograph of that crucial moment in the young girl's development: her crossing of the Mekong river in an almost transparent silk dress, gold lamé heels, and a man's flat-brimmed hat. The uncaptured reality, however, issues mysteriously in a very different photo, one that cuts across the lines of gender, generation, and geography:

> I found a photograph of my son when he was twenty. He's in California with his friends. . . . His smile strikes me as arrogant, derisive. He's trying to assume the warped image of a young drifter. That's how he likes to see himself, poor, with that poor boy's look, that attitude of someone young and thin. It's this photograph that comes closest to the one never taken of the girl on the ferry. (130)

Taken aback by the matter of fact tone in which the narrator offers us this unexpected piece of information, the reader experiences a jolt into a reality not easily grasped at the very instant he or she is sharply dislocated by a seeming inconsistency in the usual pattern of reasonable thought. At the other extreme of the composed image with which one arms oneself for the photographer, this image insists that the truth of the subject issues through a process of decomposition and disinvestment and testifies to the difference and otherness involved in the apprehension of the real.[86] It is a process that resists the fetishism at the heart of the photograph, which offers us only a part in guise of the whole, what is inert in place of what lives, changes, and is ineluctably a part of that incessant movement "of absence towards presence."[87] For Duras, only the word, whose existence is forever rooted in this disjunction, invites us toward the real; thus, it is only fitting that the most tantalizing figure of reality offered in *The Lover* is one inaccessible to the eye of the camera, one generated solely by words.

The image not taken, the girl in the sheer silk dress, lamé shoes, and man's hat, remains at the center of the text, its most inviting and ambiguous figure. And the rhythm of approach and withdrawal with which the narrative moves us toward and then away from this presence constitutes the pervasive eroticism of the novel as much as any description of lovemaking between

the girl and the Chinese lover. The absence at the text's center, as Duras underlines in an interview, also marks the unspoken love between the two lovers, a love all the more forceful because it exists entirely in the excessive pleasure of their bodies and is never betrayed by words. The love that they feel for each other remains unrecognized and undeclared, and for that reason, Duras tells us, she can only present their relation from the outside, through images of the river, the skies, and the city beyond the walls of the Chinese lover's room.[88]

Nonetheless, the image of the girl is what immediately attracts our attention and impels our desire to know. Curiously innocent, yet knowing, aware of her attractiveness, her potential to circulate in the discourse of desire and thus to serve as a significant object in the economics of exchange, she is neither a fetish object nor mere victim of patriarchal forces and oppression. She is always the subject of her own desire, the one who unabashedly observes as well as the one who is the object of the other's gaze. In *The North China Lover,* Duras underlines this point by insisting that it would be a fatal mistake to cast a merely beautiful actress in the role of the girl, for beauty relegates one to the position of the observed: "Beauty doesn't act. It doesn't look. It is looked at" (61).

Her clothes reflect the extent to which the girl has actively assumed the position of desire, her apparent innocence belied by an already jaded sense of awareness: the shoes "contradict the hat, as the hat contradicts the puny body" (13). They reflect her knowledge of her powerful capacity to attract the male gaze and the economic ramifications of such power. The bizarre combination of high-heeled evening shoes and threadbare silk dress worn with a leather belt thus speaks of a desire to provoke desire; at the same time it reveals a childlike naiveté and proclaims a recognition of her value as an object "available to all, available to all eyes, in circulation for cities, journeys, desire" (13). However, the man's hat further complicates the effect, added provocation, perhaps, but also the willful touch of ambiguity that announces a refusal to function simply as an object in the economics of exchange or conform to the contours of feminine desire as defined by neat divisions between male and female. The awareness of her sexuality has long been inscribed within this girl and with it a sense of her own power as emanating from the crucial combination of intelligence and desire:

> I know it's not a question of beauty, though, but of something else, for example, yes, something else—mind, for example. What I want

to seem I do seem, beautiful too if that's what people want me to be. (18)

She immediately differentiates herself from those other women who betray themselves by unquestionably assuming the position of object: identifying their desirability with what they think men want, stereotypical conceptions of beauty and elegance, and spending their time perfecting their carefully fabricated images before the mirror. Her own power resides in the knowledge that the question of desire is elsewhere:

> You didn't have to attract desire. Either it was in the woman who aroused it or it didn't exist. Either it was there at first glance or else it had never been. It was instant knowledge of sexual relationship or it was nothing. (19)

It is noteworthy that her recognition of the power of her own sexuality is awakened not through the experience of male desire but through a deep and spontaneous identification with another woman who, like herself, is doomed to "the infamy of a pleasure unto death, as they both call it, unto the mysterious death of lovers without love" (90). The appearance of Anna Marie Strether and the story of the devastating passion that ends in her lover's death immediately announce to the young girl a precocious knowledge of her own attraction to deathly desire, as well as foreshadowing her inevitable isolation and disgrace. Neither woman can be restricted within the parameters of a male-defined desire: Strether brings her lover to suicide, and the girl almost immediately brings to her Chinese lover the knowledge that she will deceive him and all the other men with whom she will be (42). For these women desire can never be contained but must freely circulate: from Anne-Marie Strether to the girl, to her Chinese lover, to Hélène Lagonelle: "It's via Hélène Lago-nelle's body, through it, that the ultimate pleasure would pass from him to me. A pleasure unto death" (74).[89] Not even the brothers remain outside the boundaries of this freely moving desire:

> The shadow of another man must have passed through the room, the shadow of a young murderer, but I didn't know that then.... The shadow of a young hunter must have passed through the room too, but that one, yes, I knew about, sometimes he was present in the pleasure and I'd tell the lover from Cholon, talk to him of the other's body and member, of his indescribable sweetness, of his

courage in the forest and on the rivers whose estuaries hold the black panthers. (100)

The power and fascination of the girl resides in her capacity to enact the radical division and desire that define human reality, the movement toward presence that is forever penetrated by absence. She is at once a captivating object, inciting a desire that she can neither fully embody nor fulfill, and a subjective presence that is divided from itself and its desire in the course of its efforts to create itself. (The narrator, of course, literally doubles both this act of division and creation in the process of writing the text.) Moreover, she will act out a history that she feels is already inscribed within her body and mind and one that is bound inextricably to the system from which she tries to carve out her freedom. Finally, she represents, for the adult narrator, the lure of the past, the means to an understanding of a life that remains an enigma, the image of wholeness and continuity promised by the art of photography but forever denied:

> It's the area on whose brink silence begins. What happens there is silence, the slow travail of my whole life. I'm still there, watching those possessed children, as far away from the mystery now as I was then. I've never written, though I thought I wrote, never loved, though I thought I loved, never done anything but wait outside the closed door. (25)

The enigma of that childhood, that mother, both molded by a system of scandalous political oppression, is the ground on which the narrative turns, making us, like the narrator, witnesses of events that we can never quite penetrate. Thus, somewhat indirectly we assume the historical position bequeathed to us by the Second World War. What might seem like an exaggerated statement, imposed on events greatly separated by geography and time, gains substance in light of a completely unexpected assertion on the part of the narrator: "I see the war as I see my childhood. I see wartime and the reign of my elder brother as one" (62).

If the daughter identifies her brother with the horror of her childhood, she also knows that his power is allowed to flourish only through the silent collaboration of the mother. It is, finally, the girl's relation to the mother, even more than her liaison with the Chinese lover, that offers the most compelling and enigmatic material of the narrative. How does the daughter/reader come

to terms with this woman, who at moments seems so sensitive to her daughter's desires and needs and yet is not beneath silently encouraging her to make of her body a commodity in the market of exchange? Who is this woman who seems at times a willing accomplice to the brother's mission of evil and yet is a mother capable of bringing her children experiences of intense beauty and joy beyond compare? What does one make of a woman whose will and tenacity is simultaneously a mark of her innocence, abusiveness, perhaps even madness, and yet also the sign of her profound grace?

An object of intense love and almost unavowable hate—"the beast, my mother, my love" (22)—the mother brings to her children a sensitivity to the beauty of the world so passionate that despite her unabashed hostility, the daughter tells us, "I had that good fortune—those nights, that mother" (81). Here she is referring to those nights when the mother would drive them out to see the sky, "that stretch of pure brilliance crossing the blue, that cold coalescence beyond all color" (81), but on those days when the mother orders that the house be scrubbed, and water is poured out everywhere, the children are equally wild with delight. Suddenly the mother is transformed; no longer moody and dejected and an embarrassment to her daughter, she plays the piano and sings, and the whole house is filled with "the smell of yellow soap, of purity, of respectability, of clean linen, of whiteness, of our mother, of the immense candor and innocence of our mother" (61). Despite the adult narrator's assured statement that she no longer loves her mother and cannot remember if she ever did (28), the text again and again registers her deep ambivalence: "Can we glimpse something of this woman through this way of going on? The way she sees everything she might give up, abandon—the cousins, the effort, the burden. I think we can. It's in this valor, human, absurd, that I see true grace" (96).

Although the narrator asserts the success of her separation from her mother, that both her laughter and cries are beyond memory and that she has become instead "something you write without difficulty, cursive writing" (29), one suspects that her identification with her mother is not so easily dispelled.[90] The repetitive appearance in Duras's works of the wandering beggar woman who abandons her child, and who in *The Lover* exerts such a frightening force on the young girl, reflects, on the one hand, the unresolved fear of abandonment by the mother and, on the other, the recognition of her own susceptibility to mad-

ness, perhaps the deepest and most unshakable link that binds this daughter to this mother.[91] When she is pursued by the mad-woman of Vinh Long, the terror of the girl of eight already announces this knowledge: "What's sure is the memory of my whole being's certainty that if the woman touches me, even lightly, with her hand, I too will enter into a state much worse than death, the state of madness" (84). Almost directly after this passage, the narrator records a scene that brings the twin fears of abandonment and madness together with great force. Sitting on the terrace, the daughter suddenly, and without warning, sees her mother's face undergo a dramatic transformation such that it becomes unrecognizable, as if another woman had been substituted in the place of the mother. Blank, beautiful, and young, the face takes on an unprecedented expression of happiness, and the girl is terrified by the sudden sense of absolute abandonment:

> My terror didn't come from what I've just said about her, her face, her look of happiness, her beauty, it came from the fact that she was sitting just where my mother had been sitting when the substitution took place, from the fact that I knew no one else was there in her place, but that that identity irreplaceable by any other had disappeared and I was powerless to make it come back. . . . There was no longer anything there to inhabit her image. I went mad in full possession of my senses. Just long enough to cry out, I did cry out. A faint cry, a call for help, to crack the ice in which the whole scene was fatally freezing. (85–86)

The girl's utter helplessness and hopelessness before the disappearance of her mother's familiar identity reflects the daughter's dangerous captivity within the mother's gaze: her utter dependence on the mother's image for her own sense of identity—although that look is also capable of subjecting her to objectification and humiliation—and the devastating threat of the mother's withdrawal.

This scene, which situates both mother and daughter on the edge of madness, is wrapped in ambiguity. The moods of despair and despondency associated with the mother throughout the narrative encourage us to read the episode as providing conclusive evidence of her unbalanced state—especially because this scene is preceded by a paragraph beginning, "Quite late in life I'm still afraid of seeing a certain state of my mother's—I still don't name it—get so much worse that she'll have to be parted from her children" (85). However, the fact that we are also told

that the housekeeper, Do, who was beside her, seems to have noticed nothing, might make us wonder whether the change is as much a revelation of the daughter's fears and guilt as it is the sign of the mother's instability. Such emotions are undoubtedly related to her sense of rejection caused by the mother's blatant preference for the older brother and the aggressive feelings that result: "I wanted to kill him, to get the better of him for once, just once, and see him die. I wanted to do it to remove from my mother's sight the object of her love, that son of hers, to punish her for loving him so much, so badly, and above all—as I told myself too—to save my younger brother" (7). Moreover, the narrator's refusal to name the mother's state leaves us unable to assimilate the reality witnessed. Without the comfort of the word that would translate the discomforting experience into a term that could be grasped, we are left disoriented, on the edge of a recognition that threatens to vanish before it is thoroughly transformed into a frozen image. An earlier passage where the narrator seems to be describing her mother's state more explicitly is again marked by ambiguity and contradiction: "I see that Do and my brother have always had access to that madness. But that I, no I've never seen it before. Never seen my mother in the state of being mad. Which she was. From birth. In the blood. She wasn't ill with it, for her it was like health. . . . She always had people around her, all her life, because of what they called her lively intelligence, her cheerfulness, and her peerless, indefatigable poise" (31). The comfortable border between madness and sanity has no place in Duras's text, just as clear-cut distinctions between masculine and feminine, subject and object, and past and present likewise dissolve.

While reading The *Lover,* one is never entirely sure of how to situate the mother's bizarre behavior; at one moment she seems thoroughly responsible in her commitment to provide for the future of her children and to combat the poverty to which the abominable corruption of the administration has brought her, and the next, she seems a desperate victim of the colonial powers and an accomplice to the older brother's malignant intentions. What is certain, however, is that despite her concern that her daughter escape the family's fate and the girl's own resolve to do so, the daughter, in fact, will never move beyond encircling that familial space. It is true that the narrative foregrounds her crucial moment of independence, her conscious recognition that she must assume her full sexuality and thus fulfill "certain duties towards herself" although she knows this act will mean ex-

cluding herself from her family "for the first time and forever" (35). The narrator also makes it clear that this separation and claim to freedom are inextricably connected to the knowledge that she will be a writer. Somewhat ironic and terribly poignant, then, is the narrator's concomitant avowal that she has never, in fact, made this separation and that the space of that family and the space of her writing are one:

> I'm still part of the family, it's there I live, to the exclusion of every-where else. It's in its aridity, it's terrible harshness, its malignance, that I'm most deeply sure of myself, at the heart of my essential certainty that later on I'll be a writer. (75)

The sense of the passage is all the more emphatic because of the conflation of the girl and the adult narrator in a moment that cuts across the boundaries of past, present, and future: the first I (I'm and I) referring to the adult, the last (I'll) to the girl, and the second I'm to both.

The girl's inability to break out of the boundaries set by that haunted childhood is emphasized by the strong sense of fatality that inhabits the novel, the sense that it is already too late (4), that she is already inscribed in a network of economic, political, and psychological forces so dense that any attempt to assert her subjectivity is already severely circumscribed. To be a child of that mother, "a candid creature murdered by society," is to live in an atmosphere so degrading that it simultaneously unites the children "in a fundamental shame at having to live" and in a love for their mother so strong that it is "beyond love." To choose life is ultimately to betray their mother, that is, to be "on the side of the society which has reduced her to despair." Therefore, "because of what's been done to our mother, so amiable, so trusting, we hate life, we hate ourselves" (55). Feelings of love and hate combine to fuel an atmosphere of violence so intense that it is impossible to deny one's own murderous impulses: "Everyday we try to kill one another, to kill" (54). The girl's recognition of her own capacity for hatred and violence is undeniable, especially in relation to the brutality of the older brother: "I wanted to kill him, to get the better of him for once, just once, and see him die" (7). She thus finds herself implicated in the very system of hate and brutality that she most despises in the same way that "she falls into the very misfortune my mother has always predicted for me" (45). She knows that the shame and dishonor that her affair with the Chinese lover indelibly

prints on her life will bring the wrath of her mother at the same time she witnesses her mother's silent encouragement of this act, for after all money had in some way to make its way into the house. "That's why, though she doesn't know it, that's why the mother lets the girl go out dressed like a child prostitute" (24). The girl is thus both overcome by the sense of disgrace upon her and absolutely defiant of it, because the family's situation has already forced her into a state of distress so deep that it is synonymous with shamelessness. As she tells her lover, "I don't regard my present misfortune as a personal matter. . . . I say we lived out of doors, poverty had knocked down the walls of the family. . . . Shameless, that's what we were. That's how I came to be here with you" (43).

This sense of fatality is in part what makes the image of the girl so moving and so elusive. Still very young she becomes very old, with a face "in advance of time and experience" (9), a face that precociously announces its appetite for desire and alcohol: "I acquired that drinker's face before I drank. Drink only confirmed it. The space for it existed in me. . . . Just as the space existed in me for desire. At the age of fifteen I had the face of pleasure, and yet I had no knowledge of pleasure" (9). The face whose image was never captured on film cannot be fixed in time or place—just as the narrative voice refuses to be clearly assigned to either the young girl or the adult—because the reality of that girl/adult's presence knows no such boundaries. The first line of the novel, "one day, I was already old, in the entrance of a public place, a man came up to me," literally refers to the adult, but in later readings it is impossible to read the phrase "I was already old" without hearing the echo of other words: "Very early in my life it was too late. It was already too late when I was eighteen" (4); so that images give way to words that summon up other words, producing images that will simply not stay still.

Duras, then, I would argue, assumes the legacy of the holocaust in several ways. First, she rejects the idea of the image and representation as the privileged means of gaining access to the real. She does this by continually undermining the "classical notion of mimetic language in which the sign is seen as referential (representing/replicating in a perfectly stable, self-identical manner that which it signifies)."[92] Duras is unremitting in her insistence that the reader witness the traumatic events of the past from a perspective that refuses to reduce them to a false transparency of sense in the same way that the narrator is never

allowed the comfort of having grasped a final truth unbeset by contradiction and unintelligibility. Memory, "like the language she uses, ... constantly breaks down its own referentiality."[93] Duras leaves her readers on the threshold of the real but always reimmerses them in a fragmented reality whose meaning we cannot quite put together, a past that will not stay within fixed boundaries and a memory that is marked by the need to forget as well as to remember.

Second, she underlines the degree to which the witness, who is both a participant in and observer of traumatic events, is inevitably molded by the very system she struggles against and for that reason is never left completely untainted by that experience, with the result that the absolute line between guilt and innocence becomes increasingly difficult to draw. There is no doubt that the older brother represents the embodiment of evil: "My elder brother can't bear not being able to do evil freely, to be boss over it not only here but everywhere" (60)—but the girl's admission that she herself is haunted by the desire to kill her brother, an urge in part motivated by the jealousy she feels of the privileged place he holds in relation to the mother, testifies to the extent that she, too, has been implicated in the network of fierce passions surrounding her. It is true that she is an abject victim of the vicious collaboration between mother and brother, most searingly portrayed in the scene when the mother, urged on by the brother, rails at and beats the girl for being a prostitute. But it is also true that when she is with her lover in the company of her family, she completely submits to their abominable treatment of him:

> In my elder brother's presence he ceases to be my lover. He doesn't cease to exist, but he's no longer anything to me. He becomes a burned-out shell. My desire obeys my elder brother, rejects my lover. Every time I see them together I think I can never bear the sight again. My lover's denied in just that weak body, just that weakness which transports me with pleasure. In my brother's presence he becomes an unmentionable outrage, a cause of shame who ought to be kept out of sight. (52)

The narrator registers her own susceptibility to the power of the older brother and the betrayal and hypocrisy that marks her as an accomplice to their scandalous treatment of this man who takes them dining and dancing without complaint. Moreover, she hints at a subtle attraction between this brother and sister that keeps her from dancing with him: "I was always held back

by a sense of danger, of the sinister attraction he exerted on everyone, a disturbing sense of the nearness of our bodies" (53). The unspeakable nuances of this relationship are further suggested by the girl's assurance to her lover that he need not be afraid of the brother "because the only person my elder brother's afraid of, who, strangely, makes him nervous, is me" (54). The entanglement of mother, brothers, and sister is beyond any definitive sorting out; the violence and despair that permeate their lives is all-encompassing, making absolute lines between good and evil impossible. If the elder brother is the epitome of evil, he is also a reminder of how close at hand evil is and how difficult it is to keep one's own skin pure. Herein lies the reason for the narrator's shocking and unprecedented announcement: "I see wartime and the reign of my elder brother as one" (62); the effects of neither can be contained:

> I see the war as like him, spreading everywhere, breaking in everywhere, stealing, imprisoning, always there, merged and mingled with everything, present in the body, in the mind, awake and asleep, all the time, a prey to the intoxicating passion of occupying that delightful territory, a child's body, the bodies of those less strong, of conquered peoples. Because evil is there, at the gates, against the skin. (63)

In the light of this recognition, one of the most disquieting scenes in the novel must be viewed, one that brings us directly to the site of the war and the disturbing ethical issues raised. Without any narrative connection, Duras suddenly situates us in wartime Paris with no effort to provide logical or thematic continuity. Abruptly, she provides two portraits of foreign women, both offering their homes for the entertainment of intellectuals during the German occupation. Mysteriously they appear, Marie-Claude Carpenter and Betty Fernandez, attractive, intriguing women, and just as abruptly they are gone, never to return to the text.[94] At the Fernandez home, guests are treated to the incomparable grace and beauty of the hostess and the delicious conversation of the host, Ramon Fernandez, whose unequaled knowledge and understanding of literature are offered lightly and with "a sublime courtesy" that keeps the guests rapt for hours. Sincere, loyal, compassionate, they are the most desirable of people, yet, in the next sentence, we are told, "Collaborators, the Fernandez were" (68). Stunned (and stung) by this remark, matter-of-factly stated without change of tone or style, we are put, one imagines, in the same unviable position as the

narrator when she herself had been faced with such discoveries. Does such knowledge completely vitiate one's appreciation and liking of people, canceling out all other considerations? Duras suggests not; earlier she remarks of Betty Fernandez's grace: "Nothing mars its perfection still, nothing ever will, not the circumstances, nor, the cold or the hunger or the defeat of Germany, nor the coming to light of the crime. She goes along the street still, above the history of such things however terrible" (66). Such statements leave one not completely comfortable, but that is, in part, the aim of Duras's honesty. Most important to note is that for Duras, the morally superior position is untenable; absolute distinctions between good and evil, innocence and guilt, "martyrdom and infamy" (68) are impossible, for she recognizes that there is no hard distinction between those capable of good and those whose lives become caught up in the malignant effects of brutal regimes just as there is no absolute line between those capable of horror and violence and those not. Such realizations do not in any way deny the atrocities and abominations wrought by malignant forces; neither do they refuse to assign guilt where guilt belongs, but they leave room for nuanced judgments, and, most importantly, they refuse the comfort and complacency of the position that self-servingly divides the world up into the good and the bad and allows one to evade his or her darkest impulses by projecting them onto the evil out there. In *The War,* Duras puts the matter very clearly, "We are of the same race as those who were burned in the crematoriums, those who were gassed at Maidenek; and we're also of the same race as the Nazis."[95] A member of the Resistance, the wife of a man captured and almost completely destroyed by the Nazis, Duras nonetheless refuses the comforts of a position of innocence. Her position emerges most dramatically in the words that follow her revelation that the Fernandezes were collaborators: "And I, two years after the war, I was a member of the French Communist party. The parallel is complete and absolute. The two things are the same, the same pity, the same call for help, the same lack of judgment, the same superstition if you like, that consists in believing in a political solution to the personal problem" (68). Again without transition or shift in tone, Duras unflinchingly presents the most scandalous announcement. When questioned by Bernard Pivot in an extended interview on the television program *Apostrophes,* she quietly affirmed her remark without passion or elaboration. Again the reader is left discomforted, wanting to question, qualify, remove

the outrageous quality of the remark, yet at the same time, she or he is left long meditating on these words that refuse to be reduced to an acceptable meaning and refuse to go away. In this way Duras again takes up the uneasily resolvable moral questions raised by the holocaust and engages us in an inescapable dialogue, demanding our participation and immediate involvement in that historical crisis in a way that will leave our lives "forever inhabited by that passage." Perhaps this is the only way to exorcise the demons that have taken hold in contemporary history and reinvented hell "as the space of a compulsive overlooking, the terrible space of looking and not seeing,"[96] the very attitude fostered by a culture steeped in the effects of the photographic image.

As witnesses to a life that bears testimony to personal trauma transmuted through the filter of historical crisis, readers of Duras's autobiography/novel reach toward a new sense of the possibilities of the autobiographical form, one that will always be at odds with the promise of representation offered by the visual image. Present and past meet in an act of writing that keeps us poised on the threshold of recognition so that we are continually reminded of what must never be forgotten: the dark and violent spaces that traverse all culture and all being. The promise of representation gives way to the possibilities of figuration as the lure of images returns us again and again to the resonance of words through the grace of their silences. An observation by Milan Kundera in *The Book of Laughter and Forgetting* might serve as a gloss on the seductive quality of Duras's text: "if beauty is to be perceptible, it needs a certain minimal degree of silences."[97] But an even more penetrating comment comes from Felman: "a certain way of keeping silent can make the stones speak—can intensify in other words, a certain sort of testimony that, although unspoken, speaks for itself."[98]

The next chapter brings us to a very different kind of testimony but one that also speaks out of a history of racism and genocide that is all but impossible to assimilate. Leslie Marmon Silko's *Ceremony* transports us to the Native American experience in the contemporary world but draws on ancient traditions of ritual and storytelling to create a narrative that integrates both oral and written traditions. Recognizing the dead end of Western hierarchical oppositions, Silko invites us to consider the figure of the spiderweb as a structure that refuses such dualisms and points us instead toward those points of intersec-

tion where disparate lines are woven together to create hybrid forms. The web can be considered a kind of labyrinth, but one with significant differences from the maze as it is conceived by our culture. These differences, Silko implies, offer a possible means of renewal for a global community otherwise headed for destruction.

5

Labyrinths and Spiderwebs:
Leslie Marmon Silko's *Ceremony*

THE most tantalizing quality of the labyrinth is that it testifies to the enormous skill, intelligence, and creative power of human beings at the same time that it reflects the devouring fear, bewilderment, and insecurity that threaten to dissolve our tenuously balanced lives. It is all a matter of perspective—whether one views the whole structure from without and can appreciate its impressive artistry or one is confined to its bewildering interior, unable to see the center or escape its claustrophobic contours. These dual possibilities are embodied in the figure of the great artificer himself: Daedalus, the brilliant designer and master craftsman of the Cretan labyrinth, and Daedalus, the unfortunate prisoner of his own intricate convolutions.[1] It no surprise, then, that Daedalus's only means of escape is a strategy through which he can reclaim the distant and privileged position from above that allows him again to *see,* and to seize, the whole design and master the twistings and turnings he himself has conceived. His winged flight might thus be seen as an affirmation of the power of the eyes and a turning away from the more subtle sensations of the ear whose coils are evoked by the intricate passages of the maze.[2]

In contrast to the secure and stable view from afar that offers clear and patterned forms is the precarious position within the labyrinth. This interior has been interpreted as a feminine and womblike space, seductive but deadly, an unmarked realm that must be penetrated, traversed, mastered, and then left behind. In psychoanalytical terms its dangers have been aligned with regression and its coils interpreted as a symbol of maternal longings and repressed desires. More generally commentators have emphasized that the danger of this convoluted space is that its presence—that is, the degree to which its presentness overpowers human consciousness—induces forgetting and in-

vites the severing of ties with past and future and the abandon-
ment of human will.[3] In this way the maze undermines the very
force of the heroic quest. Thus, it is imperative that the labyrinth
be mastered even if at times the crucial aid is furnished by a
woman: an Ariadne who offers Theseus the thread that provides
his bearing, affording him the spatial and temporal continuity
that the labyrinth seeks to disrupt. As Fletcher underlines,
"without the silken thread of Ariadne, the hero would suffer
from a breaking, a splintering, a rupturing of *continuous*
awareness."[4]

The presence of Ariadne, however, beckons us toward another
dimension of the labyrinth and another way of seeing the place
of women in relation to this structure—not just as an object of
regressive longing but as a woman to whom agency can be as-
cribed. The thread that Ariadne offers Theseus, which allows
him to retrace the labyrinth's windings, is both a weaving and
"a kind of writing." As "a sign that is also a design," Ariadne's
intervention reminds us that even if women have not always
had control of the word in the master discourses, they have spun
their own creations of labyrinthine design in forms of weaving
and embroidery that compare well with the arts primarily asso-
ciated with men: "the labyrinthine intricacy of engraving or of
biblical or Greek storytelling." As Miller underlines, the visual
patterns woven by women and the intricate designs of illumi-
nated writing wrought by men reveal the inadequacy of gender
distinctions that relegate women's work to the ornamental and
identify men's endeavors with the potency of language.[5] The im-
age of woman as weaver leads us further into the mysteries and
implications of the labyrinth's structure, revealing that the laby-
rinth itself is a defense against the very act of weaving under-
stood as the ultimate feminine power of the giving and taking
away of human life. Beyond Penelope, genius of the art of weav-
ing and unweaving, inscribing deferral (the crucial dimension
of the maze) within the very act of creation, lies the classical
figure of the Three Fates, spinning and cutting the threads of
our destiny, doling out the time and destiny allotted to us on
earth.[6] (It is fitting to recall here that *span* as in *life-span* comes
from the verb *spin* whose original meaning was to draw out,
stretch long.) Unlike the monumental proportions of labyrinths,
the products of such weaving—whether the fabric woven of mul-
tiple and various threads or human existence itself—are fragile:
holes appear; the cloth unravels. Is it no wonder that men flee
the knowledge of such delicate and mortal matters to create

structures of labyrinthine artifice, "monuments of unageing intellect," which nevertheless embody the very fears that they have been constructed to keep out?

The labyrinth has thus been interpreted as an archetypal image giving expression to the disorientation and total loss of perspective that threaten the male hero as he struggles to affirm his male sovereignty. In his *Anatomy of Criticism,* Frye situates the symbol within the context of his "central unifying myth," the heroic quest:

> Corresponding to the apocalyptic way or straight road, the highway in the desert for God prophesied by Isaiah, we have in this world the labyrinth or maze, the image of lost direction, often with a monster at its heart like the Minotaur.[7]

The monster at the center is the image of death that must be conquered if the initiatory rite is to be fulfilled.[8] To kill the beast is to penetrate the sacred center of life's mysteries and liberate the elemental forces that will transform the hero as well as his society. The creation, however, remains even after the death of the creator and/or enemy (who some, including Ruskin, have identified with the spider). Thus, the labyrinth beckons us to further inquiry in the same way that the figure continues to intrigue both writers and critics long after the demise of the belief in its power to give us access to the sacred mysteries.

In the Middle Ages, visual and literary labyrinths flourished, embodying cultural and religious assumptions and giving rise to allegorical interpretations. The two forms of labyrinthine structure, multicursal and unicursal models (the latter predominating within the visual arts),[9] metaphorically incorporate different, though related, versions of the human predicament. The multicursal model, offering us mazes with as many paths as dead ends, the frustrating experience of embarking on routes that lead nowhere, and continually returning us to the need to choose again, accentuates the role of moral choice in a world fraught with error, deception, and sin. On the other hand, the unicursal model has only one path, and although its way to the center is the longest one conceivable, its twistings and turnings exhausting and disorienting, the maze itself will eventually be its own authentic guide. Thus, "the single circuitous passage of the unicursal type argues that persistence in the difficult path prescribed by God—or in the devious path designed by the devil, or in the philosopher's complex argument—leads ineluctably to

the appropriate destination, be it heaven, hell, or knowledge."
Rather than focusing on the subject's judgment and responsibil-
ity and emphasizing the importance of intellectual or moral de-
cisions, this maze is a "perfect symbol of the need for the patient
endurance of unpredictable twists of fate."[10] Although at first
this model might seem less formidable than the multicursal
form that continually subjects the wanderer to paralyzing ambi-
guity and doubt, its very technical simplicity suggests an even
more terrifying subjection just because there is so little power
to choose.

Whichever the model, however, maze-walkers leave them-
selves open to the paradoxical structure of the labyrinth: an
order inextricable from the experience of purposeless confusion
and delay, a liberation inseparable from the act of entrapment.
These paradoxes, of course, are what give rise to the maze's meta-
phorical potential; although exact meanings change depending
on historical and cultural contexts, one thread is continuous:
"Its very point is to impose a confusing and difficult process on
someone because that extraordinarily baffling process is just
what it takes to prepare the maze-walker for moral, aesthetic, or
intellectual transcendence."[11] Even when notions of transcen-
dence and center are cast off, as in contemporary deconstruc-
tionist thought, they hover in the background, assuming a
presence by the very fact of denial. How difficult, almost impos-
sible, it is for us to conceive of a structure without purpose or
center, emerges as a recurring theme in Derrida's writing be-
cause, as he underlines, "even today the notion of a structure
lacking any center represents the unthinkable itself."[12]

This being said, there is no denying that modern and postmod-
ern writers have attempted to bring us closer and closer to the
"unthinkable itself." The sacred space of the medieval world with
its rites of initiation and promises of renewal gives way to the
profane space of urban streets, bureaucratic institutions, and
the labyrinthine structure of the unconscious. For writers like
Kafka, Robbe-Grillet, Calvino, and Borges, the twistings and
turnings of labyrinthine space provide no revelatory center and
promise no point of delivery. Our fascination, however, is undi-
minished, for what fascinates us in the structure is the working
of the line itself: the line in the process of contesting its own
linearity.

In Robbe-Grillet's *In the Labyrinth,* perhaps more than in
any other text, we experience on the level of both plot and form
this repetitive and convoluted structure of the line.[13] The plot—

a soldier's futile wanderings in a city of identical buildings as he traces and retraces his course in the attempt to deliver a box to a dead comrade's father—as well as the obsessively repetitive style, offers us a circuitous design of tentative beginnings and turnings, subtle variations, shifts and dead ends, all fraught with the ambiguity, contradiction, and doubleness that are the labyrinth's defining features. The experience of disorientation is here taken to a new extremity as the perspective on the maze from afar and the experience from within are no longer separable. Neither character nor readers are given the comfort of a line marking the border between interior and exterior space: the hard-edged frame of a painting, for example, will without warning become the "real" space of the soldier's movements.

The labyrinth thus pulls us in two directions: to the straight line, which "is a powerful part of the traditional language of occidental metaphysics," and to the curves, convolutions, and repetitions that contest its very linearity. The image of the straight line upholds our ideas of causality and chronology, logocentrism and hierarchy (the great chain of being); it attests to our devotion to beginnings and endings, unity and efficacy (the shortest distance between two points is a straight line). However, the labyrinth also superimposes the notion of complexity on the image of the straight line, as Miller, paraphrasing Ruskin, tells us: "The Daedalean labyrinth, made from a single thread or path curved and recurved, may serve as a model for everything "linear and complex since."[14] In the maze the line doubles back on itself, crosses, breaks, thus subverting its own linearity at the same time that it tantalizes us with the promise of an end: the completion of its line.

Writing in the wake of deconstructionism, Miller provocatively traces the implications of this imagery for the narrative line of realistic fiction, suggesting the extent to which this ancient structure can serve poststructuralist critics as well as modern and postmodern writers. For Miller the central insight is that "the image of the line cannot . . . be detached from the problem of repetition," and he goes on to "explore the way the 'simple' linear terminology and linear form of realistic fiction subverts itself by becoming 'complex'—knotted, repetitive, doubled, broken, phantasmal."[15]

In the context of modern and postmodern inquiry, the struggle within the labyrinth is almost always couched in terms of failure. The attempt to comprehend narrative structures, whether in literary forms or dreams, inevitably confronts the

refusal of words to stay put and yield a definitive meaning. Caught in a continuously expanding network of signification, words, as Freud concludes in *The Interpretation of Dreams*, will always defeat our efforts to pin them down. What he tells us about the labyrinthine designs of dreams will later be taken up by critics and applied to literary texts:

> There is often a passage in even the most thoroughly interpreted dream which has to be left obscure; this is because we become aware during the work of interpretation that *at that point there is a tangle* of dream-thoughts *which cannot be unraveled* and which moreover adds nothing to our knowledge of the content of the dream. This is the dream's navel, the spot where it reaches down into the unknown. The dream-thoughts to which we are led by interpretation *cannot*, from the nature of things, *have any definite endings*, they are bound to *branch out in every direction into the intricate network* of our world of thought.[16]

Following the disparate lines of interpretation leads to no center but further entanglement; where we expect connection and revelation (the navel), there is instead disconnection and a knot that refuses to be untied. For Miller, the impossibility of penetrating the center or mastering the labyrinthine structure of narrative is inherent in the position of the critic whose terminology is always to some degree already inscribed in, and dictated by, the text itself: "My exploration of the labyrinth of narrative terms is in its turn to be defined as an impossible search for the center of the maze, the minotaur or spider which has created and so commands it all."[17]

The fundamental question of the labyrinth is finally that of the mind thinking itself, or, as Fletcher puts it, "the process of thinking itself when that process is subjected to any deeply disorienting stress";[18] and this "failure of reason" is Miller's primary concern: "the inability of the mind to reach the center of the labyrinth of narrative terms and so command it." Miller elaborates on the impasse of the critic against the overlapping of distinctions, the seduction of false centers, and the impossibility of reaching a sufficiently distant perspective from which to approach the literary work. But at the same time that he cedes before the impenetrability of the text: "No one thread . . . can be followed to a central point where it provides a means of overseeing, controlling and understanding the whole,"[19] one feels, at the very moment of his denial, the force with which he is compelled by the momentum of the line, the drive of the perennial

quest, to oversee, understand, and control the whole. Fletcher's acute analysis of the labyrinth similarly reflects the way in which the sense of impotence and the drive for mastery invariably form two sides of the dialectic as he emphasizes how the maze with its threat of the "total loss of all controlling awareness" summons up the desire for "an increase of dimensions of perspectives." He shows us how Daedalus's escape is predicated on his ability to add to the two-dimensional space of the flat layout of the maze the third dimension of distance and posits the fourth dimension of time (memory) as the necessary addition that would ensure the desired mastery of perspective. Fletcher then concludes: "At the outer edge of the mythology of the maze there will always be found an insistent theme of the gaining and losing of a more or less complete remembrance."[20]

Stimulating and subtle as these analyses are, I cannot wonder if there is any way to free our thoughts from the compulsion for mastery and the desire to control that inevitably figure as the ground for such discussions. Is there an alternate, if not definitive, way of imagining our relation to the world that would liberate us from the drive for total recall and total vision to which we continually aspire at the same time that we deny its possibility? Is there no escape from the linearity challenged but not vanquished by the convolutions of the labyrinth? What would it mean in concrete terms to imagine a hero or heroine as someone not seeking to gain control of a world that is experienced as a fixed background—in the image of the static structure of the labyrinth—simultaneously distant and confining? If contemporary theories have provided us with the means for challenging the logocentric notions of chronology, causality, hierarchy, and efficiency, how then might we imagine the quest of a hero or heroine that refuses these categories without delivering ourselves to a hopelessly fractured and chaotic future?

Obviously, I have no definitive answers to these questions. But I do have certain insights gleaned from a novel whose symbolic structure is that of the original labyrinth, the spiderweb, a figure, however, that is not entirely in the likeness of the labyrinth as Western consciousness has conceived it. The novel is *Ceremony*, its author Leslie Marmon Silko, an American Indian born and raised on the Laguna Pueblo Reservation. She is not, however, a full-blooded Indian, but of mixed racial origin, a fact that has important implications for her novel and especially for our reading of its central image.

Part Mexican and Anglo as well as Native American, Silko rep-

resents the complex multiethnic position of many contemporary Indian writers and draws us to the particular cultural and historical circumstances in which Native Americans write today. The late 1960s and 1970s were marked by an unprecedented social and political consciousness among Native Americans in modern times.[21] The political activism of the Civil Rights movement in the 1960s, as well as the emergence of a distinctive literary tradition, epitomized by the Pulitzer Prize being awarded to N. Scott Momaday in 1969, contributed to a resurgence of interest in tribal identity by both young and old, urban and traditionalist Native Americans. Such events as the capturing of Alcatraz Island (1969) and the long occupation of Wounded Knee in 1973, during which the Oglala Sioux Nation announced its independence and sovereignty, point to a new political assertiveness that was to be reflected in the literary works of young Native Americans. The insistence on destroying stereotypes of Natives as either uncivilized creatures or noble savages, the assertion of the sacred sense of place, and the delineation of the particular horrors faced by Indian war veterans, when confronted with the unimagined forms of annihilation devised by Western culture, all figure as important concerns in this literature.

Inheritor of a rich tradition of ritual and storytelling as well as an avid student of the Western classics, Silko seeks to integrate oral and written traditions in her novel in order to address both the most urgent problems of her own people and concerns that have become essential to all Americans. Beginning with the counterculture movement of the sixties, which challenged the materialistic bias of American life and privileged communal and collective values, we have become increasingly engaged with environmental, ecological, and feminist issues that make the nonpatriarchal and nonanthropocentric cultures of our indigenous peoples emphatically relevant. The growing interest in Native writers, attested to by the large number of original and critical works published in recent years, has not, however, diminished the grave problems of Native Americans, that is, their struggle for survival both as individuals and as tribal cultures. Silko's novel thrusts on us with bitter irony the contrast between this people's rich and enduring traditions (as well as the mineral wealth of their lands) and the dire state of their present circumstances. Witness to the desecration of her people's land and values, to the alienating effects of compulsory monolingual education, and to the alcoholism, violence, and despair that

threaten to destroy her people, Silko understands the crucial importance of communal renewal. Her appeal to the spiritual values of the Native American people is no less a political act than the more militant protests enacted during the '70s, for what is at stake here is the power of her people to reassert control over their lives. As Stephen Cornell notes, the very meaning of political power must be understood somewhat differently in regard to the Native American tradition: "it was power largely perceived and pursued . . . not as a relationship among persons or institutions, but as the spiritually given capacity of objects, persons, or other natural phenomena to order and reorder relationships, events, or the world itself."[22]

Silko's novel is thus an attempt to enact a ceremony that will heal and renew her community; at the same time, it is a warning to the rest of us of the devastating future we are creating unless we confront the concrete effects of American imperialism and progress. If for Duras, the revelation of the concentration camps' atrocities is the turning point of her conscious development, one might suggest that for Silko, the pivotal moment is the awareness that the land that served for the sacred ceremonies of the Indians is the same land where scientists prepared the first atomic bomb explosion (16 July 1945). What is essential for both writers, however, is the knowledge that we can no longer take refuge in dividing up the world between we and them, the pure and the impure—whether we cast the enemy as Germans or American oppressors. It is simply too late for such self-serving ideologies. For this reason Silko directs us to the interweaving threads of the spiderweb and the unanticipated perspectives they engender.

Similar to, yet distinct from, the labyrinth, the spiderweb is formed by a series of interlacing lines, some extending outward, others circular. Essential to the structure, however, and this distinguishes it from our usual perception of the labyrinth, are the points of intersection where those lines of difference come together. Most important, then, are not the lines of opposition, dualistic categories, but those points that take part in neither unilateral direction but partake of both. The web thus focuses our attention on what is transitional, the moment of becoming, and directs us to what is marginal, impure, and what cannot be reduced to the dimensions of a line or single thread.

We again return to the image of weaving, this time as a particularly provocative image of just what has been prioritized and what has been excluded from discourse in the English language.

Françoise Lionnet, writing about the marginal position of post-
colonial Francophone writers, underlines that the positive con-
notations of the French words *métis* ("a distinct but unstable
racial category") and *métissage* (braiding) are absent from their
English counterparts. The English translations of *métis* as "half-
breed" or "mixed blood" inevitably carry connotations of "bio-
logical abnormality and reduce human reproduction to the level
of animal breeding."[23] Furthermore, they banish the primary
meaning of the word, which "refers to cloth made of two differ-
ent fibers, usually cotton for the warp and flax for the woof: it
is a neutral term, with no animal or sexual implication." This
concept of *métissage* (that is refused linguistic presence in En-
glish) thus embodies the metaphorical implications of weaving
as that which allows for difference and sanctions hybridization
in all forms including racial "mixing" rather than privileging
ideas of cultural and racial purity, an "extremely fallacious and
aberrant form of human classification, born of the West's mono-
theistic obsession with the 'One' and the 'Same.'" The fear of,
and prejudice against, interracial mixing is thus inscribed in
our linguistic as well as our historical roots. This "blind spot of
the English language" that radically informs our culture is what
Silko seeks to make visible by valorizing the principle of differ-
ence inscribed in the very act of weaving. Her novel in a sense
gives voice to what Lionnet reminds us are the social implica-
tions of Darwin's principle of divergence: "the more varied the
life forms in a given environment, the greater their chances of
thriving. Hybrid configurations and diversified descendants of
original species have the edge in the struggle for survival." If
this principle is far less noted in our culture than Darwin's
theories of natural selection, the reason is far from innocent.
As Lionnet underlines, "it is excluded by a politics of knowledge,
which values power and appropriates legitimacy to the strong."[24]

Silko brings us back to those scenes obscured by patriarchal
law: women weaving the world, and life and language luxuriant
in their diversity and multiplicity. As a woman of mixed racial
and cultural origins, she is particularly attentive to the vitality
that difference brings into being; therefore she will challenge
the cultural myths that have attempted to deny the history and
gifts of her people in order to weave new connections between
past and present, the old stories and the new, with the aim of
transforming our symbolic systems, for "the symbolic is real,
and in its symbols lies our only hope for a better world. To
interpret the world is to change it."[25]

We begin, then, with the image of the spiderweb and the way this structure transforms our vision of the quest motif around which *Ceremony* turns. The spiderweb is organic, its structure not fixed but growing, always dynamic, always seeking equilibrium: the vertical and horizontal lines reaching toward each other. As an image of the world in which (and not over and against) the hero moves, it insists on the continual need for movement and balance. The hero does not travel through a static world, imposing his will on a fixed background; his motion is always played out against a larger pattern of movement to which he must be continually attentive. This sense of a continually shifting pattern that characterizes the Native American worldview also affects Silko's understanding of narrative as the accretion of a series of related stories rather than a narrative line constructed in terms of conflict, crisis, and resolution. The form and texture of the novel is as much a reflection of the central symbol as is the novel's vision. The lines of the spiderweb figure forth an equilateral space, one that rejects all notions of hierarchy and dualistic oppositions. Silko's novel thus raises provocative questions about the relation between poetry and prose, fiction and myth, and the oral and written traditions at the same time that it valorizes mixed blood, racial impurity, the marginal, and the transitional. The following remarks are an attempt to trace out the way these two sets of questions mesh, first focusing on the text as web, that is, the way the image of the spiderweb informs the structure of the text itself and then considering the web as text, the way the spiderweb provides a vision of human existence that cannot be entirely subsumed within the parameters traditional readings of the labyrinth offer.

First, however, let me suggest that the web is every much as provocative as an image of the experience of reading as the labyrinth is. As a structure whose design is already inscribed before its becoming, yet which can only come into existence in time, the web figures forth the divided and paradoxical experience of reading: the text as something that is already there behind us yet still before us as something to be created. The image of the web neatly holds up other related questions. Does, for example, the moment of departure, the hub of the web, from which the lines of the text radiate, posit a central structure that becomes accessible to the reader in the course of reading, or do the multiple strands and crisscrossings deny the very notion of a unified discourse? Is the act of reading a means of exercising one's freedom and creativity that finally leads to liberating one-

self from the confines of the text? Or does one inevitably become embedded and entrapped by the very web of meaning he or she constructs? That such metafictional questions are not alien to Silko's novel will become obvious as we go along; for the moment let me just note that the hero's central awareness is of being in a design that "was still growing but long ago had circled him" (126).[26]

Ceremony immediately situates us within the spiderweb at the moment of its creation and with its creator Spiderwoman. The first page of the novel offers us a poem that recounts the ancient Pueblo myth of the beginning of things:

> Ts'its'tsi'nako, Thought-Woman,
> is sitting in her room
> and whatever she thinks about
> appears.

> She thought of her sisters,
> Nau'ts'ity'i and I'tcts'ity'i,
> and together they created the Universe
> this world
> and the four worlds below.

> Thought-Woman, the spider,
> named things and
> as she named them
> they appeared.

> She is sitting in her room
> thinking of a story now

> I'm telling you the story
> she is thinking.

The novel begins with the assertion of the identity of the original act of creation and all subsequent acts of storytelling. The emphasis on the ritualistic aspect of this act that Silko invokes here is intrinsic to the oral tradition of literature, but I want to underline that the image of the spider weaving its design is a visual image that immediately establishes a metaphorical relation between web and written text and so insists on the ritualistic nature of the latter. Thus, on one level, the distinction between the oral and written begins to break down, and certainly the force of *Ceremony* emerges from Silko's bringing to-

gether the distant strands of native American perspectives on language and sophisticated literary techniques.

The threads of the web—those lines that radiate outward and encircle at the same time that they go forward—embody the tension between temporal and spatial form (the synchronic and diachronic) that one finds in all narrative. In Silko this tension is crucial structurally, as well as thematically, because she attempts to expand the novel into a form in which myth and fiction, poetry and prose, the oral and written traditions are suspended in a space that knows nothing of hierarchical opposition and that calls into question the very notion of bounded space and, with it, the concept of transgression.

The web dramatically places before us the contrast between Western conceptions of space as well as time and the American Indian's view of the world. For the Native American, space is not linear, but spherical and multidimensional, and time is cyclical rather than sequential. Paula Gunn Allen, a specialist in Native American literature, traces out some of the implications of this difference:

> The circular concept requires all "points" that make up the sphere of being to have a significant identity and function, while the linear model assumes that some "points" are more significant than others. In the one, significance is a necessary factor of being in itself, whereas in the other, significance is a function of placement on an absolute scale that is fixed in time and space.[27]

The spiderweb is an emphatically nonhierarchical form. What is crucial to the structure are the points of intersection where lines of difference come together, those moments of transition (as opposed to acts of transgression) where everything hangs in the balance.

Take, for instance, the example of poetry and prose. In *Ceremony* the prose narrative is interrupted intermittently with poems that are, for the most part, retellings of Indian myth. The eye is drawn in vertically to the center of the page in a movement of contraction that counters the linear movement of the narrative. The privileged status of poetry as conveyor of meaning is immediately felt, and the time of fiction cedes to mythic time, the timeless pattern of the time immemorial stories. Existing in an autonomous space, the poems achieve a self-sufficiency that is reinforced by the lack of transitions between the poetry and what comes before and after. We might say that Silko has suc-

ceeded in giving to fiction the spatial form, the vertical dimension, it craves; while the prose narrative presents the story of Tayo, a "half-breed" returned from the Second World War broken and distraught, and recounts his struggle for a means of renewal, the poems offer stories of the land laid bare by drought, of clouds imprisoned, and of the terrible need for rain. With childlike simplicity the poems tell, for example, of the flight of hummingbird and green fly to the world below where they seek help from Spiderwoman, the mother of all creation. But such quests are never easy, to quote an oft-repeated refrain of the novel, and Spiderwoman will send them first to old Buzzard to ask him to purify the town. He, however, will do nothing until an offering of tobacco is made so back go hummingbird and fly to Spiderwoman to get advice. "Go to caterpillar," she tells them, and the story goes on and on. It is never easy, and so the story comes to us not all at once but in poetic fragments that are interspersed throughout the narrative. Matters are further complicated by the fact that this story will be further interrupted by other stories (for example, the story of coyote man, of bear child, and of Gambler who deceives the people with witchery), also presented in poetic form, so the principal story is even longer and more dispersed in its telling. One story gives rise to other stories, and each story must be told if one is to understand the timeless pattern of ceremony and ritual. Stories are inevitably embedded in other stories in the Native American consciousness, and so there is never any question of direct linear movement. The reader must hold a multitude of unfinished stories in his mind, some told in prose, some in poetic form, stories of ancient myth and of the contemporary world. The endings, like the beginnings, are not of particular importance. In talking about Pueblo forms of storytelling, Silko stresses that one can never begin at the beginning or bring any one story to a necessary conclusion, for each story is only the beginning of many stories. It is rather as the Hopis say, "Well, it has gone this far for a while."[28]

Rather than on beginnings or endings, the focus is on the crisscrossing of patterns or, as Silko puts it, "the dynamic of bringing things together" through telling.[29] In the novel such moments occur when the timeless world of ceremony and myth touch the story of Tayo and his struggle to understand his mixed-blood heritage. As we read along, we see Tayo as coyote man who has been possessed by an alien beast in his encounter with the white man's war and civilization and who must be purified and restored to health if he is to escape madness and the

self-destructive behavior of other returning veterans. However, he is also the bear child who must be called back home with extreme care and delicacy. Finally, he, like hummingbird and fly, is the means by which his people find wholeness and renewal.

In her mixing of poetry and prose, Silko would seem to have achieved the perfect balance of mythic and fictive elements. Yet one might not feel completely comfortable with this assertion, for do not poetry and myth emerge as the ascendant poles of the opposition? Are we not left with the sense of the privileged status of myth and poetry as conveyors of meaning, as the repository of timeless truths? And are not the worlds of fiction and myth finally irreconcilable? Frank Kermode, for one, would insist on the crucial difference between the two. In *Sense of an Ending*, he writes:

> Myth operates within the diagrams of ritual, which presupposes total and adequate explanations of things as they are and were; it is a sequence of radically unchangeable gestures. . . . Myths are the agents of stability, fictions the agents of change. Myths call for absolute, fictions for conditional assent. Myths make sense in terms of a lost order of time, . . . fictions, if successful, make sense of the here and now.[30]

Kermode's words suggest that any attempt to reduce fiction to mythic patterns belies the very nature of fiction. How then can Tayo's assimilation into the pattern of myth satisfy the desires provoked by fiction, especially contemporary fiction?

The answer is that things are even more complicated than I have hinted. Although almost all the poems are of mythic and legendary material, one poem is immediately striking in its deviation from this pattern. This poem is the Indian veteran's ritual telling of the good old times in Oakland and San Diego when his army uniform brought him the total sense—and the illusion—of belonging to the white man's universe: success with white women and the glory of fighting for the best army in the world. They repeated these stories, the narrator tells us, "like long medicine chants" (43), and this direct comparison, as well as the poetic form in which this contemporary story is rendered, insists on the ritual aspect of this telling and also implies that all stories are equal in their aspiration toward mythic status. All contain elements of ritual magic, and modern fabrications are not to be taken any less seriously than the ancient myths. All stories have equal value even if anthropologists insist on hierarchical distinctions between the two. Silko is adamant on this

point in her general remarks about the Pueblo oral tradition. Ethnologists, she tells us,

> differentiated the types of oral language they find in Pueblos. They tended to rule out all but the old and sacred and traditional stories and were not interested in family stories and the family's account of itself. But these are just as important as the other stories—the older stories and are given equal recognition.

Again later she reiterates, "I want to remind you that we make no distinctions between the stories—whether they are history, whether they are fact, whether they are gossip—these distinctions are not useful when we are talking about this particular experience with language."[31]

If all stories are equal, then the hierarchical opposition between myth and fiction breaks down, and this is what we see happening in *Ceremony*. Tayo will enact a ceremony long inscribed in ancient Indian tradition, but he must transfigure the ceremony if it is to be successfully brought to completion in the present. As the old medicine man knows, the rituals must be subject to change or else the traditions will die and witchery will win. Tayo must find his own way in his own time, and, in the final and most crucial stage of the ceremony, he is without guide or preexistent design. The spiderweb, those interlacing lines of past and present, is not without danger; the threat of entrapment in old, rigid forms is as real as the danger of the loss of the old stories and traditions through forgetting. This recognition reflects the Indian's deep sense of the universe as a living, growing, moving entity. Never static, its promise of continual creation and evolution affirms the individual's power, through her or his own movement, to bring about change.

The emphasis on time, on the need for growth and change, redresses the balance between the prose and the poetry, between fiction and myth. The prose in the novel is in no way subordinated to the poetry. As forceful as the poems are in their promise of eternal return, they do not overpower the intensity or particularity of Tayo's ordeal in the present time. This is in part due to Silko's skilled use of the internal monologue that brings us with painful intimacy into the fractured and guilt-ridden consciousness of the main character. There is no doubt that Silko has mastered the techniques of modernism: the psychological penetration associated with Joyce, Faulkner, and Woolf, as well as their experimentation with the handling of lived rather than

chronological time, narrative discontinuity, and shifts in voice. It would be a mistake, however, to situate the novel only in this modernist context.

The blurring of temporal boundaries, for example, may be a modernist technique, but it is also a means for embodying the distinctive sense of language and the world that Indians enjoy. Achronology is natural to the Indian writer, as Paula Gunn Allen points out, because

> events are structured in a way that emphasizes the motion inherent in the interplay of person and event . . . the protagonist wanders through a series of events that might have happened years before or that might not have happened to him or her personally, but that nevertheless have immediate bearing on the situation and the protagonist's understanding of it.[32]

Allen further points out that for the Indian, chronological time is a reflection of the white man's culture and his creation of industrial time, the time of production, profit and loss, and, even more distressing, the time of colonialization and death. In contrast, an Indian's sense of time is seasonal, cyclical, or simply suspended in space. An Indian can easily hold many different stories in mind at the same time: stories of rituals, of the land, of his people; stories of an individual and of the contemporary world. We might perhaps say that the experience of reading *Ceremony* raises us to the level of Pueblo consciousness.

The division of poetry and prose in the novel is further diminished by the colloquial form of many of the poems and the careful attention to sound and image in the prose. Furthermore, sections of the prose narrative achieve the same kind of autonomy that the poems have: a new story will suddenly begin without transition and sometimes without identification of speaker or subject with the effect that the story itself, rather than an individual, is in the forefront.

This emphasis on stories and their telling brings us directly to the concerns of contemporary critical theory. The innumerable references to words and story in the novel suggest the self-consciousness of postmodernism, but again the context is wider. The Pueblo perspective is grounded in the Indians' acute sensitivity to the world as story, as continuously shifting patterns that must be attended to and recounted. Their immediate experience also tells them that language is already story. As Leslie Silko puts it:

At Laguna, many words have stories which make them. So when one is telling a story and one is using words to tell the story, each word that one is speaking has a story of its own too. Often the speakers or tellers go into the stories of the words they are using to tell one story so that you get stories within stories, so to speak.[33]

The embedding I mentioned before is thus intrinsic to the Indian experience of language. The meaning of each word exists only in relation to other words. Its signification is not immediately present but is before and behind it in stories that give rise to still other stories. We are not far here from the infinite play of signification and deferral of meaning dear to poststructuralist thought, each sign a trace of what it is not. From the Indian perspective, we might simply say, language is fragile, which means the world is fragile because the world, as the original creation story underlines, is thought, or to complete the circle, language. In *Ceremony,* Ku-oosh, the medicine man, tries to communicate this awareness of fragility to Tayo:

"But you know, grandson, this world is fragile." The word he chose to express "fragile" was filled with the intricacies of a continuing process, and with a strength inherent in spider webs woven across paths through sand hills where early in the morning the sun becomes entangled in each filament of web. It took a long time to explain the fragility and intricacy because no word exists alone, and the reason for choosing each word had to be explained with a story about why it must be said this certain way. That was the responsibility that went with being human, old Ku'oosh said, the story behind each word must be told so there could be no mistake in the meaning of what had been said; and this demanded great patience and love. (35–36)

Until the last sentence, with its insistence on an absolute hub of meaning, one feels how closely Native American and postmodern perceptions approach each other.[34] In oral cultures the sense of the fragility, the tenuous quality of words, is crucial. Words are elusive, but for that very reason, they are all the more precious. They are invisible and therefore magical. The central insight of poststructuralist thought is the rejection of the privileged claim of the spoken word as an absolute and fixed presence, the word as the embodiment of logocentric truth; but these assumptions about spoken discourse cannot necessarily be attributed to oral cultures themselves. The fundamental awareness of the Indian is that in the beginning is the word, but

although the words are identical, this awareness is not the same as that found in the fourth Gospel where the power of the word is assimilated into the principle of meaning as unity and truth. From the Indian perspective, John immediately betrays his most important insight. This point is dramatically made by another Native American, N. Scott Momaday, in his novel *House Made of Dawn.* John, he tells us, "had to lay a scheme about the Word. He could find no satisfaction in the simple fact that the word was. He had to account for it—not in terms of that sudden and profound insight which must have devastated him at once. . . . not in terms of his imagination but only in terms of his prejudice." John's mistake, according to Momaday, is that he could not let the truth alone: "He tried to make it bigger and better than it was and instead only demeaned and encumbered it. Made it soft and big with fat."[35]

In contrast, the Indian recognizes that the power of words is inextricable from their fragility. Again, the image of the spiderweb in its combination of delicacy and strength perfectly embodies this realization. In *Ceremony* there is no doubt that the strength of words, their elemental quality, equals that of the material world. Tayo feels "the story taking form in bone and muscle" (226). Words pour out of mouths "as if they had substance, pebbles and stone, extending to hold the corporal up, to keep his knees from buckling, to keep his hands from letting go of the blanket" (12). Words have the strength of the mineral, organic, and cosmic world. There are no limits to the power of stories. If you know the proper story, you can even get to the moon, Tayo had believed when he was a child. It just "depended on whether you knew the story of how others before you had gone" (19).

With this image I will leave the question of the text as spiderweb to take up the question of the spiderweb as text or, in other words, to ask: What might a world be like that was formed in the image of Spiderwoman rather than God the father? Let me say immediately that these speculations are in no way an attempt to represent the worldview of Pueblo Indians but simply to trace out some implications of this specific novel and its use of the Spiderwoman creation myth. At the same time, I will again underline that Silko is not a purebred Indian but a mixture of Indian, Mexican, and White ancestry. And as she herself puts it,

I suppose at the core of my writing is the attempt to identify what it is to be a half-breed or mixed blooded person, what it is to grow

up neither white nor fully traditional Indian. It is for this reason that I hesitate to say that I am representative of Indian poets or Indian people or even Laguna people. I am only one human being, one Laguna woman.[36]

According to the creation story with which we began, Spiderwoman's first act is to imagine two sisters, an expansive circle, a community that would then think into existence the universe whose continuous story it would tell. Creation does not begin, as in Genesis, with the division of all things into a hierarchical order, the establishment of boundaries, and a firm line of linear descent. Spiderwoman brings into existence an ever-expanding structure whose intricacy denies the dualism of hierarchical opposition. Her web stretches from heaven to earth, establishing connection, metonymic relationships, rather than opposition between the two. Thus, if her people look upward to the holy mountain, they also look down at their feet for evidence of her power. There is an irresistible moment in the novel when the distinction between sacred and profane space collapses in the most delightful manner. Sun man, concerned about the disappearance of the rainclouds, goes out looking for his grandmother:

> There, in a sandy place by a blue flower vine,
> Spiderwoman was waiting for him.
>
> "Grandson," she said.
> "I hear your voice," he answered
> "but where are you?
> "Down here, by your feet."
> He looked down at the ground and saw a little hole.
>
> (173)

Unlike God the Father, Spiderwoman does not found a world on the principle of hierarchy and immediately establish the firm lines of law and transgression. The emphasis on linearity in biblical narrative and its rigorous chronology is, as Mieke Bal reminds us in her book on women in the Old Testament, a way of instilling in human consciousness the necessity of staying on the straight and narrow path and the great cost of deviating from it.[37] On the other hand, the structure of *Ceremony,* like that of the web, suggests that transition, rather than transgression, is the crucial matter. "Don't be so quick to call something good or bad," Old Betonie tells Tayo. "There are balances and harmonies

always shifting, always necessary to maintain. . . . It is a matter of transition, you see; the changing, the becoming must be cared for closely. You would do as much for the seedlings as they become plants in the field" (130). People make terrible mistakes; they fall into temptation, but these acts do not isolate them. The responsibility for failure is assumed by the community, out of the knowledge that each person must be guided with great care during these moments of transition, like the boy who walks in bear country and must be called back softly (170). A sensitivity to the extreme delicacy demanded at such instants is engraved deeply into Indian consciousness:

> They couldn't just grab the child
> They couldn't simply take him back
> because he would be in between forever
> and probably he would die.
>
> (130)

And so when Tayo's mother runs off with a White man and has an illegitimate child, it is the responsibility of her sister to bring her back, and her failure to do so brings humiliation on all the people: "What happened to the girl did not happen to her alone, it happened to all of them" (69).

From this perspective the Christian myth, with its emphasis on each person standing alone before Jesus Christ who would save only the individual soul, is dangerously disorienting, for it reverses the entire balance of the Indian world in its attempt to "crush the single clan name" (68). The interweaving of individual and communal responsibility is so ingrained that the Indian's encounter with the individualistic ethic of White society leaves him severely dislocated. This is why Tayo cannot believe the doctors when they try to convince him that he will never get better unless he stops using words like we and us. He knows that they are wrong, that his sickness is part of something larger, "and his cure would be found only in something great and inclusive of everything" (38). Thus, the Indian's inability to separate individual actions from the larger patterns of the world heightens, rather than diminishes, the sense of individual responsibility, for, as Tayo knows, "it took only one person to tear away the delicate strands of the web, spilling the rays of sun into the sand and the fragile world would be injured" (38).

A final point remains to be made about the contours of Spiderwoman's world. Although the notion of transition rather than

transgression prevails, the full impact of evil is in no way dimin-
ished in the novel. The powers of witchery spin out their threads
with as much tenacity and force as the more benevolent powers,
and their stories are easily as compelling. One of the strengths
of the novel is its staunch recognition of the power of evil. It
also assumes, however, the insanity of any attempt to relegate
questions of good and evil to patterns of dualistic opposition.
For the Indian to see the White man as the vicious other who
stole his land and continually flaunts this fact in his face, to
believe that all evil resides within the White race is to ensnarl
the Indian in a net that will destroy him. Even if he has to
confront the desecration of the land each day as he looks out
on the steel and chrome, on the plastic and neon that are the
White man's pride, he must not identify evil with the coming of
the White race, for that will prevent him from looking within
himself and seeing what is really happening. Besides, as Old
Betonie tells Tayo, we, that is, Indian witchery, invented White
people. In other words on one level, the other is inescapably a
reflection of the self. There is a marvelous poem in which Silko
recounts the gathering of the council of witches where each tries
to outdo the others in the concoction of new evils. One witch
sets in motion the story of the White people, and even though
the others are not so sure they want it to continue, they cannot
call the story back:

> so the other witches said
> "Okay you win; you take the prize,
> but what you said just now—
> it isn't so funny
> It doesn't sound so good.
> We are doing okay without it
> we can get along without that kind of thing.
> Take it back
> Call that story back

(138)

For the Indian to assume that all evil resides within the White
man is to be entrapped in a lie in the same way that the White
man is bound up in the lie that he owns the stolen land. What
the Indian must recognize is that the designs of witchery have
become so monstrous that unless new ceremonies can be cre-
ated that will draw on the power of all races, there is no hope.
The ceremonies of witchery are malignant inversions of the
ceremonies of creation and purification, and they have already

reached unprecedented heights in the monstrous pattern formed by the beautiful rocks taken from Indian land, a design whose destructive capacities are so staggering that, in an ironic reversal, all human beings have once again been united in a single clan: in "a circle of death that devoured people in cities twelve thousand miles away, victims who had never . . . seen the delicate colors of the rocks which boiled up the slaughter" (246). The reference, of course, is to the atomic bomb explosion that brings together the metonymic possibilities of the spiderweb with horrific force. It is the ironic and malignant inversion of Tayo's awareness of all people as originally belonging to one clan, the recognition that paralyzes him during the war and leads him to see his Uncle Josiah's face amidst the Japanese enemy. The hallucination is not, as the doctors think, a sign of his disintegration but a reflection of his realization that long ago Indians and Asians were one people. Tayo's mixed blood and his marginal status as a half-breed make him especially vulnerable to pain and loss, but they also allow him the possibility of enacting a ceremony of sufficient power to counter the malevolent designs of witchery.

Tayo's final trial suggests the vision of unmitigated power that evil assumes in the novel. Having realized that he is absolutely alone, that his former friends are in fact his greatest enemies and are about to turn him over to the officials, he runs away and hides in the rocks. To make him appear, the others light a ceremonial fire, a malignant inversion of the rites of purification, and begin to torture the one among them responsible for his escape. He watches in agony, feeling that "he would rather die" than not intervene (252). On the verge of rushing out, however, he realizes that to give in to that benevolent impulse would be to make himself a victim and give the story set in motion by witchery its desired end. He would kill the brute responsible, but he would also put an end to his own life. So he resists. In this scene there seems to me an implicit rejection of the notion of self-sacrifice or of martyrdom, a denial of any idea of good redeeming evil that is intrinsic to the Christian tradition. There is an unflinching recognition of the evil in the world that is here to stay, even if outwitted for the moment, and the terrible cost of living with it. The power of evil is staggering and continuous; it can be curtailed but not obliterated. In this relentless vision, evil is not repressed in the same way that the fact of death is not repressed: "Death isn't much," Ts'eh tells Tayo as she initiates him into her ceremonies, "sometimes they don't make it.

That's all. It isn't very far away" (229). Evil and death are fully
admitted into Indian consciousness; both are part of the met-
onymic web.

All there is for Tayo is to live through the agony of the cere-
mony and thwart, at least temporarily, "witchery's final ceremo-
nial sandpainting" (246). His only relief is to have seen the
pattern: "the way all the stories fit together—the old stories, the
war stories, their stories—to become the story that was still be-
ing told. He was not crazy; he had never been crazy. He had only
seen and heard the world as it always was: no boundaries, only
transitions through all distances and time" (246).

Tayo's journey is not totally unlike quests that we find re-
counted throughout literature. The novel's emphasis on the
need for transformation and renewal that can only come
through the meeting of present time and the timeless world of
ritual links *Ceremony* with the most ancient stories. But there
are, as I have indicated, variations that make all the difference.
The sense of a creator who dwells, not above and beyond her
creation, but within its space, continually empowering all ele-
ments of that creation, gives rise to an image of human existence
freed of the arbitrary and divisive oppositions that structure
our consciousness: the spiritual and material, the human and
natural, male and female. The image of the spiderweb, the sign
that creation is continually in motion, continually expansive,
suggests that instead of actions being conceived of as taking
place out there in opposition to a universe that is fixed and
determinate, human activity might be considered as a matter of
attunement with and attentiveness to the world.

This is the perception to which Tayo must be brought so that
he can feel the unique beauty and particularity of each aspect
of creation and experience his own deep and penetrating rela-
tion to the natural world whose elements and rhythms never
can be desecrated. "As far as he could see, in all directions, the
world was alive" (221), and that sense of vitality is "locked deep
in blood memory" (220). One of the most powerful effects of
the novel is that the reader, as well as Tayo, comes to palpably
experience the distinct quality of wildfowers, weeds, grass, sand-
stone, red clay, yellow pollen, dragonflies, wild honey smells,
the buzzing of grasshopper wings, the smell of juniper, and the
dampness of rain. Ants, frogs, and snakes with copper spots are
neither relegated to the lower orders of creation nor infused
with diabolical symbolic meanings; they are simply there with
their own distinct textures and colors, and for that reason they

are holy. Tayo will be brought to this heightened sense of reality largely through his meetings with two women, Night Swan and Ts'eh, inheritors of Spiderwoman's powers of weaving, perpetuators of the web.

Night Swan inscribes her mark on the world through dancing, the act that assumes primary importance in her life. She remembers neither names of places nor people, but she remembers every time she has danced, and what she knows she dances. It is perhaps fitting to recall here that the Cretan labyrinth was also given expression through dance, "marked out on the ground by the maze-like movements of the dancers," and, as Miller reminds us, "this dance is a form of engraving, the cutting of a furrow making a design on the earth."[38] Dance, too, can be seen as a kind of weaving, as well as writing, its steps an interweaving of signs that become designs, its web a source of entrapment as well as emancipation.[39] For Night Swan, dancing is a means of liberation, revealing the infinite power of her own feeling and desire and freeing her from the misconception that this passion is born of a desire for men. However, for the men who cannot bear the intensity of their own feelings, the dance is simultaneously a liberation and a dead end. Unable to bear the desires that Night Swan's movements have uncovered within him, such a man will first be driven to lies and then self-destructive violence when he finds that this is a woman he cannot destroy:

> He was quitting because his desire for her had uncovered something which had been hiding inside him, something with wings that could fly, escape the gravity of the Church, the town, his mother, his wife. So he wanted to kill it: to crush the skull into the feathers and snap the bones of the wings.
>
> "Whore! Witch! Look at what you made me do to my family and my wife."
>
> "You came breathlessly," she answered in a steady voice, "but you will always prefer the lie. You will repeat it to your wife; you will repeat it at confession. You damn your own soul better than I ever could." (85)

Yet Night Swan's intense physicality does not exclude a spiritual dimension, and thus she is an appropriate woman to initiate Tayo into the mysteries of human sexuality and to reconcile him to the color of his eyes as a sign of difference that cannot, and should not, be recuperated into the reassuring sense of a unified identity. As she tells Tayo, prejudice against those who are different reflects fear and insecurity, and neither Whites,

Indians, nor Mexicans have a monopoly on self-deception or self-destructive tendencies:

> "They are afraid, Tayo. They feel something happening, they can see something happening around them, and it scares them. Indians or Mexicans or Whites—most people are afraid of change. They think that if their children have the same color of skin, the same color of eyes, that nothing is changing. . . . They are fools. They blame us, the ones who look different. That way they don't have to think about what has happened inside themselves." (100)

From Night Swan, Tayo begins to understand his *difference* as a positive value, enabling him to resist racist attitudes and simplistic explanations and offering him the means to a deepened awareness of subjectivity.

Night Swan will be succeeded by Ts'eh, both a mythical figure and a realistically portrayed young woman, who has still other means of continuing the creative designs of Spiderwoman.[40] In her, as in the older woman, spiritual and erotic language are inseparable. Understanding the mysterious and healing powers of herbs, she brings Tayo to an understanding of love and the importance of memory as she matches plants and stones, twigs and roots, always attentive to their colors and forms—arranging them in designs that will ensure that a flowing vitality is preserved. She will teach Tayo that this same vitality flows through human beings and is "locked deep in blood memory" (221). For this reason nothing is lost; all one has to do, as she says in leaving him, is to "remember everything" (235). "As long as you can remember, it is part of this story we have together" (231). Not forgetting is crucial; it is the only means for the feelings between people to survive. The alternative is much worse than even death, for the destroyers "work to see how much can be lost, how much can be forgotten. They destroy the feeling people have for each other" (229). The consequences are lethal, for in destroying human feeling, they render the subject dead to himself, an inert object of his own gaze: "Their highest ambition is to gut human beings while they are still beating so the victim will never feel anything again. When they finish, you watch yourself from a distance and you can't even cry—not even for yourself" (229).

Thus, Ts'eh and Night Swan bring Tayo to an awareness of the creative and destructive forces at work in the universe. Beginning with the smallest living things, the plants whose rhythmic seasons reveal the natural cycle that includes all living crea-

tures, Ts'eh offers Tayo no more and no less than the means of survival, the metonymic, ever-shifting spider's web.

What if the labyrinth with its fixed points of entry and exit, its insistence on linear models of time and space, should cede to the image of the spiderweb, and human beings would look, not to the hero or heroine set on mastering the environment, but to the hoop dancer "who dances within what encircles him demonstrating how people live in motion within the circles of time and space"?[41]

Conclusion

LET me now try to weave together some of the threads left un-gathered and to suggest other possible patterns to explore. Such gatherings, I hope, will also point to ways in which these women writers—distanced from each other in time and space—might nevertheless be brought into significant relation.

To return at the end to our beginning is to realize the degree to which Jane Austen, so firmly grounded in the conventions of the realistic novel, nevertheless already resists the boundaries of this genre and points us toward the matters that will become the central concerns of modernist fiction. Writing in the eighteenth-century tradition in which language is grounded in fixed and determinate meanings, she nonetheless implies that the resonance of words invariably outstrips such restrictions. With her love of word play and delight in a plot that refuses the linear design of conventional narrative (challenging as well the linearity of all human communication), she also—well before Freud—situates us within the play of the unconscious. More-over, Austen's gentle but insistent irony foreshadows the in-creased self-consciousness and self-reflexivity that will mark the stance of modernist writers like Woolf. Drawing attention to these concerns in no way diminishes the necessity of situating Austen in her historical context; rather it underlines the pro-found shift in conceptions of subjectivity, as well as theories of cognition and aesthetics, that define her age. Once doubt is cast on the validity of grounding the particular in the universal law, there is no regulating the effects that follow. As concern with the social representation of identity cedes to the fascination with the mysteries of the inner life, it is only a matter of time until the form of the novel will itself be dramatically transfigured.

On the other hand, if we begin with the last chapter on *Cere-mony* and look back through the enormous differences in cul-tural contexts to *Emma*, we see that in one sense we have come full circle, for we are again in the presence of a writer who is ultimately and urgently concerned with the relationship of the individual to the communal structure. It is almost as though

196

having passed through the agonized and estranged experience of individual consciousness that is the legacy of modernism, we are only now capable of approaching the question of community again—but with the difference that this passage has made. By drawing on modernist techniques to present Tayo's fractured consciousness, Silko is able to make us feel how crucial the experience of community is for him, yet only by going beyond the limits of modernist conceptions and weaving together oral and written traditions does she integrate a vision of community into the fictional fabric itself. In *Emma,* although we might still feel a certain nostalgia, and even affection, for the stable social order represented (as we do for Woodhouse), we also feel its integrity and vitality diminishing before our very eyes. *Ceremony,* however, invites us to conceive of a notion of subjectivity that encompasses our relation to the natural world as well as the entire human community, a conception that, if not yet realized, might still in our culture be born.

Ceremony's insistence on the fragile balance of the world—both the human and the natural—is echoed in its appreciation of the delicate and tenuous nature of words. As we are reminded in the text, the significance of words can only be understood in relation to other words: "the story behind each word must be told" (35). Its meaning is not immediately present but before and behind it and therefore is as much a question of absence as of presence. These concerns are very close to those deconstructionist ideas of the infinite deferral of meaning and the trace, but what I am particularly interested in here is the way this understanding of language that posits itself in opposition to the regime of the visual image emerges in most of the writers discussed in these pages. This common thread is most obvious in the chapters on the photograph and the mirror (with its attendant effects on the genre of autobiography), but it is also present in *To the Lighthouse* and *Emma.* Woolf's novel, like "Sketch of the Past," registers the lure of the pre-Imaginary, which is often portrayed through the homogenous space of auditory experience where the firm contours of the visual image no longer prevail and temporal flux is the most significant dimension. In Austen's novel the sharp delineation of visual scenes is matched by those moments of deepest feeling that are emphatically not represented as if passion by its very excess defies representation or realistic treatment. Although Duras will later draw us more directly to such sites of passion, she, too, will only be able to suggest their abysmal depths by situating us on the edge

that separates word and image. The final thread, then, that I want to follow is the implications of this resistance to the domain of the visual; once again we return to those cultural artifacts with which we began.

As we have seen in the preceding chapters, each of these common objects immerses us in a set of ideological principles, encouraging us to take up certain assumptions about the world and our places in it without pausing to consider that these positions do not correspond to any natural order or essential reality. We are thus marked indelibly without for the most part even being conscious of this process. As I have tried to show, not only matters of gender inequality are at stake, but also the way Western culture has, both literally and metaphorically, privileged the visual sense, giving rise to effects of immense proportions.[1] The whole tradition of Western philosophy, as Martin Jay has succinctly put it, can only be understood in this light:

> From the shadows playing on the wall of Plato's cave and Augustine's praise of the divine light to Descartes' ideas available to a "steadfast mental gaze" and the Enlightenment's faith in the data of our senses, the ocularcentric underpinnings of our philosophical tradition have been undeniably pervasive. Whether in terms of speculation, observation, or revelatory illumination, Western philosophy has tended to accept without question the traditional sensual hierarchy.[2]

Encouraging our belief in our powers to see wide expanses of space, sight privileges simultaneity over temporality and "tends to elevate static Being over dynamic Becoming, fixed essences over ephemeral appearances."[3] It encourages us to reach out for eternal truths to contain and master a reality whose fleeting forms threaten us with images of our own dissolution. Moreover, the prominence of the visual, with its insistence on the distance between subject and object, has inscribed a fundamental dualism on our approach to the world, giving rise to the "concept of objectivity, of the thing as it is in itself as distinct from the thing as it affects me," which then leads to "the whole idea of *theoria* or theoretical truth."[4] Although the result has produced progress unimagined, it has also brought less desirable, and not inconsequential, effects: "the constitutive link between subject and object is suppressed or forgotten," and the living, breathing body, too, becomes consigned to objecthood.[5] That there are no easy resolutions to these matters is obvious; that we approach their complexity and understand what we sacrifice in choosing certain gains, however, is essential. What do we lose, then, in

validating the eye over the ear? Levinas, writing from an ethical perspective, would answer, a great deal:

> In sound, and in the consciousness termed hearing, there is in fact a break with the self-complete world of vision and art. In its entirety, sound is a ringing, clanging scandal. Whereas, in vision, form is wedded to content in such a way as to appease it, in sound the perceptible quality overflows so that form can no longer contain its content. A real rent is produced in the world, through which the world that is *here* prolongs a dimension that cannot be converted into vision.[6]

To resist transforming lived experience into fixed and graspable images is to leave oneself open to the jarring discomfort of the world; to refuse to turn the other into an object of the specular gaze is to leave oneself open to the call of the other. "The face," Levinas tells us, "is not in front of me (*en face de moi*), but above me; it is the other before death, looking through and exposing death. Second, the face is the other who asks me not to let him die alone, as if to do so were to become an accomplice in his death."[7] I would argue that especially since the Second World War, such ethical questions reach staggering proportions and, as Duras shows us, can no longer be separated from aesthetic concerns.

Whether we examine labyrinths, mirrors, or photographs, we are returned to the image of a subject who yearns to conquer all perspectives through a privileged position of ocular plenitude. From this privileging of the unified and stable position of the viewer, the logocentric and phallocentric structures multiply, reducing human lives to dualistic categories organized in hierarchical order. And we continually, if unconsciously, perpetuate this order. The tower gives concrete form to our willing belief in and submission to a master signifier. The letter immerses us in circuits of exchange that reflect our desire to believe in singular and fixed identities and the beneficent authority of a social system that brings into harmony private lives and the public sphere. The convoluted structure of the labyrinth contests but does not vanquish linear designs and affirms our yearning for positions of visual supremacy. Finally, the mirror and the photograph witness our insatiable hunger for an understanding of the world grounded in the ability to *see*. This study has explored the dimensions of this dominant discourse while bringing into view the ambiguity and contradictions, dou-

bleness, and suppressed alternatives inscribed within these beckoning objects: the other scenes that these writers invite us to enter for the sake of us all.[8]

While we cannot hope to remove ourselves from the vibrations of meaning inscribed in these objects, we do not simply have to reenact the old forms, but by pushing them to their limits, we can perhaps reach beyond the boundaries of their assumptions and create gestures toward new configurations. As chaos theory with its attention to nonlinear systems has demonstrated, the most minute fluctuations amplify into effects of unimagined proportions.

Notes

INTRODUCTION

1. Roland Barthes, *Camera Lucida,* trans. Richard Howard (New York: Hill and Wang, 1981), 15.

2. See the discussion of Lacan and metaphor in Juliet Flower MacCannell, *Figuring Lacan: Criticism and the Cultural Unconscious* (Lincoln: University of Nebraska Press, 1986), 91–97.

3. Jamaica Kincaid, "Xuela," *New Yorker,* 9 May 1994, 86.

4. Lionel Trilling, "Manners, Morals, and the Novel," in *The Liberal Imagination: Essays on Literature and Society* (New York: Harcourt Brace Jovanovich, 1940), 208.

5. Kincaid, "Xuela," 86.

6. Jacques Lacan, "Seminar on the Purloined Letter," in *Yale French Studies* 48 (1973): 72.

7. Virginia Woolf, "Mr. Bennett and Mrs. Brown," in *The Captain's Death Bed and Other Essays* (London: Hogarth Press, 1950), 92.

8. Primo Levi, *Survival in Auschwitz* (New York: Collier, 1961), 66.

9. These kinds of questions are raised by Susan Sontag throughout *On Photography* (New York: Farrar, Straus and Giroux, 1973).

10. This perspective is largely influenced by Shoshana Felman and Dori Laub, *Testimony: Crises of Witnessing in Literature* (Cambridge: Harvard University Press, 1987).

11. I am indebted to Françoise Lionnet for her discussion of this term in *Autobiographical Voices* (Ithaca: Cornell University Press, 1989), 13–38.

CHAPTER 1. LETTERS AND THE POST OFFICE

1. Jacques Derrida, *The Postcard: From Socrates to Freud and Beyond,* trans. Alan Bass (Chicago: University of Chicago Press, 1987), 66.

2. Jamaica Kincaid, *Lucy* (New York: Farrar, Straus & Giroux, 1990), 136.

3. Leigh Gilmore, *Autobiographics: A Feminist Theory of Women's Self-Representation* (Ithaca: Cornell University Press, 1994), 205.

4. Janet Altman, *Epistolarity* (Columbus: Ohio State University Press, 1982), 19.

5. As Charles Porter underlines, "there is always an 'internal contradiction' between the letter's implied 'spontaneity, naturalness, and originality' and the inevitable artifice of its form." See Foreword to *Yale French Studies* 71 (1986): 4.

6. Jean Rousset. *Forme et Signification* (Paris: Jose Corti, 1962), 96. My translation.

7. Altman, *Epistolarity,* 118.

8. Shoshana Felman, *Jacques Lacan and the Adventure of Insight* (Cambridge: Harvard University, 1987), 77.

9. Rousset, *Forme et Signification,* 78.

10. Linda Kauffman, *Discouses of Desire: Gender, Genre, and Epistolary Fictions* (New York: Cornell University Press, 1986), 25.

11. Laurent Versini, *Le Roman Epistolaire* (Paris: Presses Universitaire de France, 1979), 55. My translation.

12. Arthur Rimbaud, *"Lettre du voyant," Oeuvres Complètes* (Paris: Gallimard, 1954), 268.

13. Franz Kafka, quoted in Altman, *Epistolarity,* page not numbered and no citation given.

14. Jacques Lacan, "Seminar on the Purloined Letter," 38–72.

15. Ibid., 72.

16. Barbara Johnson, "The Frame of Reference: Poe, Lacan, Derrida," in *The Critical Difference* (Baltimore: Johns Hopkins University Press, 1980), 145, 144.

17. Elizabeth Goldsmith, ed., introduction to *Writing the Female Voice* (London: Pinter, 1989), viii.

18. Porter, foreword, 11.

19. Jane Austen, *Lady Susan* (Boston: Little Brown, 1892), 91.

20. John McGowan, "Knowledge/Power and Jane Austen's Radicalism," in *MOSAIC* 18 (Summer 1985): 9. Foucault's emphasis on the importance of confession as a turning point in the history of consciousness is also pertinent here: "the individual constituted as seeking and desiring subject with an inner realm of experience that confession reveals remains the subject of he who requires it." Michel Foucault, *The History of Sexuality,* vol. 1, *An Introduction,* trans. Robert Hurley (New York: Pantheon, 1985), 146.

21. Derrida, quoted in Altman, *Epistolarity,* 212 (no citation given).

22. All page references cited in the text are to Jane Austen, *Emma* (New York: E. P. Dutton, 1950).

23. Joseph Litvak also remarks on the significance of the post office in the novel with a somewhat different emphasis: "the postal service is merely a synecdoche for the much larger system of communication on which the novel centers—namely, the social text in which the characters keep construing and misconstruing one another—so that any anxiety about mail deliveries may be taken as an anxiety about the semiotic efficiency or governability of society as a whole." "Reading Characters: Self, Society, and Text in *Emma,*" *PMLA* 100 (October 1985): 766.

24. See Mary Poovey for an account of Austen's relation to the economic and social changes that resulted in the "crisis of authority" reflected in *Emma. The Proper Lady and the Woman Writers* (Chicago: University of Chicago Press, 1984), 180–82.

25. Joel Weinsheimer, "Theory of Character: *Emma,*" *Poetics Today* 1 (Autumn 1979): 201.

26. Gilmore, *Autobiographics,* 77.

27. Critics have frequently questioned the unity of Emma's identity. Litvak sees Harriet and Emma as a "composite character," each of whom "fall[s] short of uniqueness and unity because, substituting for each other, they 'mean' something other than themselves, just as a rhetorical figure means something other than itself." "Reading Characters," 769. Sandra Gilbert and Susan Gubar,

on the other hand, see Jane as Emma's reflection: "In fact, she has to succumb to Jane's fate, to become her double through the realization that she too has been manipulated as a pawn in Frank Churchill's game." *The Madwoman in the Attic* (New Haven: Yale University Press, 1979), 159.

28. Cf. Edward Neil's conclusion, which he does not relate to this passage: "*Emma* is not merely the site where the English ideology, still a powerful contemporary myth, is created, but also where it is *exposed*." "Between Deference and Destruction: 'Situations' of Recent Critical Theory and Jane Austen's *Emma*," *Critical Quarterly* 29 (Autumn 1987): 47.

29. Raymond Hillard, "*Emma*: Dancing Without Space to Turn in," in *Probability, Time and Space in Eighteenth Century Literature*, ed. Paul R. Bachsheider (New York: AMS Press, 1979), 275–98.

30. Ray Tumbleson, "'It Is like a Woman's Writing': The Alternative Epistolary Novel in *Emma*," *Persuasions* 14 (December 1992): 143.

31. Sigmund Freud, *Civilization and Its Discontents*, in *The Standard Edition of the Complete Psychological Works of Sigmund Freud*, trans. and ed. James Strachey (London: Hogarth Press, 1974), 21: 112, 133, 134.

32. Foucault, *History of Sexuality*, 61.

33. Gilmore, *Autobiographics*, 164.

34. Neil, "Between Deference and Destruction," 44.

35. Patricia Meyer Spacks, "Gossip," in *Emma*, ed. Harold Bloom (New York: Chelsea, 1987), 116.

36. See, for example, Mary Elizabeth Tobin who, while stressing the social, political, and economic content of the novel, does not see the way the system of patronage extends the psychological power of the classes in control. She has no doubt that Emma comes to an understanding of her proper role in relation "to these impoverished gentlewomen whom this capitalist and industrialized society has made vulnerable." "Aiding Impoverished Gentlewomen: Power and Class in *Emma*," *Criticism* 30 (Fall 1988): 423.

37. Claudia Johnson makes a related point in relation to Emma's attitude toward Jane: "By preferring to read Jane's story as a tale of guilty passion, Emma had maintained for herself the prerogative either of censure or of generous exoneration that placed her apart from and above Jane." *Jane Austen: Women, Politics and the Novel* (Chicago: University Press of Chicago, 1988), 137.

38. This scene is a perfect example of the emotional intensity that Austen achieves through understatement and indirection, a claim developed by Juliet Mcmaster, "Love: Surface and Subsurface," in *Emma*, ed. Harold Bloom (New York: Chelsea House, 1987), 40–44.

39. See Juliet Flower MacCannell for an interpretation of Lacan along these lines: "Lacan's insistence to the psychoanalytic profession in the *Ecrits* is radical: we must reintroduce the importance, the significance, of the Unconscious in general cultural, not unique individual, terms." *Figuring Lacan: Criticism and the Cultural Unconscious* (Lincoln: University of Nebraska Press, 1986), 85.

40. Tzvetan Todorov, *The Poetics of Prose*, trans. Richard Howard (New York: Cornell University Press, 1977), 111.

41. Freud, *Civilization and Its Discontents*, 108, 104.

42. Spacks, "Gossip," 115.

43. Tumbleson, "'It Is Like a Woman's Writing,'" 142.

44. My use of the term Imaginary derives from Jacques Lacan who uses it

to refer to the subject's identification with objectlike images of itself. This identification inaugurates the alienation of the subject in which consciousness and its objects are lost in the play of reflection. See "Mirror Stage," in *Ecrits,* trans. Alan Sheridan (New York : Norton, 1977), 1–7; and Anika Lemaire, *Jacques Lacan,* trans. David Macey (London: Routledge & Kegan Paul, 1977), 56–61.

45. See Sigmund Freud, "The Uncanny," in *The Standard Edition of the Complete Psychological Works of Sigmund Freud,* ed. and trans. James Strachey (London: Hogarth Press, 1974), 17: 241. "This uncanny is in reality nothing new or alien, but something which is familiar and old—established in the mind and which has become alienated from it through the process of repression."

46. Peter Brooks, "Freud's Masterplot: Questions of Narrative," *Yale French Studies* 55/56 (1977): 284, 282.

47. Ibid., 288.

48. Lemaire, *Jacques Lacan,* 60.

49. Spacks, "Gossip," 116. See also Harold Bloom, introduction to *Emma,* ed. Harold Bloom (New York: Chelsea House, 1987), 4. "Do we, presumably against Austen's promptings, not find Mr. Knightly something of a confinement also, benign and wise though he be?"

50. Claudia Johnson reminds us that despite Knightly's "morally privileged position," at the end he remains in the dark about some of Emma's less admirable actions and concludes: "Austen's determination to establish a discrepancy between what he knows and what we know about Emma is daring." *Jane Austen,* 141.

51. Virginia Woolf, *A Room of One's Own* (New York: Harcourt Brace, 1929), 133.

Chapter 2. Towers in the Distance

1. Robert Browning, "Childe Roland to the Dark Tower Came," lines 202–4, 182–84.

2. T. S. Eliot, "The Wasteland," line 430.

3. Carl G. Jung, *Memories, Dreams, Reflections* (New York: Random House, 1963), 225.

4. Ibid., 224, 223.

5. Ibid., 224.

6. Ibid., 225.

7. Gaston Bachelard, *The Poetics of Space* (Boston: Beacon Press, 1958), 25.

8. Sigmund Freud, *Introductory Lectures on Psychoanalysis,* in *The Standard Edition of the Complete Psychological Works of Sigmund Freud,* ed. and trans. James Strachey (London: Hogarth Press, 1974), 15:154.

9. W. B. Yeats, "Blood and the Moon," stanza 4, lines 5–6.

10. Northrop Frye, *The Stubborn Structure* (New York: Cornell University Press, 1970), 276.

11. Northrop Frye, *Anatomy of Criticism* (Princeton: University of Princeton Press, 1957), 202.

12. Frye, *Stubborn Structure,* 273.

13. Thomas Pynchon, *The Crying of Lot 49* (Philadelphia: Lippincott, 1966), 13.

14. Ibid.

15. All page numbers cited in the text are to Virginia Woolf, *To the Lighthouse* (New York: Harcourt, Brace, 1927).

16. For a detailed discussion of Woolf's perspective in relation to the status of women in her time, see Herbert Marder, *Feminism and Art* (Chicago: University of Chicago Press, 1968).

17. Cf. Marianne DeKoven's remarks on the common ground of feminism and modernism: "In addition to French theoreticians, a number of American writers and critics argue . . . that modernist form's disruptions of hierarchical syntax, of consistent, unitary point of view, of realist representation, linear time and plot, and of the bounded, coherent self separated from, and in mastery of, an objectified outer world; its subjectivist epistemology; its foregrounding of the pre-Oedipal or aural features of language; its formal decenteredness, indeterminacy, multiplicity, and fragmentation are very much in accord with a feminine aesthetic or Cixousian *écriture féminine.*" *Rich and Strange: Gender, History, Modernism* (Princeton: Princeton University Press, 1991), 8.

18. On this question, see Juliet Flower MacCannell, *Figuring Lacan: Criticism and the Cultural Unconscious* (Lincoln: University of Nebraska Press, 1986), 106–9.

19. See my discussion of "A Sketch of the Past" for further elaboration of the same question.

20. Virginia Woolf, "A Sketch of the Past," in *Moments of Being,* ed. Jeanne Schulkind (New York: Harcourt Brace Jovanovich, 1976), 81.

21. I want to emphasize that I use these terms to designate particular relations to, or ways of being in, the world rather than to refer to literal figures.

22. For another treatment of the novel in terms of the movement from the Imaginary to the Symbolic, see James Mellard, *Using Lacan, Reading Fiction* (Chicago: University of Illinois Press, 1991). His emphasis, however, is on analyzing character development in relation to Lacan's specific concepts (*objet à, dérive de la jouissance*), whereas my own focus is on the general structure of the novel (from the dual to the triangular register), its place in Woolf's development, the metaphorical potential of the lighthouse to figure forth the complexity of the Symbolic realm, and the relation of the feminine to the Symbolic.

23. Shoshana Felman, *Jacques Lacan and the Adventure of Insight* (Cambridge: Harvard University Press, 1987), 139.

24. See, for example, Toril Moi, *Sexual/Textual Politics* (New York: Methuen, 1988); and Juliet Mitchell and Jacqueline Rose, introduction to *Feminist Literary Theory* (New York: Norton, 1982).

25. Moi, *Politics,* 12.

26. Jacqueline Rose, "Feminine Sexuality—Jacques Lacan and the *école freudienne,*" in *Sexuality in the Field of Vision* (London: Verso, 1986), 80.

27. Rose, "Sexuality," 79. For Kristeva, too, despite her emphasis on the Semiotic as opposed to the Symbolic, there is no question of an inherently female writing because she, too, rejects the notion of a fixed sexual identity. See Moi, *Politics,* 163.

28. I want to stress that it is this relation to the mother, rather than her subjective presence, that must be repressed.

29. See Moi, *Politics,* 1–18.

30. Anika Lemaire, *Jacques Lacan,* trans. David Macey (London: Routledge & Kegan Paul, 1977), 90. Madelon Sprengnether's suggestion that the birth experience itself—the separation of the infant from the body of the mother—might better serve as the crucial experience of castration of the subject and liberate us from the oedipal configuration with its unfortunate patriarchal legacy is enticing (*The Spectral Mother* [Ithaca: Cornell University Press, 1990]). However, I believe it overlooks the fact that it is only through entry into the Symbolic that we inherit the language that creates the unconscious and the repression through which the primal separation is encoded. That is, we only gain access to that original birth experience through symbolic form, which allows us to then go back and articulate it. The separation from the mother's body at birth is not necessarily experienced as the fundamental cleavage that defines the subject, because such awareness only begins with the mirror phase and is then indelibly inscribed at the moment of the passage from the Imaginary to the Symbolic. Lacan recognizes the significance of this crucial physical separation; what he underlines, however, is that the Symbolic Order is the essential dimension "from which the other orders, Imaginary and real, take their place and are ordered." Jacques Lacan, *Le Séminaire de Jacques Lacan,* vol. I, ed. Jacques-Alain Miller (New York: Norton, 1958), seminar 19, 263, quoted in MacCannell, *Figuring Lacan,* 46.

31. Elizabeth Abel, *Virginia Woolf and the Fictions of Psychoanalysis* (Chicago: University of Chicago Press, 1989); Margaret Homans, *Bearing the Word* (Chicago: University of Chicago Press, 1986).

32. Lemaire, *Jacques Lacan,* 61.

33. Rose, "Sexuality," 52.

34. Sigmund Freud, *Beyond the Pleasure Principle,* in *The Standard Edition of the Complete Psychological Works of Sigmund Freud,* ed. and trans. James Strachey (London: Hogarth Press, 1974), 18: 14–16.

35. Lemaire, *Jacques Lacan,* 64.

36. Woolf's insight into the complexity of the preoedipal realm foreshadows Kristeva's interpretation, which refuses to idealize this lost maternal continent and insists "on the psychic pain and violence which in fact characterizes the early interaction between the mother and child." Jacqueline Rose, "Julia Kristeva—Take Two," in *Sexuality and the Field of Vision* (London: Verso, 1986), 154.

37. Gayatri C. Spivak, "Unmaking and Making in *To the Lighthouse,*" in *Women and Language in Literature and Society,* eds. Sally McConnell-Ginet, Ruth Borker, and Nelly Furman (New York: Praeger, 1980), 310–27.

38. Felman, *Jacques Lacan,* 61.

39. Cf. ibid., 115: "The Symbolic is the differential situating of the subject in a *third position;* it is at once the place *from which* a dual relation is apprehended, the place *through which* it is articulated, and that which makes the subject (as, precisely this symbolic, third place) into a signifier in a system, which thereby permits him to relate symbolically to other signifiers, that is, at once to relate to other humans and to articulate his own desire, his own unconscious, unawares."

40. As Ellie Ragland-Sullivan underlines, the phallus for Lacan is not to be identified with the penis, but is "a third term, neither male nor female." *Jacques Lacan and the Philosophy of Psychoanalysis* (Chicago: University of Illinois Press, 1986), 55.

41. Mitchell, introduction, 24.

42. Rose, "Sexuality," 40.

43. Ibid., 43.

44. Cf. Felman, *Jacques Lacan*, 44. "For Lacan any possible insight into the reality of the unconscious is contingent on a perception of repetition, not as a confirmation of identity, but as the insistence on the indelibility of a difference."

45. Rose, "Sexuality," 40.

46. Homans, *Bearing the Word*, 286.

47. Ibid., 17.

48. Ibid., 20, 18.

49. Abel, *Virginia Woolf*, 69.

50. Homans, *Bearing the Word*, 11, 285.

51. Abel, *Virginia Woolf*, 69.

52. Rose, "Sexuality," 61.

53. Abel, *Virginia Woolf*, 77.

54. Ibid., 236, 77.

55. Ibid., 52, 53.

56. Ibid., 55, 77.

57. Rose, "Kristeva," 147.

58. Rose, "Sexuality," 66–67.

59. Cf. Moi on the meaning of androgyny for Woolf: "This is not . . . a flight from fixed gender identities, but a falsifying metaphysical nature. . . . She has understood that the goal of the feminist struggle must precisely be to deconstruct the death-dealing binary oppositions of masculinity and femininity." *Politics,* 13.

60. "By virtue of his occupying the third position . . . the analyst, through transference, allows at once for a repetition of the trauma and for a symbolic substitution, and thus effects the drama's denouement." Felman, *Jacques Lacan,* 43.

61. Rose, "Sexuality," 64.

CHAPTER 3. REFLECTING SURFACES

1. Plotinus, *Enneads* 6,7, trans. William Inge, in *The Philosophy of Plotinus,* 2 vols. (New York: Longmans, Green & Co., 1918), 1, 30.

2. Even M. H. Abrams's, *The Mirror and the Lamp,* which uses these metaphorical figures to distinguish the mimetic theories of the eighteenth century from the expressive theories of the romantic age, attests to the continual reign of notions of visual reciprocity: "The work ceases then to be regarded as primarily a reflection of nature, actual or improved; the mirror held up to nature becomes transparent and yields the reader insights into the mind and heart of the poet himself" (New York: Oxford University Press, 1951), 23.

3. For a thorough and stimulating account of the long tradition of privileging the visual in Western culture and its denigration in twentieth-century French thought, see Martin Jay, *Downcast Eyes: The Denigration of Vision in Twentieth-Century French Thought* (Berkeley and Los Angeles: University of California Press, 1993).

4. Leigh Gilmore, *Autobiographics: A Feminist Theory of Women's Self-Representation* (Ithaca: Cornell University Press, 1994), 71.

5. I take this term from Gilmore who defines it as "those changing elements of the contradictory discourses and practices of truth and identity which represent the subject of autobiography." Ibid., 13.

6. Virginia Woolf, "A Sketch of the Past," in *Moments of Being*, ed. Jeanne Schulkind (New York: Harcourt Brace Jovanovich, 1976), 67.

7. Terry Eagleton, *Literary Theory* (Minneapolis: University of Minnesota Press, 1983), 17.

8. Jay, *Downcast Eyes,* 32.

9. Frederick Goldin, *The Mirror of Narcissus in the Courtly Love Lyric* (Ithaca: Cornell University Press, 1967), 4.

10. Jay, *Downcast Eyes,* 12.

11. Goldin, *Mirror of Narcissus,* 4–5, 48, 14.

12. Ibid., 51. "The lover's deepest conflict arises from his doubt as to the reality of what he loves. Then he vacillates between his faith that the lady is a mirror of the ideal, and his suspicion that she is merely the passive and glorified instrument of his own aspiration, reflecting what she does not truly possess. It is the most important conflict in the lover's life, for upon its outcome depends the intactness or the dissolution of his own identity; and it arises because the lover, like Narcissus, requires a mirror in order to know himself."

13. Eric Williams, *The Mirror and the Word: Modernism, Literary Theory, and George Trakl* (Lincoln: University of Nebraska Press, 1993), 3.

14. Paul Zweig, *The Heresy of Self-Love: A Study of Subversive Individualism* (Princeton: Princeton University Press, 1986), 129.

15. Jay, *Downcast Eyes,* 81, 31.

16. Montaigne, "Of Repentance," *The Norton Anthology of World Masterpieces,* ed. Maynard Mack (New York: Norton, 1992), 1: 1673.

17. In their introduction to *Life/Lines,* Bella Brodzki and Celeste Schenck see this attitude "as the classic stance of the male autobiographer," presenting the individual as a mirror of his time as well as a representative of a universal self. This tradition, they underline, is predicated on the exclusion of women: "The (masculine) tradition of autobiography . . . had taken as its first premise the mirroring capacity of the autobiographer: *his* universality, *his* representativeness, *his* role as spokesman for the community." *Life/Lines: Theorizing Women's Autobiography* (Ithaca: Cornell University Press, 1988), 2, 1.

18. M. H. Abrams, *The Mirror and the Lamp,* 69.

19. Zweig, *Heresy of Self-Love,* 181, 179.

20. Albert Guerard, "Concepts of the Double," in *Stories of the Double,* ed. Albert Guerard (Philadelphia: Lippincott, 1967), 1.

21. Otto Rank, *The Double,* trans. Harry Tucker (Chapel: University of North Carolina Press, 1971), 86.

22. Sigmund Freud, "The Uncanny," in *The Standard Edition of the Complete Psychological Works of Sigmund Freud,* ed. and trans. James Strachey (London: Hogarth Press, 1974), 17: 224.

23. Guerard, "Concepts of the Double," 3.

24. Mary Shelley, *Frankenstein* (New York: Viking Penguin, 1985), 110.

25. The list of writers who deal with the doppelgänger theme in nineteenth- and twentieth-century literature is too long to enumerate. Among those most often cited are Hoffmann, Hogg, Maupassant, Poe, Melville, James, Dostoevsky, Conrad, Woolf, and Mann.

26. Guerard, "Concepts of the Double," 2.

27. Jay, *Downcast Eyes,* 339.

28. Sigmund Freud, "On Narcissism," in *The Standard Edition of the Complete Psychological Works of Sigmund Freud,* ed. and trans. James Strachey (London: Hogarth Press, 1974), 14: 77.

29. Jacqueline Rose, "The Imaginary," in *Sexuality in the Field of Vision* (London: Verso, 1986), 170.

30. Jay, *Downcast Eyes,* 344.

31. Rose, "Imaginary," 171.

32. See Catherine Clément, *The Life and Legends of Jacques Lacan* (New York: Columbia University Press, 1983), 91; and Anthony Wilden, *The Language of the Self* (Baltimore: Johns Hopkins University Press, 1968), 168.

33. Jacques Lacan, "Mirror Stage," in *Ecrits,* trans. Alan Sheridan (New York: Norton, 1977), 4.

34. Wilden, "Language of Self," 168.

35. For discussions of Lacan's complex views on gender, see Clément, *Life and Legends;* and Juliet Flower MacCannell, *Figuring Lacan: Criticism and the Cultural Unconscious* (Lincoln: University of Nebraska Press, 1986). See my chapter on *To the Lighthouse* for my own beliefs about Lacan's relation to feminist positions.

36. Luce Irigaray, *Speculum of the Other Woman,* trans. Gillian C. Gill (Ithaca: Cornell University Press, 1985), 54.

37. John Milton, *Paradise Lost,* book 4, lines 470–72, 487–88, 477–78, 490.

38. Virginia Woolf, *A Room of One's Own* (New York: Harcourt, 1929), 60–61.

39. Simone Weil, *Le Pesanteur et la Grace* (Paris: Plon, 1988), 43. My translation.

40. Cf. the futile longing of Frankenstein's monster for others who will recognize his goodness through the power of his words rather than responding to him solely on the basis of his vile image: "I formed in my imagination a thousand pictures of presenting myself to them and their reception of me. I imagined that they would be disgusted, until, by my gentle demeanor and conciliatory words, I should first win their favours and afterwards their love." Shelley, *Frankenstein,* 111.

41. See Jenijoy La Belle for an exploration of the pivotal position the mirror occupies in women's lives: "What women do with mirrors is clearly distinct from and psychically more important than what men do with mirrors in their pursuit of generally utilitarian goals." *Herself Beheld: The Literature of the Looking Glass* (Ithaca: Cornell University Press, 1988), 9.

42. Ibid., 143.

43. Ibid., 180, 179, 148.

44. Cf. Michel Tournier, who writes in a recently published book called *Miroir des Ideés* (Paris: Mercure de France, 1994), 169: "Pour les sages musulmans, le signe est esprit, intelligence, incitation à chercher, à penser. Il est tourné vers l'avenir. Alors que l'image est matière, repliquat figé du passé. (For Muslim sages, the sign is mind and intelligence, provoking us to search and to think. It is turned toward the future while the image is matter, a fixed replica of the past.) My translation.

45. Wilden, *Language of Self,* 233, quoting Guy Rosolato, "Le Symbolique," *La Psychanalyse* V (1959): 230.

46. See Brodzki for a critique of the idealization of the maternal in relation to autobiography. *Life/lines,* 246–47.

47. One of the most striking literary examples of this occurs in Milan Kun-

dera's *The Unbearable Lightness of Being* (New Yorker: Harper & Row, 1984), 41. "Staring at herself for long stretches of time, she was occasionally upset at the sight of her mother's features in her face. She would stare all the more doggedly at her image in an attempt to wish them away and keep only what was hers alone. Each time she succeeded was a time of intoxication."

48. Page references cited in the text are to "A Sketch of the Past," in *Moments of Being,* ed. Jeanne Schulkind (New York: Harcourt Brace Jovanovich, 1976), 61–137.

49. For a summary of the trends in autobiographical criticism, see Sidonie Smith's *A Poetics of Women's Autobiography* (Bloomington: Indiana University Press, 1987), 3–19.

50. Gilmore notes the striking absence of the body from most autobiographical discourse. *Autobiographics,* 14, 83. See Sidonie Smith's chapter on Woolf in *Subjectivity, Identity, and the Body* ([Bloomington: Indiana University Press, 1993], 84–102) for a provocative and more consistently feminist-oriented analysis of "Sketch" that also focuses on the body before and after the mirror gaze.

51. Other recent works on autobiography include Shari Benstock, ed., *The Private Self: Theory and Practice of Women's Autobiography* (Chapel Hill: University of North Carolina Press, 1988); Françoise Lionnet, *Autobiographical Voices: Race, Gender, Self-Portraiture* (Ithaca: Cornell University Press, 1989); James Olney, ed., *Studies in Autobiography* (New York: Oxford University Press, 1988); Donna Stanton, *The Female Autograph* (Chicago: University of Chicago Press, 1984).

52. In her introduction to *Poetics,* Smith summarizes the arguments of Chodorow and French Feminists that lead to the assumption of a radical difference in woman's relation to representation (3–19). Like Rose, Mitchell, and Moi, I see problems in this position, for those who ascribe to woman a privileged access to a preoedipal language that she, unlike the son, does not repress seem to violate the central insight of psychoanalysis, and one especially emphasized by Lacan: the formulation of the unconscious necessitates an experience of symbolic castration that is the radical and irrevocable split of subjectivity in all human beings.

53. Gilmore, *Autobiographics,* 149.

54. The distinction between visual and auditory experience that I draw is indebted to Erwin Straus whose phenomenological analysis of sense experience first led me to reflect on this question in Woolf. *Phenomenological Psychology* (New York: Basic Books, 1966); and *The Primary World of Senses* (New York: Free Press of Glen Cove, 1963).

55. Jay, *Downcast Eyes,* 197.

56. I find Louise De Salvo's reading of this image as representing the usual and depressed state of Woolf's childhood unpersuasive as I do her general interpretation of "A Sketch of the Past": "No more accurate, articulate, or convincing portrait of the state of childhood depression has perhaps been drawn." *Virginia Woolf: The Impact of Childhood Sexual Abuse on Her Life and Work* (Boston: Beacon Press, 1989), 102–4. See Smith's remarks on the grape image for an interpretation closer to my own though her emphasis differs: "This figure of the transparent grape eyeball is critical to Woolf's critique of metaphysical selfhood and its regulation of the body." *Subjectivity, Identity, and the Body,* 95.

57. As commentators on Lacan have pointed out, there is no absolute dis-

tinction between the Imaginary and Symbolic, and these stages are to be understood structurally as well as developmentally. See Jerry Aline Fleiger's description of the Imaginary register "not as a maternal preoedipal 'stage' that merely precedes the all-important paternal oedipal symbolic but as a crucial mode of human interaction which coexists and intertwines with the Symbolic at all moments of life." "Entertaining the Ménage à Trois: Psychoanalysis, Feminism, and Literature," in *Feminism and Psychoanalysis,* ed. Richard Feldstein and Judith Roof (Ithaca: Cornell University Press, 1989), 204.

58. Cf. Lyndall Gordon, quoting from Woolf's diary: "To be vibrating in response to impressions was to enjoy, she believed, a state of illusion. Not to vibrate was to see reality: 'Things seem clear, sane, comprehensible, and under no obligation . . . to make one vibrate at all. Indeed it's largely the clearness of sight which comes at such seasons that leads to depression.'" *Virginia Woolf: A Writer's Life* (New York: Norton, 1984), 54.

59. Sigmund Freud, *Beyond the Pleasure Principle,* in *The Standard Edition of the Complete Psychological Works of Sigmund Freud,* ed. James Strachey (London: Hogarth Press, 1974), 18: 14–16.

60. Writing on Lacan's mirror phase, Clément reminds us that the armor—the integrated image—the self puts on is far from invincible and a moment of unanticipated anguish or aggression risks plunging the subject into feelings and fantasies of fragmentation and disintegration. *Life and Legends,* 95.

61. Compare Smith's contrasting interpretation of the following passages that identifies writing with "the means to achieve once again union with the body of the mother." *Subjectivity, Identity, and the Body,* 96.

62. In this way "Sketch" provides a perfect example of what Gilmore signals as autobiography's potential to "offer structural or symbolic solutions to problems they cannot solve thematically. If the problem is the mystery of 'identity,' then a symbolic solution lies in the discursive production of autobiography's myth of identity." *Autobiographics,* xv.

63. See Béatrice Didier and Shari Benstock for readings of this scene that relate it to Lacan's Mirror stage, the particularity of the girl's experience, and the question of autobiography. "Virginia Woolf *ou la chambre maternelle,*" *L'Ecriture-Femme* (Paris: Presses Universitaires de France, 1981), 227–28; and "Authorizing the Autobiographical," *The Private Self,* 12–14.

64. This provides another example for Gilmore's point that "the creation of gender is represented as a kind of violence enacted on the body in order to make something visible qua gender which did not previously appear." *Autobiographics,* 164.

65. Wilden, *Language of Self,* 264.

66. Jamaica Kincaid, *Annie John* (New York: Farrar, Straus & Giroux, 1983), 88.

67. Gordon, drawing on unpublished letters and diary entries, presents a persuasive portrait of the Woolf marriage as having a strong level of intimacy and, at times, a certain physical pleasure. *Virginia Woolf,* 157.

68. Cf. Didier's comment on this passage: "La relation speculaire que crée la mort de la mère est si profonde que l'image du miroir réapparaît dans le texte, à un degré second, celui de la métaphore." (The specular relation created by the death of the mother is so profound that the image of the mirror reappears in the text on another level, that of metaphor.) "Virginia Woolf *ou la chambre maternelle,*" 231. My translation.

69. Fleiger's portrayal of the position of the prodigal daughter is suggestive

in this regard, pointing to an option beyond the binary opposition of submission or rebellion. Such a daughter, venturing beyond the constraints of the father's law, though never entirely eluding it, returns nevertheless "to enlarge the boundaries and recast its meaning." A speaking subject, as well as a victim of the Law, she "might make use of her unique position and double perspective to critique and reshape culture." "Entertaining," 192.

70. Virginia Woolf, "Old Bloomsbury," in *Moments of Being,* ed. Jeanne Schulkind (New York: Harcourt Brace Jovanovich, 1976), 172.

71. Germaine Brée, "Autogynography," in *Studies in Autobiography,* ed. James Olney (New York: Oxford University Press, 1988), 175.

72. References cited in the text are now to Vivian Gornick, *Fierce Attachments* (New York: Simon & Schuster, 1987).

73. A contrast of this walking (open and potentially liberating) with Nelly's narcissistic and dead end gait is revelatory: "Her walk was slow and deliberate. She moved first one haunch, then the other, making her hips sway. Everyone knew this woman was going nowhere, that she was walking to walk, walking to feel the effect she had on the street. Her walk insisted on the flesh beneath the clothes. It said, 'This body has the power to make you want'" (98).

74. The title of a collection of short stories by Grace Paley.

75. Jay, *Downcast Eyes,* 346.

76. Alain Robbe-Grillet, *Ghosts in the Mirror,* trans. Jo Levy (New York: Grove Press, 1988).

77. James R. Oestrich, "What's It All About, Albie?" *New York Times,* Sunday, 8 November 1992, sec. 2, p. 25.

78. Cf. Gilmore, *Autobiographics,* 25. "I do not understand autobiography to be any experientially truer than other representations of the self or to offer an identity any less constructed than that produced by other forms of representation simply because the author intends the subject to correspond to herself or himself."

79. In an interview Kincaid affirms that the feelings in the novel are autobiographical although she had originally not wanted to admit it. See Selwyn R. Cudjoe, "Jamaica Kincaid and the Modernist Project: An Interview," *Caribbean Women Writers,* ed. Selwyn R. Cudjoe (Amherst: Calaloux, 1990), 220.

80. Donna Perry, "An Interview with Jamaica Kincaid," in *Reading Black Reading Feminist,* ed. Henry Louis Gates, Jr. (New York: Meridian, 1990), 494.

81. Gilmore, *Autobiographics,* xv.

82. Kincaid, *Annie John,* 43. Compare with Woolf's description of her earliest memories that exhibit the same emphasis on sound and the lack of firm borders between inner and outer, self and other. Subsequent page references to this novel will be cited in the text.

83. Cf. Gilmore's statement that Annie's essay "offers a condensed version of Kincaid's view of truth telling in autobiography in which what is symbolically real must be represented through events that did not occur." See also her discussion of this episode in terms of Annie's colonial identity. *Autobiographics,* 103, 100–105.

84. The either/or form of these thoughts in which mother and self are inverted reflections of each other characterizes the Imaginary: either the mother is judged as guilty or she is seen as innocent, and the daughter is held responsible for the estrangement between them. See the later discussion of this pattern.

85. Cudjoe, "An Interview," 223.

86. Ibid.

87. H. Adlai Murdoch, "Severing the (M)other Connection: The Representation of Cultural Identity in Jamaica Kincaid's *Annie John,*" *Callaloo* 13 (Spring 1990): 325–40.

88. The narcissistic doubling of the self in the mirror phase gives rise to fantasies of "the violent destruction of the double." See Jay, *Downcast Eyes,* 341.

89. Annie's attraction to the Red Girl is in part caused by her refusal to submit to the ladylike ways imposed on Annie. Watching her climb a tree, Annie comments, "I had never seen a girl do this before. All the boys climbed trees for the fruit they wanted, and all the girls threw stones to knock the fruit off the trees. But look at the way she climbed that tree: better than any boy" (56). Annie's frustration with the imposition of gender distinction is further illustrated when she is allotted only minor roles in her games with Mineu.

90. Cudjoe, "An Interview," 219.

91. Murdoch, "Cultural Identity," 333.

92. See Walter Benjamin's "The Work of Art in the Age of Mechanical Reproduction," *Illuminations,* ed. Hannah Arendt (New York: Schoken Books, 1968), 227. "Earlier much futile thought had been devoted to the question of whether photography is an art. The primary question—whether the very invention of photography had not transformed the entire nature of art—was not raised."

Chapter 4. The Image and the Word, History and Memory in the Photographic Age

1. See Walter Benjamin's discussion of aura in "The Work of Art in the Age of Mechanical Reproduction," in *Illuminations,* ed. Hannah Arendt (New York: Schoken Books, 1968), 220–25. For a discussion of Benjamin's ambivalent attitude toward this subject, see John McCole, *Walter Benjamin and the Antinomies of Tradition* (Ithaca: Cornell University Press, 1993), 2–10.

2. Benjamin, "Work of Art," 219.

3. Ibid., 220.

4. Susan Sontag, *On Photography* (New York: Farrar, Straus & Giroux, 1973), 69.

5. Pierre Bourdieu, *Photography: A Middle-brow Art,* trans. Shaun Whiteside (Stanford: Stanford University Press, 1990), 30–31.

6. Sontag, *On Photography,* 9.

7. Roland Barthes, *Camera Lucida,* trans. Richard Howard (New York: Hill and Wang, 1981), 98.

8. Ibid.

9. Siegfried Kracauer, "Photography," trans. Thomas Y. Levin, *Critical Inquiry* 19 (Spring 1993): 425.

10. Marcel Proust, *Remembrance of Things Past,* trans. C. K. Scott-Moncrieff (New York: Random House, 1981), 3: 922.

11. Sontag, *On Photography,* 23.

12. Ibid., 24, 23.

13. Barthes, 106–7, 53.

14. Ibid., 90–91.

15. John Fowles, *Daniel Martin* (Boston: Little, Brown & Co, 1977), 274. See also Benjamin's discussion of the way the camera lends itself to exploitation by

fascism in the filming of mass movements: "the violation of an apparatus which is pressed into the production of ritual values." "Work of Art," 241.

16. Barthes, *Camera Lucida,* 13.

17. Bourdieu, *Photography,* 83.

18. Barthes, *Camera Lucida,* 14.

19. Ibid., 96–97. Cf. Susan Sontag, *On Photography,* 70. "Photographs state the innocence, the vulnerability of lives heading toward their own destruction and this link between photography and death haunts all photographs of people."

20. Kracauer, "Photography," 433.

21. Sontag, *On Photography,* 178–79. Benjamin, too, underlines the way film and photography serve the forces of commodification and capital, even diagnosing the "cult of the movie star." "Work of Art," 223, 231–32.

22. Kracauer, "Photography," 432.

23. Sontag, *On Photography,* 110.

24. Kracauer, "Photography," 434.

25. Sontag, *On Photography,* 54.

26. Milan Kundera, *The Book of Laughter and Forgetting* (New York: Alfred A. Knopf, 1981), 3.

27. Milan Kundera, *The Unbearable Lightness of Being* (New York: Harper & Row, 1984), 223.

28. Ibid., 4.

29. Ibid., 248.

30. Sontag, *On Photography,* 24.

31. Kundera, "Man Thinks, God Laughs," trans. Linda Asher, *New York Review of Books,* 13 June 1985, 11.

32. Kundera, *Unbearable Lightness of Being,* 253.

33. Michel Tournier, *The Ogre,* trans. Barbara Bray (New York: Pantheon, 1984), 104.

34. Ibid., 108.

35. Kundera, *Unbearable Lightness of Being,* 57.

36. Barthes, *Camera Lucida,* 15.

37. Shoshana Felman and Dori Laub, *Testimony* (New York: Routledge, 1992), 91.

38. Ibid., 88.

39. Cf. Susan D. Cohen who underlines Duras's use of visual metaphors in "ways that deconstruct the dominant, centralizing primacy of seeing as documentation." "Fiction and the Photographic Image in Duras' *The Lover,*" *L'Esprit Créateur* 30 (Spring 1990): 56.

40. In an interview in *Libération,* Duras distinguishes between telling a story (*raconter*) as she had done in *The Sea Wall*, an earlier narrative of the same childhood events, and writing (*écrire*), emphasizing that in previous novels she was looking for a way to write *(chercher à écrire),* but in this book she had succeeded: "*Là, j'écris.*" "'*J'avais envie de lire un livre de moi,*'" *Libération* (Paris), 4 September 1984, 29.

41. Susan Handelman, *The Slayers of Moses* (Albany: SUNY Press, 1982).

42. Only after writing this chapter did I come upon Martin Jay's informative and provocative book that emphasizes French intellectuals' "intense fascination with Judaism" and the Jewish taboo on images in the last two decades. *Downcast Eyes: The Denigration of Vision in Twentieth-Century French Thought* (Berkeley: University of California Press, 1993).

43. Handelman, *Slayer of Moses,* 35.

44. Ibid., 32, 34, 33.

45. See, for example, Deborah Glassman's emphasis on Duras's "delectation of isolated, immobile images" and Trista Selous's discussion of the girl as a fetish object. *Marguerite Duras: Fascinating Vision and Narrating Cure* (Rutherford, N.J.: Fairleigh Dickinson University Press, 1991), 112; *The Other Woman* (New Haven: Yale University Press, 1988), 147–48.

46. Handelman, *Slayers of Moses,* 117.

47. Suzanne Lamy and André Roy, *Marguerite Duras à Montréal* (Montreal: Spirale, 1981), 24.

48. Handelman, *Slayers of Moses,* 63.

49. All page references cited in the text are to Marguerite Duras, *The Lover,* trans. Barbara Bray (New York: Harper & Row, 1986).

50. See the previous chapter on autobiography for a longer elaboration of this subject.

51. Jerome Beaujour, "*L'oubli de la photographie,*" *Magazine littéraire* 278 (June 1990): 49.

52. Marguerite Duras, *La Vie Matérielle* (Paris: P.O.L., 1987), 88. My translation, as are those from *Les Yeux Verts* and the articles from *Magazine Littéraire.*

53. Aliette Armel, "*Le jeu autobiographique,*" *Magazine littéraire* 278 (June 1990), 29.

54. Suzanne Lamy and André Roy, *Marguerite Duras à Montréal,* 24.

55. See Christiane Blot-Labarrere for a discussion of Duras's fascination and identification with the Jews, including the fact that her son believed his family was Jewish until he was an adolescent. *Marguerite Duras* (Paris: Seuil, 1992), 72–73.

56. Marguerite Duras, *Les Yeux Verts* (Paris: Cahiers du Cinema, 1987), 178.

57. Jacques Derrida, "Edmond Jabès and the Question of the Book," in *Writing and Difference,* trans. Alan Bass (Chicago: University of Chicago Press, 1978), 64.

58. Duras, *Les Yeux Verts,* 157, 221, 130.

59. Ibid., 177–78. Because this last passage is very powerful in French as well as not entirely clear and difficult to translate, I will give the original: "Je crois que les juifs, ce trouble pour moi si fort, et que je vois en toute lumière, devant quoi je me tiens dans une voyance tuante, ca rejoint l'écrit. Ecrire, c'est aller chercher hors de soi ce qui est déjà au dedans de soi. Ce trouble a une fonction de regroupement de l'horreur latente répandue sur le monde, et que je reconnais. Il donne à voir l'horreur dans son principe."

60. Ibid., 179.

61. Ibid., 238, 179. The original of the last passage: "Le mot juif dit en même temps la puissance de mort que l'homme peut s'octroyer et sa reconnaissance par nous. C'est parce que les Nazis n'ont pas reconnus cetter horreur en eux qu'ils l'ont commise."

62. In contrast to those critics who feel that to call into question notions of truth and representation in relation to the holocaust is to become complicit with those who challenge the existence of this unfathomable historical event, I believe that deconstructionist insights offer a means of taking up the most urgent issues raised by the holocaust. To question our powers to represent or interpret what is only too harrowingly real is not to lead the way to dispensing

with the testimony of survivors unless one follows a specious kind of reasoning.

63. Felman and Laub, *Testimony*, 163.

64. Duras, *Les Yeux Verts*, 41. "J'étais très clairement devenue une autre personne."

65. Felman and Laub, *Testimony*, 201.

66. Cf. David Hockney's view that the photograph is simply "the ultimate Renaissance picture . . . the mechanical formulation of the theories of perspective. . . . The photographic process is simply the invention in the 19th century of a chemical substance that could 'freeze' the image projected from the hole in the wall, as it were, onto a surface. It was the invention of the chemicals that was new, not the particular way of seeing. . . . So the photograph is, in a sense, the end of something old, not the beginning of something new." *That's The Way I See It*, ed. Nikos Stangos (San Francisco: Chronicle Books, 1993), quoted in Avis Berman, "Won't You Step into My Painting?" *New York Times Book Review*, 21 November 1993, p. 7.

67. Felman and Laub, *Testimony*, 81, 224, 194.

68. Ibid., 123.

69. Ibid., 116.

70. Samuel Beckett, *The Unnamable* (New York: Grove Press, 1958), 414.

71. Felman and Laub, *Testimony*, 189.

72. Lamy and Roy, *Marguerite Duras à Montréal*, 27.

73. Felman and Laub, *Testimony*, 108.

74. Lamy and Roy, *Marguerite Duras à Montréal*, 27.

75. Felman and Laub, *Testimony*, 114.

76. Leah Hewitt, *Autobiographical Tightropes* (Lincoln: University of Nebraska Press, 1990), 113.

77. Marguerite Duras and Xaviere Gauthier, *Woman to Woman*, trans. Katharine A. Jensen (Lincoln: University of Nebraska Press, 1987), 1.

78. Duras, *La Vie Matérielle* (Paris: P.O.L., 1987), 14.

79. Duras, *Les Yeux Verts*, 93. Again I quote the French to make up for what is lost in the translation: "Cette lenteur, cette indiscipline de la ponctuation c'est comme si je déshabillais les mots, les uns après les autres et que je découvre ce qui était au dessous, le mot isolé, méconnaisable, dénué de toute parenté de toute identité, abandonné . . . tout doit être lu la place vide aussi, je veux dire tout doit être retrouvé. On s'aperçoit . . . quand on lit, écoute, combien les mots sont friables et peuvent tomber en poussière."

80. Duras, *Woman to Woman*, 16.

81. Duras, "'J'avais envie,'" 29.

82. Selous, *Other Woman*, 96.

83. Beaujour, "*L'oubli de la photographie*," 50.

84. Ibid.

85. Duras, *La Vie Matérielle*, 99–100.

86. Roland Barthes's account of his search for a satisfying photograph of his mother illustrates the same point. The only photograph that restores to him a sense of her true being is one of his mother as a child that has little resemblance to the mother that he knew: "a lost, remote photo, one which does not look 'like' her, the photo of a child I never knew." *Camera Lucida*, 161.

87. Beaujour, "*L'oubli de la photographie*," 50.

88. Duras, "'J'avais envie,'" 28.

89. Cf. Hewitt's discussion of this "scandalous assumption of feminine de-

sire," in relation to the figure of the prostitute. Especially suggestive are her speculations on the metaphorical relation between prostitution and writing. *Autobiographical Tightropes,* 115–18.

90. Duras's text exhibits the same captivation in the Imaginary as the autobiographical texts discussed in the previous chapter. There I explicitly situate the matter in terms of Lacanian theory.

91. Cf. Glassman who draws the same conclusion. *Marguerite Duras,* 117–18.

92. Carol Hofman, *Forgetting and Marguerite Duras* (Niwot: University Press of Colorado, 1991), 151.

93. Ibid.

94. Hewitt points out that these women like Duras are "on the border of two cultures" and thus share her state of "social alienation—or at least disaffection." *Autobiographical Tightropes,* 120.

95. Marguerite Duras, *The War,* trans. Barbara Bray (New York: Harper & Row, 1986), 46–47.

96. Felman and Laub, *Testimony,* 108, 189.

97. Kundera, *Laughter and Forgetting,* 102.

98. Felman and Laub, *Testimony,* 133.

CHAPTER 5. LABYRINTHS AND SPIDERWEBS

1. Cf. Penelope Reed Doob, 36. For a penetrating analysis of the ambiguity and doubleness inscribed within the labyrinth's design, see her recent book, *The Idea of the Labyrinth: From Classical Antiquity through the Middle Ages* (Ithaca: Cornell University Press, 1990).

2. Martin Jay, *Downcast Eyes: The Denigration of Vision in Twentieth-Century French Thought* (Berkeley: University of California Press, 1993), 229. For Derrida's development of the image, see Jacques Derrida, *The Ear of the Other: Otobiography, Transference, Translation,* ed. Christie McDonald (Lincoln: University of Nebraska Press, 1985), 11.

3. Angus Fletcher, "The Image of Lost Direction," in *Centre and Labyrinth,* eds. Eleanor Cook, Chaviva Hosek, Jay McPherson, Patricia Parker, and Julian Patrick (Toronto: University of Toronto Press, 1983), 339.

4. Ibid., 337.

5. J. Hillis Miller, *Illustration* (Cambridge: Harvard University Press, 1992), 76–77.

6. Cf. Homer: "but there in the future / he shall endure all that his destiny and the heavy Spinners / spun for him with the thread at his birth, when his mother bore him." Penelope weaving the web of Laertes' shroud is aligned with the same power: "This is a shroud for the hero Laertes ... lest any / Achaian woman in this neighborhood hold it against me / that a man of many conquests lies with no sheet to wind him." *The Odyssey,* trans. Richard Lattimore (New York: Harper & Row, 1965), book 7, lines 196–98; and book 9, lines 144–47.

7. Northrop Frye, *Anatomy of Criticism* (Princeton: University of Princeton Press, 1957), 192, 150.

8. For a discussion of the labyrinth in terms of initiatory rites of death and rebirth, see Janet Bord, *Mazes and Labyrinths of the World* (London: Latimer New Dimensions, 1976).

9. For an account of this disparity between the visual and literary arts, see Doob, *Idea of the Labyrinth,* 46–51. The following comparison is a summary of her analysis.

10. Ibid., 5, 49.

11. Ibid., 56.

12. Jacques Derrida, "Structure, Sign and Play in the Discourse of the Human Sciences," in *Writing and Difference,* trans. Alan Bass (Chicago: University of Chicago Press, 1978), 279.

13. Alain Robbe-Grillet, *In the Labyrinth,* trans. Richard Howard (New York: Grove Press, 1960).

14. J. Hillis Miller, "Ariadne's Thread: Repetition and the Narrative Line," *Critical Inquiry* 3 (Autumn 1976): 69, 68.

15. Ibid., 68, 69.

16. Sigmund Freud, *The Interpretation of Dreams,* in *The Standard Edition of the Complete Psychological Works of Sigmund Freud,* ed. and trans. James Strachey (London: Hogarth Press, 1974), 4–5: 524.

17. Miller, "Ariadne's Thread," 72.

18. Fletcher, "Image of Lost Direction," 340.

19. Miller, "Ariadne's Thread," 72.

20. Fletcher, "Image of Lost Direction," 340.

21. For instructive discussions of this context, see Vine Deloria, Jr., *Behind the Trail of Broken Tears* (New York: Dell Publishing, 1974); and Stephen Cornell, *The Return of the Native: American Indian Political Resurgence* (New York: Oxford University Press, 1988).

22. Cornell, *Return of the Native,* 66.

23. Françoise Lionnet, *Autobiographical Voices: Race, Gender, Self-Portraiture* (Ithaca: Cornell University Press, 1989), 13.

24. Ibid., 14, 9, 14, 17, 18.

25. Ibid., 26.

26. All page references cited in the text are to Leslie Marmon Silko, *Ceremony* (New York: Penguin Books, 1977).

27. Paula Gunn Allen, *The Sacred Hoop* (Boston: Beacon Press, 1986), 59.

28. Leslie Marmon Silko, "Language and Literature from a Pueblo Perspective," in *English Literature: Opening up the Canon,* ed. Leslie A. Fiedler and Houston A. Baker, Jr. (Baltimore: Johns Hopkins University Press, 1981), 64.

29. Ibid.

30. Frank Kermode, *The Sense of an Ending* (New York: Oxford University Press, 1967), 39.

31. Silko, "Pueblo Perspective," 58, 60.

32. Allen, *Sacred Hoop,* 148.

33. Silko, "Pueblo Perspective," 56.

34. Cf. Arnold Krupat,"Post-Structuralism and Oral Literature," in *Recovering the Word: Essays on Native American Literature*, eds. Brian Swann and Arnold Krupat (Berkeley: University of California Press, 1987), 116–18.

35. N. Scott Momaday, *House Made of Dawn* (New York: Harper & Row, 1966), 81, 77.

36. Leslie Silko, quoted in biographical note in *The Next Word: Poems by Third World Americans,* ed. Joseph Bruhac (New York: The Crossing Press, 1978), 173.

37. Mieke Bal, *Femmes Imaginaires* (Utrecht: HES Publishers, 1986), 147.

38. Miller, *Illustration,* 77.

39. One thinks here of Lucky's dance in *Waiting for Godot*.

40. Cf. Per Seyersted, *Leslie Marmon Silko* (Boise, Idaho: Boise State University, 1980), 30. "Tayo's encounters with Ts'eh ... are both real and unreal. There is a dreamlike quality about their tender meetings; she seems to know about him without asking; she has the paraphernalia of a medicine woman; and in short, she has many of the qualities of Spiderwoman, the Mother who also created the land."

41. Allen, *Sacred Hoop*, 150.

CONCLUSION

1. Martin Jay, in fact, underlines that what French feminists, especially Irigaray, and deconstruction share is a mutual interest in dethroning the ocularcentrism embedded in our culture. *Downcast Eyes: The Denigration of Vision in Twentieth-Century French Thought* (Berkeley and Los Angeles: University of California Press, 1993), 493.

2. Ibid., 187.

3. Ibid., 24. Jay is here summarizing the argument of Hans Jonas, "The Nobility of Sight: A Study in the Phenomenology of the Senses," in *The Phenomenon of Life: Toward a Philosophical Biology* (Chicago: University of Chicago Press, 1982).

4. Jonas, *"Nobility of Sight,"* 147.

5. Jay, *Downcast Eyes*, 25.

6. Emmanuel Levinas, "The Transcendence of Words," in *The Levinas Reader*, ed. Sean Hand (Oxford: Blackwell, 1989), 147.

7. Richard Kearny and Emmanuel Levinas, "Dialogue with Emmanuel Levinas," in *Face to Face with Levinas*, ed. Richard A. Cohen (Albany: State University of New York, 1986).

8. In this sense my readings reflect Derrida's central insight that "metaphors based on sense experience were open to a deconstructive reading, which could unsettle them, even if they could not be dissolved entirely." Jay, *Downcast Eyes*, 508.

Bibliography

Abel, Elizabeth. *Virginia Woolf and the Fictions of Psychoanalysis.* Chicago: University of Chicago Press, 1989.

Abrams, M. H. *The Mirror and the Lamp.* New York: Oxford University Press, 1953.

Allen, Paula Gunn. *The Sacred Hoop.* Boston: Beacon Press, 1986.

Altman, Janet. *Epistolarity.* Columbus: Ohio State University Press, 1982.

Armel, Aliette. "*Le jeu autobiographique.*" *Magazine littéraire* 278 (June 1990): 28–32.

Austen, Jane. *Emma.* New York: E. P. Dutton & Co., 1950.

———. *Lady Susan.* Boston: Little Brown & Co., 1892.

Bachelard, Gaston. *The Poetics of Space.* Boston: Beacon Press, 1958.

Bal, Mieke. *Femmes Imaginaire.* Utrecht: HES Publishers, 1986.

Barthes, Roland. *Camera Lucida.* Translated by Richard Howard. New York: Hill and Wang, 1981.

Beaujour, Jerome. "*L'oubli de la photographie.*" *Magazine littéraire* 278 (June 1990): 49–51.

Beckett, Samuel. *The Unnamable.* New York: Grove Press, 1958.

Benjamin, Walter. "The Work of Art in the Age of Mechanical Reproduction." In *Illuminations,* edited by Hannah Arendt. New York: Schoken Books, 1968.

Benstock, Shari, ed. *The Private Self: Theory and Practice of Women's Autobiography.* Chapel Hill: University of North Carolina Press, 1988.

———. "Authorizing the Autobiographical." In *The Private Self: Theory and Practice of Women's Autobiography.* Chapel Hill: University of North Carolina Press, 1988.

Berman, Avis. "Won't You Step into My Painting?" *New York Times Book Review* 21 November 1993, p. 7, quoting David Hockney, *That's the Way I See It,* edited by Nikos Stangos. San Fransisco: Chronicle Books, 1993.

Bloom, Harold, ed. Introduction. *Emma.* New York: Chelsea House, 1987.

Blot-Labarrere, Christiane. *Marguerite Duras.* Paris: Seuil, 1992.

Bord, Janet. *Mazes and Labyrinths of the World.* London: Latimer New Dimensions, 1976.

Bourdieu, Pierre. *Photography: A Middle-brow Art.* Translated by Shaun Whiteside. Stanford: Stanford University Press, 1990.

Brée, Germaine. "Autogynography." In *Studies in Autobiography,* edited by James Olney. New York: Oxford University Press, 1988.

Brodzki, Bella, and Celeste Schenck. *Life/Lines: Theorizing Women's Autobiography.* Ithaca: Cornell University Press, 1988.

————. "Mothers, Displacement and Language in the Autobiographies of Nathalie Sarraute and Christa Wolf." In Life/Lines: *Theorizing Women's Autobiography,* edited by Bella Brodzki and Celeste Schenck. Ithaca: Cornell University, 1988.

Brooks, Peter. "Freud's Masterplot: Questions of Narrative." *Yale French Studies* 55/56 (1977): 280–300.

Clément, Catherine. *The Life and Legends of Jacques Lacan.* New York: Columbia University Press, 1983.

Cohen, Susan D. "Fiction and the Photographic Image in Duras' *The Lover.*" *L'Esprit Créateur* 30 (Spring 1990): 56–68.

Cornell, Stephen. *The Return of the Native: American Indian Political Resurgence.* New York: Oxford University Press, 1988.

Cudjoe, Selwyn. "Jamaica Kincaid and the Modernist Project: An Interview." In *Caribbean Women Writers,* edited by Selwyn Cudjoe. Amherst, Massachusetts: Calaloux, 1990.

DeKoven, Marianne. *Rich and Strange: Gender, History, Modernism.* Princeton: Princeton University Press, 1991.

Deloria, Jr., Vine. *Behind the Trail of Broken Treaties.* New York: Dell Publishing, 1974.

Derrida, Jacques. *The Ear of the Other: Otobiography, Transference, Translation,* edited by Christie McDonald. Lincoln: University of Nebraska Press, 1985.

————. *Writing and Difference.* Translated by Alan Bass. Chicago: University of Chicago Press, 1978.

————. "Edmond Jabes and the Question of the Book." In *Writing and Difference.* Translated by Alan Bass. Chicago: University of Chicago Press, 1978.

————. "Structure, Sign and Play in the Discourse of the Human Sciences." In *Writing and Difference.* Translated by Alan Bass. Chicago: University of Chicago Press, 1978.

————. *The Postcard: From Socrates to Freud and Beyond.* Translated by Alan Bass. Chicago: The University of Chicago Press, 1987.

————. "The Purveyor of Truth." *Yale French Studies* 52 (1975): 31–113.

De Salvo, Louise. *Virginia Woolf: The Impact of Childhood Sexual Abuse on Her Life and Work.* Boston: Beacon Press, 1989.

Didier, Beatrice. "Virginia Woolf *ou la chambre maternelle.*" In *L'Ecriture-Femme.* Paris: Presses Universitaires de France, 1981.

Doob, Penelope Reed. *The Idea of the Labyrinth.* Ithaca: Cornell University Press, 1990.

Duras, Marguerite. *La vie Matérielle.* Paris: P.O.L. 1987.

————. *Les Yeux Verts.* Paris: Cahiers du Cinema, 1987.

————. *The Lover.* Translated by Barbara Bray. New York: Harper & Row, 1986.

————. *The North China Lover.* Translated by Barbara Bray. New York: The New Press, 1992.

————. *The Sea Wall.* Translated by Herna Briffautt. New York: Farrar, Straus & Giroux, 1967.

————. *The War.* Translated by Barbara Bray. New York: Pantheon, 1986.

Duras, Marguerite, and Xaviere Gauthier. *Woman to Woman*. Translated by Katharine A. Jensen. Lincoln: University of Nebraska Press, 1987.

Eagleton, Terry. *Literary Theory*. Minneapolis: University of Minnesota Press, 1983.

Felman, Shoshana. *Jacques Lacan and the Adventure of Insight*. Cambridge: Harvard University Press, 1987.

Felman, Shoshana, and Dori Laub. *Testimony: Crises of Witnessing in Literature*. New York: Routledge, 1992.

Fletcher, Angus. "The Image of Lost Direction." In *Centre and Labyrinth*, edited by Eleanor Cook, Chaviva Hosek, Jay Macpherson, Patricia Parker, and Julian Patrick. Toronto: University of Toronto Press, 1983.

Flieger, Jerry Aline. "Entertaining the Ménage à Trois: Psychoanalysis, Feminism, and Literature." In *Feminism and Psychoanalysis*, edited by Richard Feldstein and Judith Roof. Ithaca: Cornell University Press, 1989.

Foucault, Michel. *The History of Sexuality*, vol. 1: *An Introduction*. Translated by Robert Hurley. New York: Pantheon, 1985.

Fowles, John. *Daniel Martin*. Boston: Little, Brown & Co., 1977.

Freud, Sigmund. *The Standard Edition of The Complete Psychological Works of Sigmund Freud*. 24 vols. Edited by James Strachey. London: Hogarth Press, 1974.

———. *Beyond the Pleasure Principle. Standard Edition* 18: 1–64.

———. *Civilization and Its Discontents. Standard Edition* 21: 57–145.

———. *Introductory Lectures on Psychoanalysis. Standard Edition* 15.

———. *The Interpretation of Dreams. Standard Edition* 4: 1–138.

———. "On Narcissism: An Introduction." *Standard Edition* 14: 73–102.

———. "The Uncanny." *Standard Edition* 17: 217–52.

Frye, Northrop. *Anatomy of Criticism*. Princeton: University of Princeton Press, 1957.

———. *The Stubborn Structure*. New York: Cornell University Press, 1970.

Gilbert, Sandra, and Susan Gubar. *The Madwoman in the Attic*. New Haven: Yale University Press, 1979.

Gilmore, Leigh. *Autobiographics: A Feminist Theory of Women's Self-Representation*. Ithaca: Cornell University Press, 1994.

Glassman, Deborah. *Marguerite Duras: Fascinating Vision and Narrating Cure*. Rutherford, N.J.: Fairleigh Dickinson University Press, 1991.

Goldin, Frederick. *The Mirror of Narcissus in the Courtly Love Lyric*. Ithaca: Cornell University Press, 1967.

Goldsmith, Elizabeth, ed. *Writing the Female Voice: Essays on Epistolary Literature*. London: Pinter, 1989.

Gordon, Lyndall. *Virginia Woolf: A Writer's Life*. New York: Norton, 1984.

Gornick, Vivian. *Fierce Attachments*. New York: Simon & Schuster, 1987.

Guerard, Albert. "Concepts of the Double." In *Stories of the Double*, edited by Albert Guerard. Philadelphia: J. B. Lippincott, 1967.

Gunn, Janet Varner. *Autobiography: Towards a Poetics of Experience*. Philadelphia: University of Pennsylvania Press, 1982.

Handelman, Susan. *The Slayers of Moses*. Albany: SUNY Press, 1982.

Hewitt, Leah. *Autobiographical Tightropes*. Lincoln: University of Nebraska Press, 1990.

Hillard, Raymond. "*Emma:* Dancing Without Space to Turn in." In *Probability, Time and Space in Eighteenth Century Literature,* edited by Paul R. Bachsheider. New York: AMS Press, 1979.

Hofman, Carol. *Forgetting and Marguerite Duras.* Niwot: University Press of Colorado, 1991.

Homans, Margaret. *Bearing the Word.* Chicago: University of Chicago Press, 1986.

Homer. *The Odyssey.* Translated by Richard Lattimore. New York: Harper & Row, 1965.

Irigaray, Luce, *Speculum of the Other Woman.* Translated by Gillian C. Gill. Ithaca: Cornell University Press, 1985.

"'*J'avais envie de lire un livre de moi.*'" *Libération,* 4 September 1984, 27–29.

Jay, Martin. *Downcast Eyes: The Denigration of Vision in Twentieth-Century French Thought.* Berkeley: University of California Press, 1993.

Jelnick, Estelle C. *The Tradition of Women's Autobiography: From Antiquity to the Present.* Boston: Twayne, 1986.

———, ed. *Women's Autobiography.* Bloomington: Indiana University Press, 1980.

Johnson, Barbara. "The Frame of Reference: Poe, Lacan, Derrida." In *The Critical Difference.* Baltimore: The Johns Hopkins University Press, 1980.

Johnson, Claudia. *Jane Austen: Women, Politics and the Novel.* Chicago: University Press of Chicago, 1988.

Jonas, Hans. "The Nobility of Sight: A Study in the Phenomenology of the Senses." In *The Phenomenon of Life: Toward a Philosophical Biology.* Chicago: University of Chicago Press, 1982.

Jung, Carl G. *Memories, Dreams, Reflections.* New York: Random House, 1963.

Kauffman, Linda. *Discourses of Desire: Gender, Genre, and Epistolary Fictions.* Ithaca: Cornell University Press, 1986.

Kearny, Richard, and Emmanuel Levinas. "Dialogue with Emmanuel Levinas." In *Face to Face with Levinas,* edited by Richard A. Cohen. Albany: State University of New York, 1986.

Kermode, Frank. *The Sense of an Ending.* New York: Oxford University Press, 1967.

Kincaid, Jamaica. *Annie John.* New York: Farrar, Straus & Giroux, 1983.

———. *Lucy.* New York: Farrar, Straus & Giroux, 1990.

———. "Xuela." *New Yorker,* 9 May 1994, 82–92.

Kracauer, Siegfried. "Photography." Translated by Thomas Y. Levin. *Critical Inquiry* 19 (Spring 1993): 421–36.

Kristeva, Julia. *Powers of Horror.* Translated by Leon Roudiez. New York: Columbia University Press, 1982.

———. *Revolution in Poetic Language.* Translated by Margaret Waller. New York: Columbia University Press, 1984.

Krupat, Arnold. "Post-Structuralism and Oral Literature." In *Recovering the Word: Essays on Native American Literature,* edited by Brian Swann and

Arnold Krupat. Berkeley and Los Angeles: University of California Press, 1987.

Kundera, Milan. *The Book of Laughter and Forgetting.* New York: Alfred A. Knopf, 1981.

———. "Man Thinks, God Laughs." Translated by Linda Asher. *New York Review of Books,* 13 June 1985, 11–12.

———. *The Unbearable Lightness of Being.* New York: Harper & Row, 1984.

La Belle, Jenijoy. *Herself Beheld: The Literature of the Looking Glass.* Ithaca: Cornell University Press, 1988.

Lacan, Jacques. *Le Seminaire de Jacques Lacan,* vol. 1, edited by Jacques-Alain Miller. Paris: Seuil, 1975.

———. "Mirror Stage." In *Ecrits.* Translated by Alan Sheridan. New York: Norton, 1977.

———. "Seminar on the Purloined Letter." *Yale French Studies* 48 (1973): 38–72.

Laclos, Pierre-Ambroise-Francois Choderlos de. *Les Liaisons Dangereuses,* edited by Yves Le Hir. Paris: Garnier, 1961.

Lamy, Suzanne, and André Roy. *Marguerite Duras à Montréal.* Montreal: Spirale, 1981.

Lemaire, Anika. *Jacques Lacan.* Translated by David Macey. London: Routledge & Kegan Paul, 1977.

Levi, Primo. *Survival in Auschwitz,* edited and translated by Stuart Woolf. New York: Collier, 1961.

Levinas, Emmanuel. "The Transcendence of Words." In *The Levinas Reader,* edited by Sean Hand. Oxford: Blackwell, 1989.

Lionnet, Françoise. *Autobiographical Voices: Race, Gender, Self-Portraiture.* Ithaca: Cornell University Press, 1989.

Litvak, Joseph. "Reading Characters: Self, Society, and Text in *Emma.*" *PMLA* 100 (October 1985): 763–73.

MacCannell, Juliet Flower. *Figuring Lacan: Criticism and the Cultural Unconscious.* Lincoln: University of Nebraska Press, 1986.

Marder, Herbert. *Feminism and Art.* Chicago: University of Chicago Press, 1968.

McCole, John. *Walter Benjamin and the Antinomies of Tradition.* Ithaca: Cornell University Press, 1993.

McGowan, John P. "Knowledge/Power and Jane Austen's Radicalism." *MOSAIC* 18 (Summer 1985): 1–15.

McMaster, Juliet. "Love: Surface and Subsurface." In *Emma,* edited by Harold Bloom. New York: Chelsea House, 1987.

Mellard, James. *Using Lacan, Reading Fiction.* Chicago: University of Illinois Press, 1991.

Miller, J. Hillis. "Ariadne's Thread: Repetition and the Narrative Line." *Critical Inquiry* 3 (Autumn 1976): 57–78.

———. *Illustration.* Cambridge: Harvard University Press, 1992.

Milton, John. *Complete Poems and Major Prose,* edited by Merritt Y. Hughes. New York: The Odyssey Press, 1957.

Mitchell, Juliet. Introduction 1 to *Feminine Sexuality*. New York: Norton, 1982.

Moi, Toril. *Sexual/Textual Politics: Feminist Literary Theory*. New York: Methuen, 1988.

Momaday, N. Scott. *House Made of Dawn*. New York: Harper & Row, 1966.

Montaigne. "Of Repentance." In *The Norton Anthology of World Masterpieces*, vol. 1, edited by Maynard Mack. New York: Norton, 1992.

Murdoch, H. Adlai. "Severing The (M)other Conncection: The Representation of Cultural Identity in Jamaica Kincaid's *Annie John*." *Callaloo* 13 (Spring 1990): 325–40.

Neil, Edward. "Between Deference and Destruction: 'Situations' of Recent Critical Theory and Jane Austen's *Emma*." *Critical Quarterly* 29 (Autumn 1987): 39–54.

Nolan, Edward. *Now Through A Glass Darkly: Specular Images of Being and Knowing from Virgil to Chaucer*. Ann Arbor: University of Michigan Press, 1990.

Olney James, ed. *Autobiography: Essays Theoretical and Critical*. Princeton: Princeton University Press, 1980.

———, ed. *Studies in Autobiography*. New York: Oxford University Press, 1988.

Ovid. *Metamorphoses*. Translated by Rolfe Humphries. Bloomington: Indiana University Press, 1955.

Perry, Donna. "An Interview with Jamaica Kincaid." In *Reading Black Reading Feminist*, edited by Henry Louis Gates, Jr. New York: Meridian, 1990.

Plotinus, *Enneads*, III, 6,7. Translated by William Ralph Inge. *The Philosophy of Plotinus*, 2 vols. New York: Longmans, Green & Co., 1918.

Poovey, Mary. *The Proper Lady and the Woman Writer*. Chicago: University of Chicago Press, 1984.

Porter, Charles. Foreword to *Yale French Studies* 71 (1986): 1–14.

Proust, Marcel. *Remembrance of Things Past*. Translated by C. K. Scott-Moncrieff. 3 vols. New York: Random House, 1981.

Pynchon, Thomas. *The Crying of Lot 49*. Philadelphia: Lippincott, 1966.

Ragland-Sullivan, Ellie. *Jacques Lacan and the Philosophy of Psychoanalysis*. Chicago: University of Illinois Press, 1986.

Rank, Otto. *The Double*. Translated by Harry Tucker, Jr. Chapel Hill: University of North Carolina Press, 1971.

Rimbaud, Arthur. *"Lettre du voyant."* In *Oeuvres Complètes*. Paris: Gallimard, 1954.

Robbe-Grillet, Alain. *Ghosts in the Mirror*. Translated by Jo Levy. New York: Grove Press, 1988.

———. *In the Labyrinth*. Translated by Richard Howard. New York: Grove Press, 1960.

Rose, Jacqueline. *Sexuality in the Field of Vision*. London: Verso, 1986.

———. "Julia Kristeva—Take Two." In *Sexuality in the Field of Vision*. London: Verso, 1986.

———. "Feminine Sexuality—Jacques Lacan and the *école freudienne*." In *Sexuality in the Field of Vision*. London: Verso, 1986.

Rousset, Jean. *Forme et Signification*. Paris: Jose Corti, 1962.

Selous, Trista. *The Other Woman.* New Haven: Yale University Press, 1988.

Seyersted, Per. *Leslie Marmon Silko.* Boise: Boise State University, 1980.

Shelley, Mary. *Frankenstein.* New York: New Viking Penguin, 1985.

Silko, Leslie Marmon. *Ceremony.* New York: Penguin Books, 1977.

————. Quoted in biographical note. In *The Next Word: Poems by Third World Americans,* edited by Joseph Bruchac. New York: The Crossing Press, 1978.

————. "Language & Literature from a Pueblo Perspective." In *English Literature: Opening up the Canon,* edited by Leslie A. Fiedler and Houston A. Baker, Jr. Baltimore: Johns Hopkins University Press, 1981.

Smith, Sidonie. *A Poetics of Women's Autobiography.* Bloomington: Indiana University Press, 1987.

————. *Subjectivity, Identity, and the Body.* Bloomington: Indiana University Press, 1993.

Sontag, Susan. *On Photography.* New York: Farrar, Straus and Giroux, 1973.

Spacks, Patricia Meyer. "Gossip." In *Emma,* edited by Harold Bloom. New York: Chelsea House, 1987.

Spivak, Gayatri C. "Unmaking and Making in *To the Lighthouse.*" In *Women and Language in Literature and Society,* edited by Sally McConnell-Ginet, Ruth Barker, and Nelly Furman. New York: Praeger, 1980.

Spregnether, Madelon. *The Spectral Mother.* Ithaca: Cornell University Press, 1990.

Stanton, Donna, ed. *The Female Autograph.* Chicago: University of Chicago Press, 1984.

Straus, Erwin. *Phenomenological Psychology.* New York: Basic Books, 1966.

————. *The Primary World of Senses.* New York: The Free Press of Glen Cove, 1963.

Tanner, Tony. *Jane Austen.* Cambridge: Harvard University Press, 1986.

Tobin, Mary-Elizabeth. "Aiding Impoverished Gentlewomen: Power and Class in *Emma.*" *Criticism* 30 (Fall, 1988): 413–29.

Todorov, Tzvetan. *The Poetics of Prose.* Translated by Richard Howard. New York: Cornell University Press, 1977.

Tournier, Michel. *Miroir des Idées.* Paris: Mercure de France, 1994.

————. *The Ogre.* Translated by Barbara Bray. New York: Pantheon 1984.

Trilling, Lionel. Introduction to *Emma.* Boston: Houghton Mifflin Co., 1957.

Tumbleson, Ray. "'It Is like a Woman's Writing': The Alternative Epistolary Novel in *Emma.*" *Persuasions* 14 (16 December 1992): 141–43.

Versini, Laurent. *Le Roman Epistolaire.* Paris: Presses Universitaire de France, 1979.

Weil, Simone. *Le Pesanteur et la Grace.* Paris: Plon, 1988.

Weinsheimer, Joel. "Theory of Character: *Emma,*" *Poetics Today* 1(Autumn 1979): 185–211.

Wilden, Anthony. *The Language of the Self.* Baltimore: Johns Hopkins University Press, 1968.

Williams, Eric, *The Mirror and the Word: Modernism, Literary Theory, and George Trakl.* Lincoln: University of Nebraska Press, 1993.

Woolf, Virginia. "Mr. Bennett and Mrs. Brown." In *The Captain's Death Bed and Other Essays.* London: Hogarth, 1950.

———. "Old Bloomsbury." In *Moments of Being,* edited by Jeanne Schulkind. New York: Harcourt Brace Jovanovich, 1976.

———. *A Room of One's Own.* New York: Harcourt Brace, 1929.

———. "A Sketch of the Past." In *Moments of Being,* edited by Jeanne Schulkind. New York: Harcourt Brace Jovanovich, 1976.

———. *To the Lighthouse.* New York: Harcourt, Brace, 1927.

Zweig, Paul. *The Heresy of Self-Love: A Study of Subversive Individualism.* Princeton: Princeton University Press, 1986.

Index

Numbers in parentheses indicate the pages referred to by the notes.